D0909008

CURIOSITY

AND ITS TWELVE RULES FOR LIFE

F.H.BUCKLEY

NEW YORK · LONDON

First American edition published in 2021 by Encounter Books, an activity of Encounter for Culture and Education, Inc., a nonprofit, tax-exempt corporation. Encounter Books website address: www.encounterbooks.com

Manufactured in the United States and printed on acid-free paper. The paper used in this publication meets the minimum requirements of ANSI/NISO Z39.48 – 1992 (R 1997) (*Permanence of Paper*).

FIRST AMERICAN EDITION

LIBRARY OF CONGRESS CATALOGING-IN-PUBLICATION DATA

Names: Buckley, F. H. (Francis H.), 1948- author.
Title: Curiosity: and its twelve rules for life / by F. H. Buckley.
Description: New York: Encounter Books, 2021. |
Includes bibliographical references and index. |
Identifiers: LCCN 2020036873 (print) | LCCN 2020036874 (ebook) |
ISBN 9781641771849 (hardcover) | ISBN 9781641771856 (ebook)
Subjects: LCSH: Curiosity. | Risk-taking (Psychology) |
Self-actualization (Psychology)
Classification: LCC BF323.C8 B83 2021 (print) | LCC BF323.C8 (ebook) |
DDC 155.2/32—dc23
LC record available at https://lccn.loc.gov/2020036873
LC ebook record available at https://lccn.loc.gov/2020036874

For Ben and Max

Contents

THE TWELVE RULES

ONCE WE LIVED in a garden. It gave us everything we wanted, and while we were there we'd never die. And then, because of Eve's curiosity, we were driven from it. We were sent to a new world, one of labor and pain. In it we're also condemned to death, and that has made why we live a puzzle to us. But the new world is a garden too. Unlike Eden, things happen here. It's a world of passion and nobility, action and surprise, a world we can shape by the force of our will. It's a world that asks us to look, to search, to learn. Curiosity, which was a fatal sin in Eden, is a necessary virtue in the new world.

That's why we can't stand being bored. In the first sentence of his *Metaphysics*, twenty-three hundred years ago, Aristotle said that all men by nature desire to know. Give us a box, and we'll open it. Hand us a book, and we'll read it. Tell Eve not to eat of the tree of life, and that's just what she'll do. We're curious, and naturally so.

Even the gods on Olympus were curious. You might have expected that they'd be content up there, where they had

everything they wanted. But they got bored and came down to see what we were up to. Sometimes they'd mingle in our quarrels, taking sides with one group against the other, Greeks versus Trojans. Sometimes they'd come down and visit with us.

Like the gods, we might think we have everything we want, but we still want to get out and do something. We get bored. In our contentment, there's always an edge of sadness, a sense that something is missing. We're jarred out of our lethargy and look for adventure. Sometimes it's found at the end of the street. Sometimes it's a continent away.

We can easily fall into a rut, however, and need to be prompted to try new things. That's the spirit in which I offer the twelve rules of curiosity. They're not a road map; they're not even a set of rules, though it simplifies things to call them that. What they're not is Jordan Peterson's twelve rules for life. Those were guidelines on how to survive and surmount the challenges of life in a bleak and cold climate. Perhaps that's what you'd expect from a Canadian writer. How to survive in a forbidding world is the great theme of Canadian literature, according to Margaret Atwood. By contrast, the twelve rules of curiosity are meant for the more spirited and fun-loving people I met when I moved from Canada to the United States. They thought that we live in a world of wonders that offers opportunities for enjoyment and delight and that all we have to do is reach out and grab them.

Survival is not enough. We also need to create, to struggle and not to yield, to be curious about the world and what we owe other people. Every leap of knowledge and every entrepreneurial firm was created by a person who was curious. When you pull all this together, what you have are the rules of curiosity.

Now, more than ever, curiosity matters. In 2020 we learned

just how much our health, our happiness, our sanity, depends upon it. Shut in during a pandemic, we yearned to get out, to meet other people, and when that wasn't permitted we languished. Then, during a summer of riots and protests, we were told that there was one great evil and that it was immoral to be curious about anything else. The formerly innocent pleasures of sports and entertainment offered no escape. All this happened during an extraordinarily bitter impeachment and election year which, for all its rancor, had on both sides become mind-numbingly repetitive and boring. That might have worked to Trump's advantage, but for the way in which he, too, had begun to bore us with his thin-skinned animosities.

There is only one way out of the madness, and that is to let our curiosity take us by the hand and lead us.

Follow your curiosity, therefore. It will encourage you to take risks, to be creative, sociable, and entertaining. It will ask you to think about how you should live. That's the greatest question of all, and one that a book about curiosity must answer.

Rule 1: *Don't make rules.* Rules are a first cut at how we should behave. They're usually worth following, and no one wants to junk the Ten Commandments. But they govern only a small part of our lives. They don't tell us what's wrong about being unkind or mean. That's where curiosity comes in. Moral heroes, people like the rescuers who sheltered European Jews during the Second World War, or like Bishop Myriel in *Les misérables*, are remembered because they were curious about the fate of forgotten people.

Rule 2: *Take risks.* Nothing novel was ever created without risk-taking. If you only bet on sure things, you're not curious

about the outcome. It's only when there's a real gamble that anything new is created or something heroic is done. The soldiers who fought for their country, the great explorers, were risk-takers. The incurious stayed put and kept the home fires burning.

Rule 3: *Court uncertainties.* Risks are different from uncertainties. You can assign a probability to a risk: 50 percent it's heads, 50 percent it's tails. With uncertainty you don't know what the probabilities are. It's a shot in the dark. But that's the gamble the entrepreneur takes when he starts a new business, particularly when he offers the public something it never had before. That's the story of the new economy of the internet, with the personal computers and apps that we never knew we needed before they were offered to us.

Rule 4: *Be original.* The beaten path is beaten down when people mindlessly follow it. That's always the safe thing to do, but safety never created anything new. To strike off from the path, the first step is always originality and a curiosity about the weaknesses, falsehoods, and banality of received ideas. That's how Albert Camus broke with collaborators during the Occupation of France and, afterward, with the fashionable postwar communists.

Rule 5: *Show grit.* New things tend not to come easily. It takes grit, the virtue of people who don't give up. Like Cardinal Newman, they'll follow their ideas even when they take them to a place they never wanted to go. Or, like philosopher Ludwig Wittgenstein (1889–1951), they'll persevere even though it pains them to continue.

Rule 6: *Be interested in other people.* Curiosity makes you want to meet other people. You're not curious if you shut yourself up in your room. Curiosity is also the touchstone of love. That's how you can tell whether you're in love – you'll want to know everything there is about the other person.

Rule 7: *Be entertaining.* We owe positive duties to make others better off, and that includes the duty to amuse them. We'll need a few well-chosen stories, perhaps a clunky joke, something to bring a smile to their faces. And the first step is always a curiosity about what they'd find entertaining. Before a comedian like Bill Murray can be funny, he has to be curious about what makes people laugh.

Rule 8: *Be creative.* A work of art, whether a twelfth-century Gothic cathedral or a strikingly original painting of the nineteenth century Pre-Raphaelites, will always be the product of an innovator with a spark of curiosity. And if it's great art, it will tell us something important about ourselves and what we seek from the world.

Rule 9: *Be open to the world.* People who refuse to take any pleasure from life are necessarily incurious. The aesthetes of the later nineteenth century pretended to be jaded, to be too sophisticated to be interested in anything out there. Emotionally, however, that was an unsatisfying dead end for them.

Rule 10: *Don't be smug.* Moral people are curious people. They'll want to know how they might have hurt other people by what they've done or failed to do. The incurious are moral mediocrities. They pay little attention to the people they

harm and are too easily satisfied with themselves. Incuriosity might even be the root of all evil. When you do wrong, it's because you weren't curious about how you should live.

Rule 11: *Don't overreach*. From Pandora to Eve, people have been punished for their excessive curiosity. They might have quarreled with the gods like Prometheus, or they might have been guilty of hubris like Robert Oppenheimer, the man behind the atomic bomb.

Rule 12: *Realize you're knocking on heaven's door*. Curious people will ask themselves the most fundamental questions of all: what might await us when we die, and what sense we're to make of life if we think that nothing does. Those are questions boomers will increasingly ask as they see their friends and lovers die.

When you think of people who've made their mark and whom you admire, you'll always come up with a list of people with a spark of curiosity. You'll not remember the copycats, the people who thought what everyone else was thinking. There are the bores, and then there are people who are curious. On which side would you want to be?

That makes it look easy. It's not. If there's a natural desire to know, there's also a natural desire not to know. We have a dark side that wants to hide from the world. It's particularly pronounced with people who are depressed, but at times we'll all prefer to stay indoors. Sometimes we're in denial about something painful. Sometimes it's too cold outside.

Sometimes it's rational to avert your gaze. There are things we're not meant to see, things such as public executions that

are degrading to watch. There's an explosion of pornography on the web, and maybe that's not such a good thing. There are also the Holy of Holies that are veiled from our eyes and the forbidden games we're not meant to play. Curiosity killed the cat and turned Lot's wife into a pillar of salt. Curiosity doesn't discriminate between good and evil, wise and foolish. That's left for other instincts, such as self-preservation or the duties we owe our Creator.

If curiosity can lead us astray, some people have blamed boredom. It prompts us to get out and do something, and Søren Kierkegaard (1813–55) said this leads to a self-defeating search for pleasure. The fourth-century desert monks thought much the same thing. They called curiosity the noontime devil, because it kept them from their prayers. And, like the desert monks, Blaise Pascal (1623–62) believed that curiosity was overrated and distracted us from thinking about eternal salvation.

Pascal was on anyone's list of the greatest thinkers of all time – a scientist and mathematician, and a moralist whose words were touched with fire. And like Aristotle, he believed we are curious by nature. But he didn't think there was anything noble about this. Instead, he said, our curiosity leads to pointless and unsatisfying diversions that are more like a punishment than a pleasure.

What's wrong with diversions? you might ask. With them we enter a world of play and take a break from life's grim seriousness. We recharge our batteries and go back to work refreshed. Pascal knew all about that. His good friend, the Chevalier de Méré, was a gambler, and Pascal even constructed an argument for belief in God around gambling. In his famous wager, he asked us to compare the payoffs we'd get from religious belief to what we'd get from nonbelief.

Suppose there's a very small probability that God exists, he said. Maybe 0.01 percent. Still, the payoff from belief would be an infinitely happy reward in heaven, and that's a gamble worth taking.[1] It's way better than Powerball.

At worst, diversions are wasteful departures from what we ought to be doing or thinking. We keep up with what's happening on Facebook and Twitter, and we're surrounded by noise. That might not be very productive, but where's the punishment? Pascal's answer was that everything we do on earth is a meaningless diversion. Playing a computer game, winning a high honor – none of it counts. The punishment comes from wanting to do something, anything, when it'll never really satisfy us.

"All of our unhappiness comes down to a single thing," he said, "which is that we don't know how to remain at rest in our room."[2] If we did, we wouldn't need to expose ourselves to the wars, quarrels, and passions that so often end poorly. We'd stay home and be content. But we can't do that. We need to get out because, in our natural state and alone in a room, we recognize our emptiness.[3] That's why prison is so painful, why solitary confinement is the worst nonphysical punishment we can imagine. But once the prisoner is set free, he soon discovers how small is the payoff from doing things, how little earthly rewards matter, how that kind of curiosity is a dead end.

But that's not how Pascal lived. Even he was curious about earthly diversions. At sixteen he published a treatise on the geometry of conic sections, and at nineteen he invented the first calculating machine. He didn't simply do mathematics, marveled Ludwig Wittgenstein. "It's as though he were admiring a beautiful natural phenomenon."[4] With his wager he was a father of probability theory, and in fluid mechanics

he is remembered for Pascal's law. As a controversialist, he wrote his *Provincial Letters* to defend his persecuted Jansenist friends against their powerful Jesuit enemies. Finally, the *Pensées* he left us on his death are the most profound reflections on the sense to be made of life and the need to try to do so.

Near the end of his life, his curiosity prompted him to create the world's first bus service, his *carrosse à cinq sols*, the five-penny carriage.[5] And he didn't just think up the idea. Like a good entrepreneur, he secured government approval for a detailed route around the right and left banks of Paris, with shelters for those waiting for the next bus. It would be first class all the way, and to attract the right sort of clientele he'd ban pages and lackeys. A month before his death, he was still fiddling with a fifth route, down the pont Notre-Dame Saint-André-des-Arts, and the carrefour de Buci where I used to buy my baguettes, and then back along the Luxembourg Gardens.

Pascal preached contempt for the world, but the world was not to be mocked. Nor should it be, unless you're a cloistered monk. Pascal was right about how diversions pale in time, but that simply means we should go out and find new ones. Curiosity tells us to keep moving and never be satisfied. That was Pascal's own story, in his restless search for new discoveries. Curiosity is not the desert monk's noonday devil but a smiling god who beckons us to enjoy the satisfactions and joys of an active life. That's why curiosity matters, why we need a taste for it.

There's less curiosity today than in the past, however. In a politically charged time, we're told that only a very few things matter and that, like the desert monks, we should think of them and them only. We've allowed people to hate and

become incurious about their political opponents. We've placed all our chips on harsh ideologies that, by purporting to explain everything, teach us to ignore inconvenient counter-examples. We've also tried to take the risk out of life, banning games on playgrounds and subjecting entrepreneurs to bur-densome safety regulations. Curiosity, which used to be a liberal virtue, is increasingly a conservative one, as progressives bury themselves in a distorted universe of risk-free lives, intersectional victims, and cartoon-like villains.

Finally, the loss of both religious awe and a transcendent vision of life and death has resulted in a banal culture of minimalist concerns and politicized art and literature. Great art is made by people who are curious about what happens when life ends or of the sense to be made of life if they think that nothing does. Sensible policy papers and law review articles have their place but can never answer life's more fundamental questions. For that, what is needed is a sense of curiosity and an understanding of its rules for life.

DON'T MAKE RULES

THE FIRST RULE is not to make rules. Rules are meant to bind us and remove future choices. The curious person will recognize that it's better to keep his options open.

Some philosophers have even wondered whether there's such a thing as following a rule. They think that whatever we do can be made to be in accord with a rule, that it's always a matter of interpretation.[1] We thought we had a rule to do something, but once we get there, we find it conflicts with another rule or is subject to a special exception.

That's how we treat the rules that govern us. We don't treat them as strict rules. Instead, we allow ourselves a reasonable amount of slack, and what's reasonable can't easily be defined. Where I live, ten miles over the speed limit is fine. In some places it's fifteen, in other places five. It depends on where you live or on the day of the month. It depends on a whole lot of things.

Rules are mental shortcuts that are meant to economize on the costs of search and investigation. They're brittle and

simplistic. It's what's outside of the rules, the slack we give ourselves, that requires enquiry and judgment. We'll need to know how the rule gets bent, and that will take curiosity.

But then we do set rules for ourselves, New Year's resolutions and the like. We oscillate between making those rules and breaking them. We go back and forth, and it all starts when we make the rule – which raises the question why we bother in the first place. Why not do without rules and meet each new challenge as it arises, without recourse to blinders from the past?

So why do we make rules for ourselves? We make them to

1. *bind ourselves when we think we'd otherwise succumb to temptation;*

2. *give ourselves the illusion that we can control the future;*

3. *try to commit to a rational life plan; and*

4. *flee from moral responsibility.*

In each case, we'd be better off if we could do without the rule and let our curiosity lead us where it will.

Try Not to Tie Your Hands

If we think we're weak willed, we might make rules to remove temptation from our path. For example, we might think that it would be a good thing to give up desserts and then back this up with a New Year's resolution. That way, when we have dessert in February, we'll have committed a double wrong: we'll have eaten the forbidden pie, and we'll have confessed to ourselves that we're too weak willed to

stick to the resolution. We'll have shamed ourselves, and the fear of doing so might help keep us dessert-free.[2]

We can reinforce the resolution by telling our friends about it. The alcoholic might publicly announce that he's sworn off liquor, knowing that he'll be observed if he takes a drink. If he joins AA and backslides, he's supposed to confess this at the next meeting, and that will increase the shame of rule breaking. Similarly, people who want to lose weight might form a side bet by telling friends that they've gone on a diet, so that they'll suffer an additional humiliation when they're seen to order up dessert. Joining a diet club with weekly weigh-ins also shames us into losing weight. There isn't much point to paying the membership dues apart from the embarrassment factor if you don't lose weight.

Some temptations can be removed by private contract. For example, we might take out a home mortgage that requires monthly payments to the bank. If we fail to keep up the payments, we'll lose the house, and we won't let that happen. Without the precommitment, the money we earn might burn a hole in our pockets, as it did for W. C. Fields. "I spent half my money on gambling, alcohol and wild women," he said. "The rest I wasted."

So the rule might keep you on the straight and narrow. But then making the rule is a confession that you're weak willed. It's a second-best strategy, and with greater strength of will the problem drinker could take a single drink and let it go at that. Life is lived best when we can have a glass of wine at dinner without getting drunk afterward, or when we have a single slice of pie on occasion without going entirely sugar-free. But a single glass of wine is not an option for the alcoholic, because he's weak willed. His rule reveals his weakness, and not the moderate drinker's strength of character.

He might need his rule. But it's still a confession of failure. With his rules, the natural spendthrift might become a miser and the natural sluggard a humorless health fanatic. Hand-tying rules shade into overcontrol, and a mixed strategy that allows for occasional backsliding might result in a higher level of well-being than the fanatical abstinence of a rule-bound life. Such rules are "an awkward expedient, not the ultimate rationality," as George Ainslie writes.[3]

All the same, I confess that I've needed hand-tying rules myself. I've bound myself not to throw away money by taking out a steep home mortgage, for example. I've also missed flights, and to compensate for this, I make it a rule to arrive at the airport a good hour early. Economist George Stigler observed that a person who has never missed a plane has spent too much time in airports. Perhaps. But for me the choice is between missing no planes and missing a whole lot of them.

Rules Won't Let You Control the Future

The future is a mixture of the foreseeable and the unforeseeable. That the sun will rise in the east tomorrow is foreseeable. What's unforeseeable are the unexpected surprises. They might be pleasant. Someone might tell you they admire you or you might get a raise. They might also be troubling, like a car accident or a sudden illness. But whatever the future might hold, we can't dismiss our curiosity about it and try to contain it with a set of rules.

Some people nevertheless try to do so. Immanuel Kant was so rule-bound that the people of Königsberg set their watches by his daily walks. Eight times up and eight times

down, the German philosopher would trudge along a little street. He had rules for everything – for when he'd get up in the morning to when he'd have his coffee to times for reading and lecturing. He even had rules for dinner conversations: first local news, then foreign news, then general discussion, and finally wit and humor. He never married and hardly ever left Königsberg.

Rule-bound people like Kant seem to flee from life and turn themselves into machines. Life is an open door, and they derive a grim satisfaction from shutting themselves up in a closet. But if he was incurious about life, Kant was curious about philosophy and, by narrowing his focus, became the greatest thinker of his time. That doesn't describe the rest of us, however. If we retreat from the world, it's not to do philosophy. Instead, we might adopt a strict regimen of rules to give us the illusion of security against the unforeseeable. Surely nothing bad can happen to us, we might think, if we have rules for everything we do.

That's not going to work, of course. Rules can't prescribe what to do in every possible future world, and that's especially true of the flabby mission statements and strategic plans that organizations come up with. In *Jerry Maguire*, Tom Cruise questions the meaning of life and, to discover it, prepares what he thinks is the perfect mission statement. It's just aspirational enough to be totally vacuous. Most mission statements are like that, and chances are that your employer has one. Take a look at it and ask yourself if it tells you anything at all about what you should be doing.

Those mission statements and slogans aren't actions. Instead, they're substitutes for making a decision and getting something done. But we like them because they offer the comforting illusion that we can plan the future and

eliminate the anxiety that comes from having to make hard choices when the universe plays tricks on us and doesn't unfold as we expected. As Jerry Maguire's superiors understood, that's never going to work. They listened to his mission statement and promptly fired him.

Rules Can't Make You Perfectly Rational

We're accustomed to relying on the internet when we make our decisions, and what it gives us is a choice of rules. These simplify life and might even seem to offer the false promise of a perfectly rational and planned future that leaves no room for curiosity.

If I have to travel, for example, I'll get onto a website like Kayak that offers an array of prices, routes, airlines, and departure and arrival times. It doesn't yet exist, but suppose there were a website that gave me all that and in addition informed me about the probability of canceled flights and lost luggage for each airline. I had to fly to South Bend recently and was given a choice between a connection out of either Charlotte or O'Hare. I picked Charlotte because many of my past O'Hare flights had been canceled. Sometimes that was because of the weather, so I'd find it useful if the website could factor in the weather too.

I expect to see all this before very long on the web. Suppose further that the website knew my preferences about prices, one-stops, airlines, and airports. It could then book the flight without my saying anything more than "Get me to South Bend on Friday by 4:00 P.M." It might even look at local traffic and arrange for a driverless Uber car to pick

me up at my house at the right time. I'll have asked Siri to arrange things, and she'll be giving me rules.

If all that were possible, imagine taking it to the next level, where we rely on the web to tell us whether or not to travel. The trip to South Bend was for a conference. There was no honorarium to show up, and I had already submitted the paper I was to present. Had I stayed home, I could have gotten some work done. But then I'd have missed seeing people I wanted to see at the conference. Might I let Siri make that decision as well, if it had a full mapping of my preferences?

Suppose further that, with a complete knowledge of every kind of scholarship that's out there, Siri tells me what I should write about. I had planned to write about Aristotle, but Siri tells me that there's a hole in railway scholarship. Everyone's writing about Aristotle, and no one is writing about railways. Earlier on, when I was a student, she might have told me that legal studies weren't for me. Instead, I should become a dentist. Or a fireman.

Some artificial intelligence theorists tell us that all this is just around the bend. They're assuming away all informational and computational costs and channeling the omniscient, super-intelligent computer imagined by French mathematician Pierre Laplace (1749–1827). Knowing everything there is to know and possessing limitless intelligence, Laplace's monster of rationality could even predict the future with certainty. It would know exactly what's best for me to do, and I might wisely sacrifice my freedom, say good-bye to curiosity, and bind myself to following the rules it gives me.

That's not going to happen, however, and one reason why is our uncertainty about the future, a subject I take up

in chapter 3. The future isn't determined by the past, and we're not going to be able to predict everything that might happen. There are a gazillion possible future worlds, and we'll just have to improvise. That was Harold Macmillan's answer when he became British prime minister and was asked what would determine his government's policies. "Events, dear boy, events," he answered. But Laplace's computer won't know what these will be until they happen.

It would be like the Golem in Jewish folklore. The Golem was a gigantic, manlike creature made from clay and given superhuman strength. Lacking a human brain, it would perform its instructions literally, and that was the problem. In one story, the Golem was ordered to draw water from a well and, without a stop mechanism, continued to do so until the house was flooded. Only humans can improvise when the unforeseeable happens.

Self-driving cars are like that. In 2018 a self-driving Uber killed a jaywalking pedestrian. The car could recognize pedestrians, but only when they jaywalked at a crosswalk, and that's not what had happened. Elaine Herzberg of Tempe, Arizona, crossed in the middle of the street, and the car ran her over. It couldn't override the rules when they killed people. It takes a person, not a machine, to do that. Since then, Uber has fixed the bug, but inevitably, there will be others. The cars might drive as carefully as humans, but they're still Golems.

There's a further reason why we're not going to be able to plan our lives according to the rules given by Laplace's computer. It's not just that future events are unknowable. We also can't be sure how we'd react to them until they do happen, and that was the theme of George Eliot's novel about Renaissance Florence, *Romola*.

Tito Melema, a shipwreck, lands in Florence with nothing but his charm and the gem stones in his pocket. These belong to his adopted father, Baldassarre Calvo, whom Tito thinks might have died in the shipwreck. But one day, Tito receives a message from Baldassarre. He has been sold into slavery and asks Tito to ransom him with the gems. To do so, however, Tito would have to abandon the promising start he has made in life, and he ignores the request.

Two years pass, and now Tito is an honored member of Florentine society. One day, he observes three prisoners who are brought before him. One of them makes a break and runs for sanctuary in the Duomo but trips and grasps Tito's arm to steady himself. It is Baldassarre, and the two men recognize each other. Tito turns white, and a friend asks him whom he has seen. "Some madman, surely," answers Tito. He says this instinctively, thoughtlessly. "The words had leaped forth like a sudden birth that has been begotten and nourished in the darkness."[4] But having said this, and having been heard by Baldassarre, he can't take it back and has to maintain the pretense that he doesn't know his adopted father. The rest of the novel recounts how his second betrayal will doom him. It was a momentary and impulsive lapse, but it made all the difference. Tito is a scoundrel, and we don't mourn him. But Eliot's point was that our characters aren't fixed and that things could have gone either way.

There are moments like that in each of our lives. We slight a person once, fail to repair the breach, and make an enemy for life. We glance at a woman across the room, and that way lies romance, adventure, and, for good or ill, a very different life. But then a friend breaks in to tell us a little story, the woman leaves, and the moment is over. Examine your life and you'll likely come up with many such moments.

There were doubtless many more of which you were igno-
rant, moments when a guardian angel guided your steps.
Reason had nothing to do with it.

That's what Aristotle thought. He looked at how we
decide on a course of action and said it was a mixture of
desired end states and the means chosen to get there. And
while Siri might help me with the means, she can't help
with the ends:

*We deliberate not about ends but about means. For a doctor does not
deliberate whether he shall heal, nor an orator whether he shall per-
suade . . . nor does anyone else deliberate about his end. They assume
the end and consider how and by what means it is to be attained; and
if it seems to be produced by several means they consider by which it
is most easily and best produced. . . . Deliberation is about things to
be done by the agent himself, and actions are for the sake of things
other than themselves. For the end cannot be a subject of deliberation,
but only the means.*[5]

An all-knowing Siri can pick the best flight for South
Bend. But if Aristotle is right, she can't tell me whether I
should go to South Bend in the first place, or what kind of
paper to write. Reason kicks in only after we choose our
ends and cannot choose them for us. Before it could do that,
Siri would have to know our full set of preferences, what we
desire, what we fear, how we'd trade off costs against
rewards, when we'll be governed by our virtues and when
by our vices. But Siri won't know this, because we won't
know it ourselves until it happens.

That's why, when a future Siri purports to tell us what
goals we should pursue, we should resist her. She might
pretend that she has a full mapping of our preferences, but

she really won't. She won't know what will make us best off, because our ends aren't chosen by reason but by something else, which Pascal called the knowledge of the heart.[6] Without that knowledge, without sentiments and passions that are neither rational nor irrational, we couldn't even take two steps. The dream of an incurious rule-bound life, governed by Laplace's all-knowing computer, is a mirage.

Rules Won't Save You from Responsibility

That's not to say that rules don't matter. They're the first cut at a moral answer, and in many cases, that's all you need. "Thou shalt not kill" doesn't admit of too many exceptions. But rules are not enough. We might think that we've followed all the rules but still wonder whether something more is wanted of us. The moral life is more than the rule-driven life.

That's the thought behind the Netflix series *Shtisel*, about an ultra-orthodox Haredi family in Israel. The family follows the Ten Commandments and the 613 Commandments of the Torah, they say blessings before meals and they'll touch the mezuzah when leaving the house. But that doesn't define who they are or exhaust all of the ways in which people may be praised or blamed. The father, Shulem Shtisel, is deeply loyal and honorable, but he's oblivious to other people's feelings and can be morally thick-headed. The son, Akiva, is a profoundly decent person, but he's infuriatingly shy in pursuing the woman he loves. They're all good people, but the series shows how complex life can be and the impossibility of reducing it to a list of rules.

Lawyers understand the limits of rules from their efforts at drafting long-term contracts. The goal in such cases is to

assign rights and responsibilities for everything that might happen thereafter, and the problem is that this is impossible. A perfectly specified contract would tell the parties what to do in every conceivable future state of the world, completely covering every possible contingency. But too many things might happen. A "complete contingent contract" can never be written, and the best one can hope for is that, when the unexpected happens, we'll find a good judge who'll interpret the contract the way the parties would have written it had they addressed their minds to the possibility.

A complete contingent set of moral rules isn't feasible either. Too many things can happen for anyone to prescribe what to do in each of the countless possible future worlds. We might try to encase the future in cement with our rules, but as Leonard Cohen sang, there's a crack in everything. That's how the light gets in. The best we can hope for is that we'll have the moral sense to recognize that the commandments are incomplete guides and that, like a good judge, our conscience will guide us.

Even more than lawyers, novelists understand the limits of rules. That's an idea than runs through Victor Hugo's *Les misérables*, where the heroes are the rule breakers. To feed his starving family, Jean Valjean steals a loaf of bread, and that's enough to condemn him to five years in the galleys, with fourteen more years added on for trying to escape. When he's finally released, he's given a meal and shelter by the saintly Bishop Myriel. But Valjean is now a hardened criminal, and that night he steals the bishop's silverware. When the police capture him he tells them the silver was a present. He's taken to the bishop, who backs him up and gives him silver candlesticks he says Valjean had forgotten to take. The bishop has lied to the police, but when they've left, he

tells Valjean that with the silver, he has bought Valjean's soul for God.

Valjean had broken the rules, but so did the bishop. He was supposed to tell the police the truth and let justice take its course. What's excluded from justice, however, is the grace shown by the bishop. If all we did was follow rules, there'd be no room for a mercy that bends the rules, that ignores them. Valjean didn't deserve the silverware, and he didn't deserve the way the bishop lied on his behalf. But if we never got anything more than our just deserts, where would we be?

On leaving the bishop, Valjean steals a small coin from a little boy. He does this out of habit, but it's a crime, and if he's caught, he'll be sent to the galleys for life as a repeat offender. He escapes, changes his name, and builds a successful and worthy life. Years later, however, he's discovered by the merciless Inspector Javert, the symbol of hateful rule-bound justice. Pursued by Javert, Valjean hides with Sister Simplice. Is he with you? Javert asks the sister. "Are you alone in the room?" Yes, says the nun – even though Valjean is hiding in the corner. "Have you seen Valjean?" No, says Sister Simplice. Two quick lies, one after the other, from one who had never lied before. "O holy maiden," writes Hugo. "May this falsehood be remembered to thee in Paradise."

At the novel's end, Javert finally corners Valjean. But he can't bring himself to make the arrest. Valjean has saved his life from a mob, and Javert lets him go. And then he throws himself into the Seine to drown. He can't reconcile the mercy he has shown Valjean with the merciless requirements of the criminal law, and since then, the name Javert has become the byword for a heartless adherence to legal rules.

Oscar Wilde also understood the limits of rules. In 1895 he had been condemned to two years' hard labor in prison for the then crime of gross indecency with men. Nine days after he was released, he wrote a ten-thousand-word letter to the *Daily Chronicle* to condemn the prison system's incurious cruelty. The prison had dismissed one of its warders for giving a cookie to a little child who had just been convicted and was about to be taken away to his cell. The boy was desperately in need of human sympathy, and it was for this that the warder was fired. That was the cruelty of a rule-driven system, wrote Wilde:

Ordinary cruelty is simply stupidity. It is the entire want of imagination. It is the result of our days of stereotyped systems of hard-and-fast rules, and of stupidity. Whenever there is centralization there is stupidity. What is inhuman in modern life is officialism. . . . It supposes that because a thing is the rule it is right.[7]

The same bureaucratic lack of curiosity condemned Pierre Pucheu, in the eyes of Albert Camus. Camus was a hero of the French Resistance against the Nazis, and Pucheu was a Fascist technocrat who became Marshal Pétain's minister of the interior during the Occupation. Under pressure from his German overlords, Pucheu selected French hostages to be executed. Later, when he saw how the war was going, he tried to join the Free French in Casablanca, but once there he was arrested and tried for treason.

While Camus had a visceral hatred of the death penalty, he agreed that Pucheu deserved to die. Too many people had been killed to pardon the collaborators, and justice demanded that some of them pay for their crimes. And what was Pucheu's crime? More than anything, said Camus, it

was his failure to understand how a bureaucrat's adherence to formal rules could amount to moral blindness. Behind his desk, Pucheu had signed orders that condemned people to death. That showed a lack of imagination, said Camus,[8] but he could just as well have called it a lack of curiosity.

TAKE RISKS

CURIOUS PEOPLE are risk-takers. If there's no risk, there's nothing to be learned and nothing to be curious about. Imagine pulling a lever at a one-armed bandit in Las Vegas where the payoff never varies. Most people would think that a pretty good metaphor for hell. We'd all shun it for games with a chance of gain or loss.

It's only when there's an element of risk that worthwhile discoveries are made. No one knew that a bus service would work until Pascal gambled on it. Every advance in learning, every adventure, is like that. And even if, having aged out, we take fewer risks than we once did, we can still follow risk-taking heroes in our entertainments. We'll read about wars and explorers or detectives like Michael Connelly's Harry Bosch who have chosen curiosity as a profession.

Buy the Beanstalk

Life is a wasting asset. It's like a mine full of precious gems, immensely valuable before mining begins but less and less so as the gems are extracted. When the last gem is dug up, the mine is worthless. Similarly, when we're young and it's all before us, choices matter greatly. When we die, it's all behind us. In between, choices are at first important and then become increasingly inconsequential. The big decisions come right at the start.

We take bigger risks when we're young, and we're hard-wired to do so. A growing body of empirical evidence finds that our preferences about risk aren't stable and that we become more risk-averse as we grow older.[1] That's true of individuals, and it's also true of societies as they age. In younger societies, you'll see higher levels of risk-taking and self-employment. In aging ones, you'll see more conservative savings and investment behavior. You don't see old bungee jumpers.

Adventuresome younger sons have always been drawn to the city. One of them, in the fourteenth century, was Dick Whittington. In the folktale, he reaches London, only to give up in despair and turn back. But then he hears the Bow Bells of London ringing, and what they seem to be saying is "Turn again, Whittington, Three times Lord Mayor of London." So he turns back to London, where he prospers and does indeed become Lord Mayor.

It's a great little story because it tells children to have pluck and follow where their curiosity leads. That's the theme of a lot of folktales. They became folktales because they were repeated, and they were repeated because they

offered good advice. They told kids it was OK to trade the cow for the magic beanstalk. Go off and seek your fortune, they told Jack; be a giant killer. Children must take risks when they start out in life, and folktales offer them the kind of encouragement they need.

Don't Miss Out

Most people in the military are risk-takers. That wasn't true for boomers who were drafted and didn't have a choice. But the volunteer knows he's electing to put his life on the line, and that's the biggest risk of all.

Several motives enter into it. Many people enlist out of patriotism. That happened after Pearl Harbor, when a country that had had little desire to fight suddenly shed its isolationism to create an enormous army and navy that provided the margin of victory in the Second World War. Hundreds of years earlier, the promise of plunder brought English longbowmen to fight in the wars in France. But there was one more reason to go to war, said Oliver Wendell Holmes Jr. (1841–1935).

Holmes was for twenty years a member of the Massachusetts Supreme Court and for thirty years thereafter a member of the U.S. Supreme Court. He gave us many of the rules we live by, and by 1932, when he retired, he had become an American institution, one of the country's foremost public figures. Even now, he is one of the most cited of all U.S. jurists. But before all that, he had been a soldier.

When he was twenty, Holmes left Harvard College to fight for the North in the Civil War. The future Supreme Court justice was shot three times and left for dead at Antietam,

where he might have died had his father not found him. He never lost his love of life. On what he believed to be his deathbed after a battle, one of his regrets was the recollection of "several fair damsels whom I wasn't quite ready to leave."[2] At ninety, he saw a pretty woman pass by his house and said, "Ah, to be eighty again!"

He brought the same passion to everything he did. After the war he studied law and as a judge became one of the greatest intellectuals of his time. But he never forgot the youth who had gone to war. After he died, two uniforms were discovered in his closet, with a note that read, "These uniforms were worn by me in the Civil War and the stains upon them are my blood."

The Civil War memorials are coming down in the South because they celebrate slavery. But that's not why soldiers enlisted, said Holmes, either in the North or in the South. It wasn't the grand political issues so much as the fear of being bored if the soldier stayed home. On both sides, "hearts were touched by fire," and soldiers learned that indifference should be scorned. "As life is action and passion," he concluded, "it is required of a man that he should share in the action and passion of his time at peril of being judged not to have lived."[3]

The Civil War statues commemorate the fallen, but they're also monuments to risk-taking and curiosity.

In the urban dictionary, there's an acronym for this: FOMO. The fear of missing out. It's the anxiety we feel when we think that other people are living better lives than we are. It's what school kids in Saturday detention feel when they imagine their friends having fun on the playground. It's the rage of the Incel (involuntary celibate) male when he sees the handsome "Chad" out on a date. It's the

civilian's embarrassment when he sees himself in the company of uniformed marines. We don't want to miss out, and that is a spur to an active life and to curiosity.

Explore the World

I grew up on the western prairies, at the tree line. Three miles north of us, the farms stopped. The forest began and continued another five hundred miles north, to the frozen Arctic tundra. For a child it was a magical place, with hundred-foot pine trees and clearwater lakes. During spring thaw, when the six-foot snowbanks melted, we'd lash together a raft to cross the lakes that would form on the broad meadows. We were curious and wanted to see what was out there, and along the way we took a few risks.

We weren't the first Europeans to explore our backyards. Two hundred years earlier, French Canadian *coureurs de bois* had been there before us. They thought nothing of stepping into a canoe in Montreal and getting off in Louisville, St. Louis, or Louisiana. They paddled up the St. Lawrence, the gateway to the continent; portaged around the rapids; and brought missionaries to the plains. From tales they had heard they dreamed of a great western sea that would empty onto the Pacific and open up trade to China. The Sieur de La Salle was so taken with the idea that his neighbors mockingly called his estate "China," which is why it's the name of the present Montreal suburb of Lachine. La Salle never found his sea, of course, but he did canoe down the Mississippi in 1682 to claim Louisiana for Louis XIV.

None of the *coureurs de bois* ever reached the Pacific. They did traverse the western prairies, however, and the greatest

of them were members of the La Vérendrye family. The father, the Sieur de La Vérendrye, fought for Louis XIV at Malpaquet in 1709, where he won a battlefield commission. Returning to Quebec, he was the last great French Canadian explorer. He and his sons went in search of a river that led to the western ocean, and while they never found it, they were the first to reach the Rocky Mountains and the prairies that became the world's breadbasket.

From the French government, La Vérendrye received a monopoly on the western fur trade, but he was too much the explorer to become a successful businessman. If his affairs brought him back to Quebec, he returned as soon he was able to the western frontier. Like the other *coureurs de bois*, he sought glory and gain, but without the curiosity to see what was out there none of them would have left their farms. The recklessness that doesn't count pennies was required before setting out on a three-year voyage to Niagara Falls, the Black Hills, or the mouth of the Mississippi. Besides, what could compensate for the very real risk of torture?[4]

The *fleurdelisé* flag followed the explorers, and by the middle of the eighteenth century, there were French forts from Maine to Louisiana. Beyond the Appalachians, North America was French and Indian. Had it been otherwise, had French Canada remained a strip of *arpents* hugging the St. Lawrence, it would not have been worth the taking, and Britain would not have bothered to conquer it in 1759. Then, in 1774, the Quebec Act of the British Parliament expanded that province's borders to include Ohio, Michigan, Indiana, Illinois, Wisconsin, and Minnesota. Without that, and without the American desire to expand westward, there might never have been an American Revolution.

The curiosity of the explorer had changed the course of history, as it often has done.

Accept Downside Risks

When you're a risk-taker, things sometimes go badly. Otherwise it wouldn't be a risk. But that doesn't necessarily impeach the initial decision to live a risky life. On his last visit to North Sentinel Island, I don't think John Chau had any regrets.

North Sentinel is in the middle of the Indian Ocean and about the size of Manhattan. In every way it's a lush and tropical paradise. Its sandy beaches are surrounded by coral reefs, and it's at the same latitude as Costa Rica, with year-round highs in the eighties and lows in the seventies. If you wanted to get away from it all and didn't worry about boredom, it wouldn't be a bad place to end up. Apart from the fact that you'd likely be killed.

It's inhabited by a Stone Age tribe called the Sentinelese. We've observed them from drones and offshore boats but know next to nothing about them – their customs, their language, or even how many of them there are. They are hunter-gatherers and don't grow their own food. From ships that have washed up on their beaches they've made arrowheads and spears, which they'll hurl at low-flying aircraft, but they can't produce anything like that themselves. Their women wear fiber strings, and the men wear waist belts, but otherwise they're naked.

North Sentinel is only thirty miles from the Andaman Islands, which are favored by Western surfers and feature luxury beach resorts and fabulous seafood restaurants. If you'd like to visit them, the Andamanese tourist board

would be only too happy to help. But you'll not see tourists on North Sentinel. It's a protectorate of the Indian government, whose boats patrol the island to prevent anyone from going ashore. That's partly to protect visitors, whom the Sentinelese are apt to kill, and partly to protect the Sentinelese from the infectious diseases they'd pick up if exposed to visitors. Survival International, an NGO that campaigns for indigenous tribes, calls the Sentinelese the most isolated people in the world.

The Sentinelese want nothing to do with us. If strangers get too near, they'll threaten them with arrows. If visitors show up, they'll turn their backs on them or engage in communal mating. In 2006, two Indian fishermen approached the island to search for crabs. They dropped anchor and fell asleep. In the morning, other fishermen shouted to warn them, but they were probably drunk and didn't wake up. When next they were seen, their bodies had been strung up on bamboo stakes, facing out to sea like scarecrows.

While it's illegal and dangerous to visit North Sentinel Island, that didn't stop Chau, a twenty-six-year-old American missionary. From his childhood he was passionately curious about the tribe and wanted to convert its members. He took every immunization shot he could and quarantined himself before his visit to minimize the risk of infecting the Sentinelese. In 2018 he approached the island twice by canoe, doing everything he could to signal his friendliness. He yelled, "My name is John. I love you and Jesus loves you. Here is some fish." On the second visit, things got dangerous, as he recounted in his diary:

I set off toward the north shore. As I got closer, I heard whoops and shouts from the hut. I made sure to stay out of arrow range and as

they (about 6) yelled at me, I tried to parrot their words back to them. They burst out laughing. Probably were saying bad words or insulting me. The two dropped their bows and took a dugout to meet me. I kept a safe distance and dropped off the fish and gifts. At first they poled their dugout past the gifts and were coming at me, then they turned and grabbed the gifts. I paddled after them and exchanged more yells.

Here's where this nice meet and greet went south. A child and a young woman came behind the two gift receivers with bows drawn. I kept waving my hands to say "no bows" but they didn't get the memo, I guess. By this time the waves had picked up and the kayak was getting near some shallow coral. The islanders saw that and blocked my exit. Then the little kid with bow and arrow came down the middle. I figured that this was it, so I preached a bit to them, starting in Genesis and disembarked my kayak to show them that I too have two legs. I was inches from [an] unarmed guy (well-built with a round face, yellowish pigment in circles on his cheeks, about 5ft 5") and gave him a bunch of the scissors and gifts. Then they took the kayak. Then the little kid shot me with an arrow, directly into my Bible which I was holding in front of my chest.[5]

The arrow shaft buried itself at a passage from Isaiah ("I revealed myself to those who did not ask for me"). That used to be called the *sortes vigillianae* – open up Virgil's *Aeneid* or the Bible at random and look for the clues it gives you. But if there was a message in the passage, Chau ignored it. He returned the next day for a third visit. But this time his curiosity proved fatal, and now he's buried under one of those sandy beaches.

Chau didn't get much sympathy from the Western media. He was accused of cultural imperialism and mocked for what was seen as naïveté. The consensus was that he was an

ignorant Evangelical who got what he deserved. But then he had known exactly what the dangers were and wasn't deterred. The same can be said of the Jesuit missionaries whom the *coureurs de bois* brought to convert the First Nations tribes. One of them, Isaac Jogues, was captured by the Iroquois, who tore out his fingernails and cut off his thumbs. He managed to escape, and when he returned to Europe the pope permitted him to consecrate the Host with his mutilated hand, a necessary dispensation since church law required that it be held by the thumb and forefinger. But rather than remain in France, he returned to Canada, where a few months later the Iroquois killed him. He knew what the risks were and had no regrets. Today he's Saint Isaac Jogues.

We're given a choice in life: to be or not to be a risk-taker. It's a predisposition, like the virtue of courage, that determines how you'll behave in the future. If you're a risk-taker, sometimes it turns out well, and you're a hero. Sometimes it leads to death, as it did for Chau and Jogues. But even in that case, it might have been the right choice for them when, years before, they had to choose between curiosity and cowardice, between their faith and a riskless life.

COURT UNCERTAINTIES

UNCERTAINTY ISN'T the same thing as risk. With risks, you know the probabilities for different outcomes. If you put ninety white and ten black balls in an urn and pick one at random, there's a 90 percent probability that it will be white. Soldiering can be like that. There might be one probability that you'll be killed, another that you'll be wounded, and a third that nothing bad will happen. Uncertainty is different. There are different possible outcomes, but you won't know the probabilities for each. Instead, you're in Donald Rumsfeld's world of unknown unknowns.

"There are known knowns," said Rumsfeld.

There are things we know we know. We also know there are known unknowns; that is to say we know there are some things we do not know. But there are also unknown unknowns – the ones we don't know we don't know. And if one looks throughout the history of our country and other free countries, it is the latter category that tend to be the difficult ones.

That was in 2002, when Rumsfeld was the secretary of defense and wanted to explain why grand strategy was so hard. Had we listened more closely, we might have realized that the Second Iraq War wouldn't go as planned.

The message about uncertainty is always useful advice, since we seem to have a mental bias against it. We saw rising house prices in 2007 and assumed that that's how things would continue. People who really couldn't afford it went out and bought big houses or second vacation homes. How could they lose, they thought? But then the housing bubble burst, and that gave us the Great Recession of 2008–9.

Something like that happened in the 1970s during the oil crisis, when gas prices bounced up and down and there were lines at the pumps. The oil companies and their big customers were on notice that prices were uncertain but assumed that nothing much would change. They thought that oil prices would be flatlined. But the only thing that's flatlined is our ECG when we die.

We learned this in 2020. After an epoch-making impeachment trial, then a pandemic, followed by the Black Lives Matter protests and riots, we waited for things to settle down, and they never did. We had thought there was such a thing as normalcy, and there isn't.

The distinction between risk and uncertainty goes back to economist Frank Knight in *Risk, Uncertainty and Profit* (1921). Today it's been popularized by Nicolas Taleb in a series of books, notably *The Black Swan* and *Antifragile*. Taleb argues that, while we'd like to think we know how things will turn out, we're often fooled by randomness and uncertainty. Swans are mostly but not invariably white in color. Sometimes there are black ones. They're outliers. The world, and especially that part studied by economists and gambled

on by market traders, is full of outliers like that. They're the things no one could have predicted, things that change everything.

In spring 1861, no one expected the Civil War. Like Lincoln, many Americans thought that the South was bluffing and in its own good time would come to its senses. Virginia took two votes on secession, and the Unionists won both. And even if some states were to secede, nobody expected a war. In the *New York Tribune*, Horace Greeley editorialized that if some states wanted to leave the Union, "we shall feel constrained by our Devotion to Human Liberty to say, Let them go!"[1] But then Fort Sumter was bombed; Lincoln called up the army; and on a third vote, Virginia seceded. Looking backward, we can pretend that the war had to happen, but that's just the hindsight bias.

Faced with randomness, people sort themselves into three groups, says Taleb. There are the *fragiles*, people who lose big from outlier events like the Great Recession. The second group comprises the *resilient*, people who can ride out the storm and not be affected by it. These are government employees, academics with tenure, most professionals. They've made a career out of their incuriosity. The third group is composed of the *antifragiles*, the entrepreneurs with a spark of curiosity who thrive on uncertainty. They'll exploit the golden upsides, while the downsides are simply learning experiences from which they'll bounce back stronger than ever. "I wouldn't be where I am now if I didn't fail a lot," billionaire Mark Cuban tells us. "The good, the bad, it's all part of the success equation."[2]

The antifragile entrepreneur must be willing to gamble on business opportunities. He's looking for a payoff, and he'll not put his time and money in government savings

bonds or blue chip firms but on the uncertainty whose value can't be measured before the wheel is spun. He's the producer who creates something that, beforehand, consumers never knew they wanted. And that's the story of the new, high-tech economy that gave us things we didn't know we couldn't do without.

I didn't know I needed emails thirty years ago. They hadn't been invented. There's a 1994 clip from the *Today Show* on YouTube, in which you'll hear Bryant Gumbel wondering what's that thing that looks like an *a* with a circle around it. He was seeing a @ for the first time. "You mean you write to it, like mail?" he asked. Soon we all became heavy email users. Then I started getting emails with a lot of grammatical errors in them. They were from the first Blackberries, and they were so addictive that people called them "Crackberries." By 2007, however, my tech-savvy friends were boasting about their iPhones. Apps? I thought. Who needs them? I didn't see the point. Neither did Blackberry.

Back in the Dark Ages, we didn't even know we needed computers. Neither did IBM. In 1943, its president thought there was a world market for only five of them. Thirty years later, we knew better, at least for business purposes. But home computers? In 1977, the founder of Digital Equipment Corp. didn't think anyone would want one. That was the year the Apple II was introduced, and by 1985, Apple had sold more than two million of them.

That's the miracle of the new high-tech economy. Crucially, someone understood not only what consumers wanted but also what they would want if it were given to them. In the case of Apple, that person was Steve Jobs.

Jobs didn't invent the Apple II. That was Steve Wozniak. Jobs really didn't invent anything. What he brought to

Apple was a sense of what consumers would want and the design skills and determination to make it happen. By the time he died, he had made Apple the world's top high-tech company, eight times bigger than IBM. What IBM had had was a storied history, a progressive ethos and tens of thousands of highly skilled workers. What Apple had was an entrepreneur with a taste for gambling.

That makes it sound simple, doesn't it? If you want your company to grow, just hire Steve Jobs. Only how do you tell him apart from the guy with what he says is a can't-miss idea that goes nowhere when it's tested? And if you could identify the Steve Jobs, if he were a known known, where would the profit be? He'd have captured it himself.

Economists tell a joke about this. Two University of Chicago economists are walking back to their office when Milton Friedman tells George Stigler, "Look, there's a twenty dollar bill on the sidewalk." To which Stigler answers, "No there isn't."

Economists have a peculiar sense of humor. The joke is funny to them because it expresses the idea that there are no windfalls in economics. There wasn't a twenty dollar bill on the sidewalk because, had there been one, someone would already have picked it up. Nor are there any undiscovered products like computers that consumers would want. If they existed, someone would already have provided them.

That's what rational choice economics, Chicago style, tells us.[3] The problem, however, is that it explains away the entrepreneurs who strike it rich, the agents of change and disruption like Steve Jobs, people whom we couldn't identify before they got started. You'll hear people say, "If only I had bought shares in Apple in 1977." Except that those

shares were priced correctly at the time, in terms of what we knew back then.

You couldn't even have bought them, if several state securities regulators had had their way. They have the discretion to block share issuances when they think they're extremely speculative, which certainly describes Apple in 1977. But if we're only permitted to buy economic sure things, we're not going to get rich. The sure thing, like an ounce of gold, gives a payoff exactly equal to its cost, and what you get is exactly what you paid for.

What's different about the gambles taken by the Steve Jobses is that they're not based on defined probabilities and known outcomes. Instead, we're in Donald Rumsfeld's world of unknown unknowns, where outcomes are uncertain and can't be assigned a probability. I can say that there's a 30 percent chance it will rain tomorrow, but no one could have said what the probability was that the Apple II would take off. It was a gamble, and if we never took gambles, we'd still be living in caves. "If people did not sometimes do silly things," said Ludwig Wittgenstein, "nothing intelligent would ever get done."[4]

The Austrian school of economics is built around uncertain outcomes and the need for creative entrepreneurs like Steve Jobs who take a gamble. They may not know how to market their product, how to advertise or ship it; they don't know who the customers are or where they live, and they don't know if anyone wants it. But they bring a sense of "alertness" to a business, one that recognizes an unfulfilled and even unrecognized consumer demand.

What's missing from Austrian economics, however, is a way to recognize alertness before the fact. Here's how the

leading Austrian economist defines it. "It is this entrepre-neurial element that is responsible for our understanding of human action as active, creative, and human, rather than passive, automatic, and mechanical."[5] But the problem is that this can't be identified except with the benefit of hindsight.

So what goes into alertness? In Steve Jobs's case it was an obsessive desire to produce a personal computer that, as it turned out, consumers would want. Crucially, he was will-ing to take a gamble, to place a bet without knowing what the payoff might be, to search for El Dorado without know-ing whether it really existed. Jobs brought an extra spark to his firm, and I can think of no better word for what that might have been than *curiosity*.

BE ORIGINAL

THERE'S SAFETY in numbers. We're not likely to get ticketed if we drive at the same speed as everyone else. We're not about to crash and burn if we follow the crowd. The Japanese have a saying for this: "The nail that sticks out gets hammered down." But that's a recipe for an incurious life, and a poorer one too. We'll not see new discoveries, new inventions, and new devices if people simply mimic what everyone else is doing. Curiosity lies on the off-ramp.

Sometimes it takes courage to be original and stick out from the crowd. That's the story of Émile Zola, who defended Captain Alfred Dreyfus when he was falsely accused of espionage and exiled to Devil's Island. With the benefit of hindsight, we'd like to think that was a slam dunk, that only the most benighted people would have condemned Dreyfus. But it was just the opposite. The army, the church, and many of the intellectuals thought he was guilty. So did Edgar Degas, Paul Cézanne, Auguste Renoir, and a

good many of the French Impressionists. It was mostly the outsiders who said Dreyfus was innocent.

In 1898 Zola published *J'Accuse* to defend Dreyfus. The highest levels of the army had conspired in a cover-up, wrote Zola, and what was behind this was anti-Semitism. The real traitor was another French officer, whom Zola named. The French army has dared to punish an innocent man, he wrote. "As they have dared, so shall I dare."

Dare to tell the truth, as I have pledged to tell it, in full, since the normal channels of justice have failed to do so. My duty is to speak out; I do not wish to be an accomplice in this travesty. My nights would otherwise be haunted by the specter of the innocent man, far away, suffering the most horrible of tortures for a crime he did not commit.

J'Accuse became the byword for those who speak up for the unjustly condemned. When nuclear scientist J. Robert Oppenheimer was investigated as a security risk in 1954, journalists Joseph and Stewart Alsop wrote to defend him in an article titled "We Accuse!" But those who stand out from the crowd sometimes pay a price. The French government charged Zola with criminal libel, and he had to flee the country. Four year later, he died in bed of carbon monoxide poisoning. His supporters said that his enemies had blocked up his chimney and that he was murdered, but nothing could be proven.

Exile. Death. Those are extreme penalties for failing to follow the crowd. But doing so will always take gumption.

It's OK to Be a Rebel

In seventeenth-century France, when heresy was a crime, Blaise Pascal was the Zola of his day when he defended an austere Catholic sect called the Jansenists. All that were great and good – the pope, the theology faculty at the Sorbonne, the Jesuits – had attacked their views about salvation and grace. But they were Pascal's friends. His sister and niece were nuns at the sect's convent at Port-Royal des Champs near Versailles, and in 1655 he spent a month there teaching children (where one of the students was the sixteen-year-old orphan Jean Racine). And when the Jansenists were attacked, they asked him to defend them. I know nothing about theology, he answered. "It doesn't matter. You are young and you know how to write."

That whetted Pascal's curiosity. He wanted to understand the dispute, and what he produced was one of the greatest works in French literature, *The Provincial Letters*. Voltaire called them the first work of genius in French prose.[1] The letters took on the powerful Jesuit order, charging them with pandering for their noble penitents with the promise of easy absolution for their sins. Jesuit missionaries in New France, such as Isaac Jogues, were fearless ascetics, but in Paris other members of the order were supple, power-seeking politicians.

Adopting the pose of an ingenuous provincial, Pascal reported on his efforts to understand the Jesuits, and when he described their doctrine of "sufficient grace" as a grace that does not suffice, a court that could not understand theological disputes did know enough to laugh. What delighted was the pinprick to the moral pretensions of a

spiritually proud order observed in the act of toadying for political gain.

Pascal dispatched the Jesuits with ridicule, but when one Jesuit questioned the orthodoxy of the cloistered Jansenist nuns, he responded with vehemence. The nuns were accused of not believing in the real presence of Christ's body and blood in the Eucharist, an unpardonable heresy and a crime. Abandoning the mask of satire, Pascal lashed forth against the Jesuits in the sixteenth letter:

Who would believe you, my Fathers. Do you even believe it your-selves, miserable lot that you are?... Cruel and cowardly persecu-tors! Must, then, the enclosed cloister afford no shelter from your calumnies?... You are calumniating those who have no ears to hear nor mouths to answer you.[2]

When asked if he had been too harsh, Pascal said he felt obliged to warn his countrymen. It was as if, he said, there were twelve public fountains in Paris, and one of them was poisoned. It was his duty to tell everyone to stay away from it and to name the poisoners.[3]

Pascal wrote anonymously, and the authorship of the letters was a mystery when they first appeared. But so many people were in on the secret that it got out before long.[4] The letters themselves were condemned, ordered to be burned, and placed on the Index of Forbidden Books. With the king and pope both determined to crush their movement, most of the Jansenists knuckled under. Not Pascal, however. If the pope condemned the Jansenists, then the pope was wrong, said Pascal. You are schismatic! accused the Jansenist leader, Antoine Arnauld. No, replied Pascal. I am faithful. It is the entire Church that is schismatic![5]

Don't Be a Conformist

Italian novelist Alberto Moravia tried to explain why so many of his countrymen became Fascists under Mussolini. It was because of their desire to fit in, to seem normal, to follow the crowd. He called the novel *The Conformist.*

Of course, some of the Italians were sincere Fascists and not conformists. That was also true of many of the French collaborators during the German Occupation. But then others were conformists who wanted to get along with the occupiers. They were people like Robert Brasillach.

Brasillach was a prominent intellectual in prewar Paris and fell in with the right-wing Action française crowd. Fascism, he said, was the poetry of the twentieth century – anticonformist, antibourgeois, exalting in the marches and cathedrals of light at Nuremburg.[6] But while other members of Action française, notably Charles Maurras, despised the Germans, Brasillach got along famously with them.

He was mobilized in 1939 and taken prisoner by the Germans in 1940. They freed him in 1941, and he quickly took his place as a champion of Marshal Pétain's New Order. He returned to his role as the editor of the viciously anti-Semitic *Je suis partout*, which during the Occupation published the names and locations of Jews in hiding. He was eminently suggestible, and if his new friends proposed a visit to Germany, why, he'd go along with them and even make it to the eastern front. He never voiced support for the death camps, but when a French bishop condemned Pétain's role in the roundup of Jewish children, the Rafle du Vel' d'Hiv', Brasillach expressed indifference to their fate. They shouldn't be separated from their parents, he wrote; that

would be inhumane. Rather, the Jews should be expelled en bloc.[7]

Had he evaded capture, on the liberation of France in 1944, Brasillach might eventually have been forgiven, and even rewarded with an edition of his writings in the *Bibliothèque de la Pléiade* like Céline, the most notorious anti-Semite of them all. Instead, Brasillach hid until his mother and relatives were imprisoned and then gave himself up to protect them. He was charged with collaboration (intelligence with the enemy), and after a five-hour trial and twenty minutes of jury deliberation, he was convicted and sentenced to death.

After the liberation, ten thousand French collaborators were executed, eight hundred after a regular trial. Brasillach was the only one condemned for his writings, and the cream of the French literary establishment, including François Mauriac, Jean Anouilh, Paul Claudel, and Jean Cocteau, petitioned De Gaulle to pardon him. Brasillach's lawyer brought the petition to an impassive De Gaulle, who blew cigar smoke in the lawyer's face and took only a moment to reject it. The thirty-six-year-old Brasillach was executed at dawn the next morning, after crying out "*Vive la France, quand même*" to the firing squad. Long live France, anyway. He wasn't lacking in panache.

Albert Camus also signed the petition for clemency. He despised Brasillach but was opposed to the death penalty. He himself was anything but a conformist. During the German Occupation, he edited the Resistance magazine *Combat*, and when the war was over, he rebelled against the fashionable communism of his fellow intellectuals, people like Jean-Paul Sartre. In 1951 he published *The Revolt* (*L'Homme révolté*), in which he condemned the French Stalinists. He didn't mention Stalin by name, but he did compare what

was happening in Russia to the Reign of Terror during the French Revolution, and for hard-core leftists this was the end of the line. Sartre published a response that announced a final break between the two men. My dear Camus, he wrote, our friendship wasn't an easy one, but I'll regret the loss of it. If you've broken with me, it's no doubt because it needed breaking.

For Brasillach, conformity meant collaboration with the Germans. By the 1950s, conformity meant communism and anti-Americanism. But Camus was never a conformist. He liked America and was secretly proud of his resemblance to Humphrey Bogart. He also broke with the Left over what to do about the then French colony of Algeria, where Camus had been born and grown up. The non-French Algerians wanted independence, and on both sides the contest became bloody. For people like Sartre, the contest was simple: either you were on the side of the Arab rebels, or you were on the side of the oppressor. But the rebels had begun to kill innocent civilians. Camus had always argued that France had to do right by the Algerian people, but he knew the kind of people who were being threatened, and they included his mother. It wasn't simply a question of taking one side or another and accepting all of its excesses. "I believe in justice, but I will defend my mother before justice."[8]

Writers crave attention and get it by attaching themselves to what George Orwell called the smelly little orthodoxies of the day. They'll be the ones who'll win the prizes and be invited on the talk shows. Theirs are the names you'll have heard of. Their conformity is self-serving and costless, but they imagine themselves to be moral heroes.

And the nonconformists? In America, the great newspapers, the prime networks, apply a filter that excludes their

voices, and they're also silenced by the social media giants. The price of admission is conformity. Stepping away from the herd comes at a cost, and the first step is always a refusal to follow the crowd and a curiosity about the weaknesses, falsehoods, and banality of received ideas.

SHOW GRIT

NO ONE SAID it was supposed to be easy. If it was, somebody would already have done it, and then where would be the surprise, the curiosity about something new? So it's going to take grit, the virtue of the person who doesn't give up. It's the form of curiosity at the sticking place.

Grit is an old-fashioned virtue, one associated with an earlier generation that stayed married and didn't leave their jobs. People with grit persevere and don't complain, which means they won't much care for millennial snowflakes. Nor might they care for boomers either, since we never stuck around much in one place, in our relationships or our jobs. We were told that it's admirable to reinvent ourselves and start all over again, that it shows we're alive and curious about new experiences.

Moving around may indeed be a sign of curiosity, but it sacrifices another form of curiosity – that of digging down and carrying projects through to their successful completion. Above all, that's a scholar's virtue, because the scholar's task

is prolonged and difficult. The dilettante who flits around from one big idea to another seldom comes up with anything worthwhile.

For scholars, grit can take three forms. The *courageous* scholar doesn't let his detractors push him around. The *scrupulous* scholar will be prepared to probe the weaknesses in his arguments even when they lead to places he never wanted to go. And the *steadfast* scholar won't give up even when it pains him to continue.

Be Courageous

Arrogance can make a scholar incurious, if it tells him not to pay attention to critics and to ignore the weaknesses in his arguments. But it can also make him curious, if it steels him to enter the lists and defend his ideas against all comers. Such a person was Henry Manne, the dean who hired me at the law school where I now teach. He had something about which to be arrogant, and he knew it. I sat in his office one day, along with another colleague, when the talk turned to a third colleague. "X is pretty smart," said Henry. A pause. "Of course, he's not as smart as me." Another pause. Then, "Mind you, no one is as smart as me." All of this with a straight face and without a hint of irony.

Manne was born in 1928 and grew up in Memphis. After law school, military service, and a short stint in law practice, he began a law teaching career, where he bounced around from one school to another. In 1961 he found himself at UCLA and began taking his lunches with economist Armen Alchian. Over the course of a summer Armen taught him microeconomics, and when it was over, Henry told Armen,

"You know, what you've been teaching me has some application in the law." To which Armen answered, roughly, "Ah, get out of here." At that moment, Henry told me, "*I* was law-and-economics."

The law-and-economics perspective favored free market rules, and that's what attracted Manne. He was a libertarian who thought that government planning would lead to economic waste and tyranny. With that in mind, and brimming with self-confidence and the knowledge that he was first off the mark with a new discipline, he ventured into corporate law scholarship looking for people to shock. It didn't take long. Even he was bowled over by the reaction to his *Insider Trading and the Stock Market* (1966).

Ten years later, when I studied at Harvard Law School, the professor told the class, "If you think I'm right wing, you should see this guy Manne." Insider trading liability had recently been broadened by the Securities and Exchange Commission, and academics took it for granted that it was shameful and should be illegal. And here was this professor telling us it was a good thing? He was condemned for what one reviewer called his "rather ostentatious amorality"[1] and for his failure to consider such "noneconomic goals as fairness, just rewards and integrity."[2] That was what just about everyone thought, except Manne.

A less courageous man might have backed off, but that wasn't in Manne's nature. Instead, he launched a center to teach law-and-economics to law professors. Academics from the top law schools attended, caught the bug, and became prominent devotees in their own right, and today there isn't a top-twenty law school without a sizable group of law-and-economics scholars. The center also offered courses for federal judges, and at one time a third of the federal bench had

learned from Manne how economic insights might inform the rules we live by.

Manne never sold himself short. When he subsequently wrote an intellectual history of law-and-economics, he had to be gently told that he had overused the first-person singular pronoun. And whether his arrogance was a sin or an honest recognition of self-worth, it made him curious to pursue his scholarly agenda and courageous in defending it against his attackers. And that made him one of the most influential twentieth-century legal academics.

Be Scrupulous

In 1863 a retiring Catholic priest was sent a copy of an article that attacked his character. It had been written by Charles Kingsley, the author of *Westward Ho!* and the Regius Professor of Modern History at Cambridge, and it said that

truth, for its own sake, had never been a virtue with the Roman clergy. Father Newman informs us that it need not, and on the whole, ought not to be; that cunning is the weapon which heaven has given to the saints wherewith to withstand the brute male force of the wicked world which marries and is given in marriage. Whether his notion be doctrinally correct or not, it is at least historically so.[3]

John Henry Newman had been an Oxford don and Anglican priest and one of the leaders of the Anglo-Catholic revival in his Church. This infuriated anti-Catholic bigots like Kingsley, who thought that Newman, while posing as an Anglican, was in reality a covert Catholic who was leading

good honest Englishmen to cross the Tiber and "pope." Then, when Newman left the Anglican Church to become a Catholic priest, Kingsley thought this confirmed his worst suspicions about Newman's motives and truthfulness.

Newman protested "this grave and gratuitous slander" to the publisher and asked to be provided with evidence that he had ever been untruthful. In reply, Kingsley offered to withdraw the charge, but Newman was not satisfied and ironically summarized where things stood:

Mr. Kingsley relaxes: "Do you know, I like your tone. From your tone I rejoice, greatly rejoice, to be able to believe you did not mean what you said."

I rejoin: "Mean it! I maintain I never said it, whether as a Protestant or as a Catholic."

Mr. Kingsley replies: "I waive that point."

I object: "Is it possible? What? Waive the main question! I either said it or I didn't. You have made a monstrous charge against me, direct, distinct, publicly. You are bound to prove it as directly, as distinctly, as publicly; – or to own you can't."

"Well," says Mr. Kingsley, "if you are quite sure you did not say it, I'll take your word for it; I really will."

My word? I am dumb. Somehow I thought that it was my word that happened to be on trial. The word of a Professor of Lying, that he does not lie.[4]

In debate, Kingsley was no match for Newman, whose defense in his *Apologia pro Vita Sua* was for English literature what Pascal's *Provincial Letters* had been for French literature – the most sustained and devastating satire in the language. When pressed to prove his charge, Kingsley simply relied

on the prejudices of a Protestant Englishman, saying that whatever Newman said should not be believed because he was a Catholic.

The stain on Newman's character remained, however – the suggestion of falsehood, the idea that while he was an Anglican, he had really been a "Romanist" disguised in Protestant livery. And so he felt himself bound, as a duty to himself and to his Church, to explain how in all sincerity he had been led to leave one Church for another. The result was his *Apologia*, one of the greatest of spiritual autobiographies. It had to be, he said, the key to his whole life, to show what he was and what he was not. He wrote from morning to night, often without taking meals, and as much as twenty-two hours in a single day. As he did so, he was continually in tears.

The book was a scrupulous examination of conscience by one who felt impelled to do so in defense of his new religion. If Newman was personally shy, he was intellectually curious, and that had led him to the positively un-Anglican study of Christian dogma and theology. While an Anglican, Newman brought to his Church the fine scholarship of one who wanted to know just what Anglicans did or could believe.

Anglicanism, he had thought, was a *via media*, an Anglo-Catholic middle of the road that was neither Protestant nor Catholic but one that rejected what he saw as heretical Protestant doctrines as well as the excesses of an unreformed Catholic Church. Most Anglicans, and especially Evangelicals like Kingsley, thought this entirely too sympathetic to Catholicism.

As a young man, Newman would have agreed with them. But after taking a mediocre Oxford degree, he had the for-

tune to be offered a fellowship at Oriel College, the center of what became an Anglo-Catholic revival. In their demand for orthodoxy and their rejection of religious liberalism, the group had the impetuosity of youthful rebels. One of them, Hurrell Froude, handed Newman an Evangelical essay, saying it would make his blood boil. "One of our common friends told me, that, after reading it, he could not keep still, but went on walking up and down in his room."[5] Such was the hothouse atmosphere of the movement that came to be centered around Newman.

The Anglo-Catholics wrote a series of essays called the Tracts for the Times, and this gave them the name of Tractarians. The greatest number were written by Newman, but they came to an abrupt end with his Tract 90. In it, Newman had argued that the Thirty-Nine Articles of the Anglican Church, to which students at Oxford and graduates of Cambridge were required to swear, were not inconsistent with Catholic doctrine but only with Catholic practices, which Catholics themselves were not obliged to believe or follow. As such, the Anglican Church was truly Catholic in its doctrines, with the same set of beliefs it had held before the Reformation.

Tract 90 provoked a storm of protest. If Newman was right, then Catholics could swear to the Thirty-Nine Articles and be admitted to the universities and civil offices. But excluding them had been one of the points of the Thirty-Nine Articles. Newman's enemies had waited for just such a misstep; now they would pounce. He was asked to withdraw the Tract. This he refused to do. He was asked to keep silent. This also he refused. With a small group of sympathetic friends, he left Oxford to live in a small monastic community a few miles away. There he preached his last

sermon as an Anglican and, when he finished, retired from the pulpit, took off his gown and hood, and laid them over the altar rail. In doing so, he signaled that he would no longer serve as an Anglican minister. The sermon was titled "A Parting of Friends," and when it was over nearly everyone in the congregation was in tears.[6]

Two more years passed as he worked out any remaining doctrinal differences with Rome. Then, on October 8, 1845, he wrote to his sister Jemima,

I must tell you, what will pain you greatly. This night Father Dominic the Passionist sleeps here. He does not know of my intention, but I shall ask him to receive me into what I believe is the one fold of the Redeemer.

He remained close to Jemima after this, but his other sister didn't forgive him, and they never spoke again.

He ended the *Apologia* by recalling his farewell to Oxford in 1846 and his days there thirty years earlier:

There used to be much snapdragon growing on the walls opposite my freshman's rooms there, and I have for years taken it as the emblem of my own perpetual residence even unto death in my university.

On the morning of the 23rd I left the Observatory. I have never seen Oxford since, excepting its spires, as they are seen from the railway.[7]

The *Apologia* took its readers through the history of Newman's ideas, step by step, from his arrival at Oriel to his decision to convert, and showed how, though he had never intended it, and though the possibility would have dismayed him, he had found the *via media* crumbling beneath his feet.

His scholarship had taken him down a winding path, where the steps proved unstable and his footing gave way, and had brought him finally to Rome.

As he went through the theological controversies that defined Catholicism, in which *this* was determined to be Church dogma while *that* was heresy, he concluded that the Protestants and Anglicans were on the wrong side of orthodoxy and that he could not condemn the popes of the sixteenth century without condemning those of the fifth century as well. If so, the claim that the nineteenth-century Church of England was the successor of a pre-Reformation Church in his country must fall.

That was in 1841. It took Newman four more years before he met with Father (now Blessed) Dominic Barberi. Did he hesitate before he converted? If so, we shouldn't be surprised. What his submission to the Church entailed, as he realized, was a loss of all that he had held dear, his faith apart – Oxford, his family, his friends other than the few who followed him to Rome, a Church that had made him its pet. He delayed because he owed duties to his bishop, to people under his care. But then he recalled that Pascal had said "I die alone" and resolved to think of his own soul above all else.[8]

Besides, he was joining a Church that, though he thought it the true faith, was nevertheless very different in its culture and people. And if Anglicans thought his beliefs suspect before he converted, some members of the Catholic hierarchy repaid the compliment afterward. He toiled in relative obscurity until he wrote his *Apologia* in 1864. Even then, the Church hierarchy mistrusted him, and in *Eminent Victorians* Lytton Strachey recounted how Cardinal Manning saw him as a rival to be thwarted. Newman was only given the

cardinal's hat when he was seventy-eight years old. Today he's known as Saint John Henry Newman.

It is exceedingly rare for someone who had invested in one faith to abandon it for another. In all the time I've taught at universities, I cannot recall a single academic who changed directions in his scholarship. Instead, they burrowed down in their little niche, and if they sometimes found a stray thought intrude, something that might have told them that their beliefs were suspect, or, worse still, boring, they managed to suppress it. They forgot that ideas need to be sharpened by being tested against the strongest of counterarguments and that they should welcome and not cancel dissenting voices. After all, the stakes would have been so much lower for them than they were for Newman. There would be no loss of friends or tenure, no leap into the darkness of an alien culture. They were safe. But they were incurious.

Newman was curious, however, and scrupulous too. He was willing to follow his principles wherever they might lead, even down a slippery slope to a place he had never wished to be. The censure of fellow Anglicans, especially over Tract 90, helped nudge him on his way, but then a less principled man would have admitted defeat and adjusted his principles to fit his Church. That Newman could not do, and he's therefore a model of gritty curiosity.

Be Steadfast

Aristotle thought that the excess of any virtue is a vice. If it's virtuous to be scrupulous, then there's a point where, taken too far, this might become the vice of scrupulosity. That's a form of self-deception, the opposite of the typical kind

where a person is in denial about his faults and thinks himself better than he really is. With scrupulosity, one is in self-denial about one's goodness and blames oneself for trivial sins. That was a disorder to which Jansenists were especially prone, and in its secular form among academics, scrupulosity may lead to an unyielding and agonizing search for answers. Sometimes they'll elude you, but sometimes your gritty steadfastness will make you the greatest scholar in your field.

So it was with Ludwig Wittgenstein. If Cardinal Newman was scrupulous, Wittgenstein was an example of scrupulosity and of how painful a thoroughgoing self-examination can become. He dwelled on his faults and was given to thinking himself a worse person than he really was. When he was forty-eight, he required five of his friends to listen to a confession of his sins. These were so venial that his friends were surprised. He told them how, on hearing that an acquaintance had died, he reacted as if he hadn't heard this before. But he really had and was feigning surprise, so he thought himself a hypocrite. And he wasn't really a virgin, because as a young man he had had sexual relations with a woman. His friends were relieved. From the buildup, they had been led to expect something far graver. One of them was exasperated and exclaimed, Do you want to be perfect? "Of course I want to be perfect," he roared.[9]

He was born in 1889 into an extremely rich and cultured Viennese family. Brahms, Mahler, and the youthful Pablo Casals were welcomed at musical soirées at the Palais Wittgenstein. Ludwig's brother Paul, a pianist who lost his right arm in the First World War, had pieces for the left hand composed for him by Maurice Ravel and Sergei Prokofiev. Gustav Klimt painted the wedding portrait of his sister Margaret, who was analyzed by Sigmund Freud and who helped

him escape from the Nazis. The modernist architect Adolph Loos was a friend, and Wittgenstein designed the interior of a house in that style. But three of his brothers committed suicide.

At nineteen, Wittgenstein traveled to Manchester to work on the new field of aeronautics and perhaps become a pilot. To do so, he needed to learn mathematics, and from this he became interested in the philosophical foundations of the subject. In 1911 he moved to Cambridge to study under philosopher Bertrand Russell, who had begun to publish the *Principia Mathematica* with Alfred North Whitehead. Wittgenstein had a dismaying degree of intense penetration, and Russell found him a handful. He'd arrive in Russell's rooms around midnight and announce that he'd commit suicide when he left. Then he'd pace the room like a caged tiger. Once, after a long period of dead silence, Russell asked him whether he was thinking about logic or about his sins. "Both!" answered Wittgenstein.[10]

At the end of his first term he asked Russell, "Will you please tell me whether I am an idiot or not?" Russell said he wanted to know why. "Because if I am a complete idiot I shall become an aeronaut; but if not, I shall become a philosopher." Write a paper for me, answered Russell. Then I'll tell you. So Wittgenstein did. After reading one sentence, Russell told him, "No, you must not become an aeronaut."[11] Wittgenstein later said that this ended nine years of loneliness and suffering, during which he had continually thought of suicide.[12]

Russell put Wittgenstein up for membership in the Apostles, the secret intellectual society at Cambridge whose members included historian Lytton Strachey and novelist E. M. Forster. But Wittgenstein was repelled by the facile cleverness

of his fellow members and by its set of active homosexuals and quickly resigned. Whether Wittgenstein was actively gay is a matter of some dispute. Certainly he had loving friend-ships with male friends, but it is unclear whether they involved physical intimacy, and Wittgenstein was troubled by the slightest show of sexual desire.[13]

At the outbreak of the First World War he volunteered for the Austrian army. He was decorated for bravery, but his unit was captured, and as a prisoner of war, he finished what would become the only book he'd publish in his lifetime, the *Tractatus Logico-Philosophicus*. The book was written in an epigrammatic and cryptic style, and in the preface Witt-genstein wrote that "perhaps this book will be understood only by someone who has himself already had the thoughts that are expressed in it.... Its purpose would be achieved if it gave pleasure to one person who read it and understood it."[14] Unsurprisingly, he had trouble finding a publisher.

The *Tractatus* argued that we understand the world though our language and that to be meaningful, a statement must be a picture of reality.[15] This served to divide statements into two categories: those that are meaningful and those that are not. A statement that purports to represent the world, such as "this table is red," and that might be either true or false, is meaningful. A tautology that is unconditionally true, such as "red is a color," says nothing about the world and is devoid of sense.[16] As a criterion of meaning, this also excluded statements about religion and metaphysics. In the famous last line of the *Tractatus* Wittgenstein wrote, "Whereof we cannot speak, thereof we must be silent."[17]

A circle of Viennese intellectuals, including philosopher Rudolph Carnap and mathematician Kurt Gödel, greatly admired the book and asked Wittgenstein to meet with them.

They argued that statements are not meaningful unless they can be empirically verified, a doctrine that came to be called logical positivism. This was not unlike what Wittgenstein had written in the *Tractatus*, and he said he agreed with them. A few years later, British philosopher A. J. Ayer visited the Vienna Circle and brought back their ideas to England in *Language, Truth and Logic* (1936). In it he wrote that statements about the nature of God and claims about right and wrong are nonsense in the strict sense of that word. "If I say to someone, 'You acted wrongly in stealing that money,' I am not stating anything more than if I had simply said, 'You stole that money.'"[18] Logical positivism was a severely reductionist theory, but for the next twenty years it dominated Anglo-American philosophy.

Ayer never quite moved on from logical positivism. But Wittgenstein thought that the philosopher's first duty was a relentless curiosity, and rather than trying to define the meaning of a statement, he began to ask how the phrase was used. Not logic, but ordinary usage, was the criterion of meaning, and he no longer thought that a sentence must have a definite sense. He expressed this by asking whether it is possible to play chess without the queen. Since the answer is obviously yes, the implication was that statements could be meaningful without clear and definite rules and without regard to the logician's demand for rigor. The false simplicity of the *Tractatus* had been a wrong turn, and what it described was "the idea of a language more primitive than ours."[19]

A friend and colleague of Wittgenstein, philosopher Norman Malcolm, offered another account of how he came to abandon the ideas Wittgenstein expressed in the *Tractatus*. Wittgenstein had told economist Piero Sraffa that a proposition and the fact it describes must have the same "logical

form." In response, Sraffa brushed the underside of his chin with his fingertips, a gesture Italians understand to mean contempt. "What is the logical form of that?" asked Sraffa.[20]

Wittgenstein returned to Oxford in 1929 and began to give classes for a small group of students. He made notes of his lectures, but these he constantly revised, being too much a perfectionist to produce a second book. He would work up a typescript and then find it worthless, boring, and artificial. It was clear, however, that he had moved beyond the *Tractatus*, which he thought had contained grave mistakes. From lecture notes taken by his students and from his manuscripts and extensive typescripts, a book called *Philosophical Investigations* was published after his death in 1951. For the next twenty years this inspired a school called Ordinary Language philosophy. This has been satirized in the plays of Tom Stoppard and chided for its indifference to politics. But it attracted the smartest philosophers of the day and brought clarity to the seminar room. It also saved Anglo-American philosophy from phenomenology.

Ordinary Language philosophy cannot be reduced to a single theory, and indeed it was largely antitheoretical and devoted to demolishing long-held theories, such as those of metaphysics and even of logical positivism. If philosophers would simply attend to the way language is ordinarily used, said Wittgenstein, they would see that many of their problems aren't really problems at all. It wasn't a question of replacing one theory with another; rather, it was a way to escape from the need for a theory and was like showing the fly the way out of the fly-bottle.[21]

Those were the ideas Wittgenstein tried to express in his lectures, and these were quite unlike the way in which philosophy is ordinarily taught, where a lecturer presents the

ideas of a famous philosopher and then asks, "What do you think Socrates meant by that?" Apart from St. Augustine and Pascal, Wittgenstein was poorly read in philosophy and instead took up problems and tried to work them out before his class. It was like tightrope walking without a net.

No one who has ever taken a class in this manner will ever forget how painful the experience can be, on both sides. A question is posed and silence follows as people try to come up with responses. There is no PowerPoint to fall back on, no recourse to what some other philosopher might have thought. For someone like Wittgenstein, the experience could be excruciating. He lectured without notes and simply stood before his class, thinking aloud. The night before he would lie awake, rehearsing what he would say, but even then he'd stand for minutes on end and exclaim, "This is difficult as hell!" or walk about in despair and say, "I'm a fool, I'm a fool."[22]

At various times in his life he tried to quit philosophy, as one would flee from a terrible storm. After the First World War he became a schoolteacher in a remote Austrian village. When his Cambridge fellowship expired in 1935, he visited Moscow and Leningrad with a plan to work as a common laborer in the Soviet Union. Later, in the Second World War, he became a hospital orderly in a bombed-out part of London. For his own peace of mind he spent long periods in remote villages in Norway or on the west coast of Ireland.

Had he been a religious believer, he might have been more forgiving of himself. What belief offers, he thought, is the sense that nothing seriously wrong could ever happen to one.[23] But he never could believe everything that his Catholic students believed. He'd go only halfway. He had their belief in sin, just not in absolution.

12257

He had been baptized a Catholic and instructed in the faith. In the army, and afterward as a schoolteacher, he gave his religion as Catholic. He was also Jewish by descent, and one of the sins he confessed to his friends was that he had let people believe he was Aryan. He prayed when he felt bad and hoped that his friends prayed for him.[24] At various times he thought of joining a monastery. But he never abandoned the idea, expressed in the *Tractatus*, that religious dogmas were unintelligible. It's not that they were nonsense, as the logical positivists thought. What they were trying to say mattered, and mattered more than anything. The problem was that they were trying to say the unsayable.

What religion meant to him was something that couldn't be expressed in words. Instead, it was a passionate commitment to a religious frame of reference that is neither true nor false, reasonable nor unreasonable.[25] He would have liked the maxim attributed to St. Francis of Assisi: "Preach the Gospel at all times. When necessary, use words."

When serving in the Austrian army, he had found a copy of Tolstoy's *Gospel in Brief*. The book, which recounted the life of Christ shorn of any miracles, captivated Wittgenstein, especially the ideals of purity and perfection from St. Matthew's Gospel. After the war he returned to Vienna and gave away all his money to his family. Thereafter he lived a life of extreme simplicity. At Cambridge he had two spare rooms, with a camp bed and a canvas deck chair. There was no bookcase and no books, and his papers he kept in empty shoe boxes. He never wore a tie. For meals he always wanted the same thing: porridge for breakfast, vegetables at lunch, and eggs at dinner. Shortly before he died, he recalled the inscription Bach had written on the title page of his *Little Organ Book*: "To the glory of the most high God, and that my

neighbor may be benefited thereby." That is what I should have liked to be able to say about my own work, he added.[26]

Wittgenstein is often taken to be a radical, but in his life and scholarship he was more of a conservative. His love of the Gospels, his admiration for St. Augustine and Pascal, and his desire for moral and intellectual purity distinguished him from truly radical philosophers like Russell and Ayer. His rejection of scholarly cant would have won Samuel Johnson's praise, and Ordinary Language philosophy was a commonsensical rejection of metaphysical abstraction and reductionist theories.

He was also an example of the benefits and burdens of scrupulosity. His steadfastness and unwillingness to tolerate any sham or inadequacy in his work made him the greatest philosopher of the twentieth century, and also the unhappiest. Yet before he lapsed into unconsciousness, his last words were, "Tell them I've had a wonderful life."[27] Perhaps, at the end, he felt that he had earned absolution through his gritty curiosity and forgave himself.

A good many things go into grit. It's an umbrella term for Manne's assertiveness and courage, Newman's intellectual rigor and integrity, and Wittgenstein's intensity and steadfastness. People who've written about grit don't tell us how to acquire it. But they're like muscles that are strengthened by exercise, and to acquire grit, it suffices to practice it. And that's what you should do, if you want to be curious.

BE INTERESTED
IN OTHER PEOPLE

YOU'RE NOT CURIOUS unless you want to meet other people. The philosopher who can't be distracted from his work isn't curious. The desert monk who shuts himself up in his cell isn't curious. The misanthrope who hates people isn't curious. We're what Aristotle called a *zōon politikon*, a political or social animal,[1] and we're naturally curious to meet other people, to learn something from them, to be entertained by them.

Contact with other people satisfies our need for solidarity with others, which is one of the most basic of human needs. It's also a form of insurance, since we feel a need to look after each other. In addition, we're simply curious about other people. When we're alone, we'll no sooner meet a stranger but we'll want to know something about him. We're also going to be curious about other things, too, so we'll have something to talk about with him. We'll want to know

what's happening in the world or in his little corner of it. Maybe we'll want to tell him a few dad jokes or complain about the bicycle lanes. Wanting to meet other people is a spur to general curiosity.

That includes the need to find out what interests people of the opposite sex, if you hope to attract them. The sixteenth-century court of Urbino, as described in Baldassare Castiglione's *Book of the Courtier*, was "the very Mansion place of mirth and joy" and became the model for how one should behave in civilized, mixed company. The author suggests that, to attract women, the ideal courtier should learn poetry, famous speeches, and history. "For beside the contentation that hee shall receive thereby him selfe, hee shall by this meanes never want pleasant intertainements with women which ordinarily love such matters."[2] Perhaps the list needs to be updated, but the principle remains the same.

We need to meet other people, and that's why novels like *Robinson Crusoe* and films like *Cast Away* are so gripping. They speak to one of our deepest fears: being cut off from everyone else. That's also why solitary confinement is the harshest form of punishment, short of capital punishment. Inmates in solitary at our supermax prisons are confined to their cells for twenty-three hours a day, under constant high-tech surveillance. Visits and phone calls are seldom permitted. That takes an enormous toll. Studies of the effects of solitary confinement report widespread physical and mental health problems, including depression, anxiety, hallucinations, delusions, and suicidal thoughts.[3]

Curiosity about other people is a life-saving instinct, because without it we can lose our desire to live. That's what happened to Tara Condell, a pretty young Manhattan dietician. She wrote that she had a great life, that she could

travel anywhere she wanted, and that she could eat meals other people could only dream of. Her Instagram page was filled with pictures of her dining in places like Vietnam, Peru, and Italy. But she felt detached from other people. During what should have been the happiest and the darkest times of her life she felt absolutely nothing. And so, after posting a suicide note on her website, she hung herself.[4] She was only twenty-seven. She had had all the diversions modernity could offer, but they were as unsatisfying as Pascal said they'd be.

Stay Connected

Condell described her sadness as "the ultimate first world problem." It's not a problem in the third world, where people are emerging from abject poverty. And even in the first world, we're materially much better off than we were fifty years ago. But if we're wealthier, we're also lonelier, and that can be deadly. Lonely people are more likely to kill themselves, and more people have done so in recent years. Between 1985 and 2004, the percentage of Americans who told a friend something of personal importance to themselves during the prior six months fell from 73 to 51 percent, while the percentage of people who had no such confidants rose from 10 to 25 percent.[5] That is a staggering loss in social solidarity.

What Condell had experienced was a malaise of modernity, where people are cut off from each other and feel abandoned in a heartless world. In part, that's a consequence of the move to an information economy and the loss of blue-collar jobs. People who are out of work lack the sense of self-worth and the human contact they'd have had with

coworkers. They're also more likely to kill themselves.[6] Among Americans aged thirty-five to sixty-four, the suicide rate rose by nearly 30 percent between 1999 and 2010. For men in their fifties, suicide rates jumped by nearly 50 percent.[7] Add to this the ravages of the opioid crisis, which preys on the unemployed and which claims nearly as many American lives each year as the entire Viet Nam War.

Mobility also has something to do with it. Tara Condell had grown up in San Francisco but had moved to New York. We move around a lot. Half of Americans live in a different state or country from the one in which they were born and grew up. We'll end up in a place where we won't know our neighbors, and where we won't have to worry about what they think of us, for good or ill. In earlier research, my coauthor and I found that there are higher bankruptcy and divorce rates in high-mobility states, and we attributed this to the loss of social networks and their sanctions.[8]

In addition, the growth in the size of government has made us lonelier. In the 1830s Alexis de Tocqueville reported that Americans seemed to have a special genius for forming associations or clubs. It was how a church got built in John Ford's *My Darling Clementine* (1946), and it was how things got done without asking the government to do it for you. Tocqueville admired that in Americans. It kept their government small. Two hundred years later, our government isn't so small anymore. Through its social safety net and public works, it's doing things we want it to do, and we might not want to change that. But at the same time, it's become less necessary to cooperate with other people, and that's made us less curious about them and lonelier.

That doesn't mean that we've turned ourselves into desert monks. We're still curious to meet other people, even if that

might take more of an effort today. Instagram didn't do much for Tara Condell, but other social media sites, such as Facebook and Twitter, keep us connected to other people, including people we'd otherwise never see. They don't substitute for direct, personal contacts, but then there's a website for that too. Meetup had eight million users in 2010 and twenty-five million by 2013 and connects people with the same interest in clubbing, dirt biking, or Jane Austen. The more modernity separates us from one another, the more we'll try to overcome this, for few instincts are healthier than a curiosity about other people. It can save your life, and if suicides spiked in 2020, it's because the pandemic kept us apart.

Look for Romance

In 1969 two Swedish films treated audiences to soft core porn. Massachusetts banned them as pornography, and it took a U.S. Supreme Court decision before they could be seen in theaters. They were called *I Am Curious Yellow* and *I Am Curious Blue.*

That's one kind of curiosity. If he's to be believed, Giacomo Casanova was the greatest of lovers, and he said it was curiosity that made him so. "The source of love … is a curiosity which, combined with the inclination which nature is obliged to give us in order to preserve itself, does it all."[9]

But do we always know whom we love, or when it happens? One moment we're not in love, the next moment we are? Some people say that that's what happened to them. They speak of a thunderclap, a *coup de foudre*, love at first sight. That's what happened to Michael Corleone in *The*

Godfather when he saw his first wife walking with a group of women. "I think you got hit by a thunderbolt," says the bodyguard. In 1274 the same thing happened to Dante when he first saw Beatrice. "Behold a god more powerful than I am, who will rule over me," he said to himself. And, "O misery, since I will often be troubled from now on."[10]

Mostly, love isn't like an on-and-off switch, however. We recognize it only in hindsight. We remember a time when we first met and weren't in love, and then we feel we're in love, and we're not sure when it all happened. Perhaps that doesn't matter, so long as we know we're in love. But then, do we always know that either? We might remember the first time we told someone "I love you" and imagine that that's when it all happened, as if love is a performative utterance – as if we create the bond by speaking it. But that's not it either. We might speak the words and be lying to the person to whom we're speaking. We might also be lying to ourselves. So how do we tell?

Stendhal's *The Red and the Black* answers that question by exploring the ambiguities, lies, and self-deception of people who think themselves in love. Julien Sorel, the clever son of a peasant in a provincial town, is hired to tutor the children of M. de Rênal, the town's mayor, and, out of boredom and class envy, decides to seduce his wife. Mme. de Rênal, who had been married at sixteen, and who had never known what it is to be in love, finds herself infatuated with Julien, ten years her junior. She daydreams about a match between Julien and her maid, and then is transported with joy when she finds that he has refused the maid. "Is it possible that I love him?" she asks herself. Step by step, like a conquering Napoleonic hero, Julien overcomes her qualms and fears of damnation and becomes her lover. Afterward, when he

leaves her bedroom, he realizes that he is loved – and asks himself, is that all there is to love?

The affair becomes known, and Julien is sent away to a seminary, and then to Paris. There he ascends the heights of French society and is about to marry the aristocratic and absurdly romantic Mathilde de la Mole when the lady's father receives a letter from Mme. de Rênal warning that Julien is a social-climbing hypocrite who preys on women. The match is broken off, and in revenge Julien shoots Mme. de Rênal. He is condemned to die but, before he is executed, falls in love with Mme. de Rênal, who has survived and who shames herself by leaving her husband and visiting Julien in prison. The prisoner of a false society, where his actions are those of an actor in a play, Julien at last finds one authentic love, when she comes to him after he shot her.

Did he ever love her before then? The answer is no. And we know this because he so easily forgot her after he left for the seminary and Paris. The touchstone of love is curiosity. People in love want to know everything they can about the other person – what they were like as kids, what movies they enjoy, what music they like. We'll also want to know who their friends are, who they hang with, and we can become morbidly curious about the other people we fear they're seeing. We know that Mme. de Rênal loved Julien because she remained curious about him after he left. Had she forgotten him, as he had forgotten her, she couldn't be said to have loved him.

Blaise Pascal was never in love with a woman, but a woman was in love with him. Her name was Charlotte de Roannez. She was ten years younger than Pascal and the sister of his friend the Duke of Roannez. Pascal had been a man of fashion, frequenting the salons and passing from

château to château, and that was how they met. She was a vain and lazy aristocrat who loved finery and had enjoyed the company of dashing and worldly wits,[11] but Pascal was cut from a different cloth, and she became smitten with him. She was curious to know everything about him, and when he became intensely religious, she did too.

We don't have the letters she sent him. We do have his replies, and they reveal a woman who is tortured by how distant he is to her. She complains that he does not write to her. Then she tells him of the pain of separation from him. She's been given a choice, she tells him: either marry another person they want her to marry or withdraw from the world to a convent. I really don't want to do either, she adds. He replies that she should withdraw from the world unless she has a good reason to stay in it. But he refuses to propose and give her the reason she was looking for. His responses are always those of a father confessor and never betray a hint of love. She finally tells him that she has decided to become a nun, and he expresses his joy at this: "GOD be praised, I have no more fears for you, but am full of hope!"

She fled to a Jansenist convent but was quickly made to leave and, after Pascal's death, was forced into a loveless marriage. Her only consolation was to read and reread Pascal's letters, which her husband forced her to burn when she was dying. For the rest of her life she regretted that she had been prevented from becoming a nun.[12] To what extent this had been her personal desire and to what extent it had been her declaration of love for Pascal we do not know. Nor she either, perhaps, so mysterious and curious are the ways of love.

A love like that belonged to a more formal time, when religious and social constraints more closely bound people. The greater the barriers were, the more intense was the pas-

sion and the more dramatic the lovers. When Julien Sorel is guillotined, an exultant Mathilde de la Mole rescues his head and takes it home with her.[13] For her part, Mme. de Rênal dies soon after Julien's execution. Of the two women, she was the one most truly in love with Julien.

Novels like that are more likely to strike a chord with older readers, who grew up at a time when there was a greater mystery about the opposite sex and a greater need to satisfy one's curiosity. Today, our culture and schools have helped erase the sense of sexual difference by promoting the idea that gender differences shouldn't hold women back. Not that many people would object to this. It's meant that women can ascend to leadership positions in business and politics that once were reserved for men.

All the same, this hasn't eliminated the mystery about sexual differences, or our sense of curiosity about them. It's no easier to figure out what attracts people today than it ever was, and the proof is the *Washington Post*'s Datelab feature. Each Saturday, the *Post* reports on a blind date it set up. It asks for volunteers and pays for their meal at a fancy restaurant. The goal is to find two people who will want to see each other after the first date, and the newspaper tries its best to figure out what would make two people click. Between two gay men it never seems to be a problem. There's no mystery there, apparently. But between a man and a woman, the *Post* seems to strike out 90 percent of the time. The two enjoy each other, have a great evening, and then never want to see each other again. The imponderables between the sexes are just too great to predict what will make for a successful couple. So the mystery and the curiosity remain.

BE ENTERTAINING

Comedian Bill Murray loves to photo-bomb wedding parties. At a pub he'll hop behind a bar to serve drinks. At restaurants he'll pick French fries from other people's plates. When the Poet's House, a library in Manhattan, was being built, he showed up to read poems to the construction workers. Murray believes he has a duty to entertain other people, and since he's a well-known and funny comedian, he's always able to do so.

What Murray recognizes is that we have positive as well as negative duties to others. Our negative duty is not to cause harm, and that embraces rules against lying, cheating, and stealing. But there are also positive duties to go out and make things better for other people. That might involve contributing to a charity or working a food kitchen. Beyond material welfare, there are also the numberless acts of kindness that make other people happy, by smiling at strangers on the street or showing respect for them. In addition, like Murray, we have a duty to be entertaining, to amuse, to raise

a laugh. Material welfare is important, but as Lionel Trilling noted, man does not live by bread alone – he also needs strawberry jam.

The duty to entertain other people is a duty to be curious about them. Nothing is interesting in itself, so you'll have to know what will amuse them. And then you'll have to be curious about what you're going to say, if the entertainment is to be a success.

A friend of mine understood this after he was diagnosed with inoperable cancer. He was given chemo, and before long none of his old friends would have recognized him. His hair fell out, and he put on tons of weight. The cancer quickly spread, and he was told he had only a year to live. But he decided to do something about it. He saw himself in a mirror and knew what he should do. He had come to look like a clown, so he dressed up like one and learned some magic tricks. And then he entertained the kids in the cancer ward of a children's hospital. In the time that was left to him he made sick children happy and was happy himself.

There are less theatrical ways of entertaining people, but they'll also require curiosity. Years ago, I was sitting in a park in Boston when a stranger came up and apropos of nothing started telling me a story. I can't remember it, but he told it well, with a beginning, a middle, and an end that adorned the tale with a moral. When he had finished, I asked him why he had told it. I wasn't a wedding guest, and he wasn't the Ancient Mariner. It turned out that he was at a storyteller's conference and was practicing on me. I never saw him again but expect that he subsequently entertained a good many people with his well-rehearsed stories.

Many of us do things like that. We have a store of twice-told tales, amusing incidents that we dine out on. First we

experience them in real life, then we recall them to entertain others. We might polish them up a bit, perhaps improving on them to our advantage. We add in the witty things we hadn't the presence of mind to say at the time. Over time we can get quite professional about this, so long as we remember to find a different audience each time.

We'll also have stories from things we've read, and our curiosity is sharpened by the prospect of sharing them with friends. We'll wait for our little cues, and when we hear them we're at the ready to supply an amusing tale. It might be about the Battle of Waterloo or a baseball hero or the best way of navigating your way around D.C. traffic. It doesn't matter. We've learned something entertaining, and we did so because we hoped to be able to share it. That had whetted our curiosity.

A bit of vanity can enter into this. Pascal thought that vanity was behind all our learning. We swot up on things simply to parade what we know.[1] John Adams, one of our best-read presidents, agreed. In a letter to his wife he famously praised disinterested learning[2] but nevertheless thought we wouldn't bother if we weren't vain:

If Crusoe, on his island, had the library of Alexandria, and a certainty that he should never again see the face of man, would he ever open a volume? Perhaps he might; but it is very probable he would read but little. . . . The universal object and idol of men of letters is reputation. It is the notoriety, the celebration, which constitutes the charm that is to compensate the loss of appetite and sleep, and sometimes of riches and honors.[3]

Maybe a bit of that isn't such a bad thing, however. If you're going to be really good at entertaining other people,

why not take some pleasure in it? If you don't enjoy telling the story, it probably won't go over very well. So why not enjoy the performance, as long as you don't take this too far? When people laugh at their own jokes, they're mostly not very funny. It's as if you're telling the listener to laugh along with you. Otherwise, he wouldn't get the punch line. The same is true when you take too much interest in your own stories – you'll be less likely to know whether your audience enjoys them.

The duty to entertain works both ways. You should entertain others, and they should entertain you. That's something Oscar Wilde understood. He was the most gifted and entertaining storyteller of his time and said he couldn't think except in stories.[4] But he knew that duties to entertain are reciprocal and expressed the thought at the premiere of his first great play, *Lady Windemere's Fan* (1892). When it was over, the applause was long and enthusiastic, and the audience clamored for a word from the author. Wilde did not disappoint:

Ladies and Gentlemen. I have enjoyed this evening immensely. The actors have given us a charming rendering of a delightful play, and your appreciation has been most intelligent. I congratulate you on the great success of your performance, which persuades me that you think almost as highly of the play as I do myself.[5]

Wilde's point was that a good conversation is like an exchange of gifts. You offer an amusing story, and your friend reciprocates with one of his. Neither of you should sit back and let the other person do all the entertaining. Conversations are meant to be two-sided, back and forth – unless you're stuck with someone who wants to be the only person talking. That's the very definition of a bore.

We're apt to think that bores are people who have nothing to say. But that might say more about us than about them. If we tried, they'd have plenty to talk about. Only one person in a thousand is a bore, said Harold Nicolson, and he's interesting for that reason.

The real bore is someone with too much, not too little, to say. He remembers the old Gospel song and thinks, "This little light of mine, I'm going to let it shine." You can find him anywhere, but he's most often seen near a university, where he's the pedantic academic who wants to impress people with his learning. He talks in paragraphs, not sentences, and he'll hold forth at length about the Electoral College or impeachment. Try as you might, he'll always swing the conversation back his way.

When that happens, what was meant to be a two-sided conversation turns into a monologue. But we can also hold a silent conversation with ourselves in our head, and they're more than monologues. We speak our ideas and sharpen the thought by responding to imagined objections. That was how Marcus Aurelius wrote his *Meditations*, the best-known guide to Stoic ethics. He addressed the book *tōn eis eauton* – to himself. It was how René Descartes began to philosophize. Shut up alone in a room, next to his stove, he started to converse with himself about his own thoughts.[6] And that was how Ludwig Wittgenstein did philosophy. "Nearly all my writings are private conversations with myself," he wrote. "Things I say to myself tête-à-tête."[7] We carry on an interior conversation between speaker and listener and so are curious about our thoughts.

We might also carry on desert island conversations with people long dead. That's how W. E. Du Bois saw it. "I sit with Shakespeare, and he winces not. Across the color line

I move arm and arm with Balzac and Dumas, where smiling men and welcoming women glide in gilded halls." Perhaps, in a racially segregated society, that was the best an African American scholar could do, but it was still enough to make him one of the leading intellectuals of his day.

Our spouses and parents seem present to us, even after their deaths, and we'll want to share things with them. That's been a theme of a host of films like *Ghost* and of TV series like *Shtisel*, where a dead wife and mother pops in from time to time to chat with her husband and son. Queen Victoria, who went into a deep and extended mourning after the death of Prince Albert, always felt the presence of her dead husband. When, years later, she saw how the Duomo in Florence had been restored, she brought out a miniature of him and held it up. She did this to show him something interesting.[8] That's why she was curious to see it.

We took the duty to be entertaining more seriously in the past. A century ago, people were encouraged to learn a musical instrument so they could play it when company came over. We didn't rely on the background noise from the television or downloads on iTunes. An old friend of mine had memorized Robert Service's "The Cremation of Sam McGee" and recited it for me after dinner. That was fun, but it doesn't much happen anymore.

If I had to pick a date when it all changed, it would be April 10, 1964. That was when pianist Glenn Gould gave his last public concert. While he was one of the greatest interpreters of eighteenth-century classical music, Gould was also a modern techie and had a little recording studio in a local hotel. He learned how to splice together tapes of his recordings, like today's hip-hop artists, and thought this was part of the creative process. That wasn't possible in a live

performance, which Gould thought was artistically inferior to what could be done in a recording studio. Besides, he was an eccentric and a recluse and likened the concert hall to a competitive sporting event. "I detest audiences," he said. "I think they're a force for evil."[9] And so he retired from public performances, and we were left with the records he'd release from time to time.

We've offloaded the duty to entertain on the media. That's made us duller. It's also made us less curious to learn about other people and the things that might amuse them, and less sociable and lonelier. That's why we should never forget our duty to be entertaining.

BE CREATIVE

CREATIVE PEOPLE are curious to discover new things, but how do you become creative? You can't bottle it, and no one ever became creative by reading a book on the subject. We can't even identify a single trait that describes creativity in different disciplines. There's mathematical creativity and artistic creativity and poetic creativity, and what do any of those have to do with the creativity of an entrepreneur like Steve Jobs? A few people have been creative across different fields, people such as Leonardo da Vinci and Pascal, but they're rarities. Perhaps *creativity* is a portmanteau word that tries to stuff wholly dissimilar things into a single suitcase.

Nevertheless, there are creative people in every field, and we should try to emulate them. The problem is that it doesn't seem to be the sort of thing you can adopt by force of will. Perhaps it's innate, a spark of genius you're born with. That seems to have been the case for some highly creative people who went on to invent one thing after another, as though creativity had been coded into their DNA. But if that's how

75

it works, trying to be creative would be like trying to make yourself taller – either you have it or you don't.[1]

Perhaps it's not an innate skill, however. Creativity has also been seen as a gift from outside of ourselves. In Greek mythology, inspiration came from one of the nine muses, and if you were a good poet, Calliope (epic poetry), Erato (love poetry), Euterpe (lyric poetry), or Polyhymnia (sacred poetry) was declaiming through you. That was how Socrates understood creativity. The poet who recites his verses is beside himself and not really in his senses. It is the goddess herself who speaks.[2]

And yet the muse's voice was never wholly external either. As the daughter of memory (Mnemosyne), she speaks from within a person with ideas that are his ideas. He is the creator and no one else. That's what one truly creative artist, Rick Hart, thought. He worked at Washington's new Gothic cathedral and came to it as a hippie who thought that great art could be created by a collective of artisans. But as he grew more skillful, he changed his mind. "I learned that great art can't be produced by a committee," he told me. "It can only be created by the genius of an artist." Hart went on to design and sculpt *Ex Nihilo*, on the tympanum above the gates of the cathedral, portraying the creation of men and women out of nothing.

Hart though that only individuals are creative and never a group of people. But sometimes it takes two creative people with dissimilar skills to bring a product to market. That was the story of the Apple personal computer, with designer Steve Jobs and inventor Steve Wozniak. New ideas can also come from brainstorming by a group of creative people. That was how J. Robert Oppenheimer organized the atomic bomb project at Los Alamos during the Second World War.

He collected an eclectic group of brainy people, threw them together in an isolated town, and then required them to work together. Working with a group can also inspire a highly productive team spirit, as it did for the group of creative young painters who formed the nineteenth-century Pre-Raphaelite Brotherhood.

Whether in a group or not, we're still going to need individuals to come up with ideas, so what goes into their creativity? Three things, I argue: the wish to surprise, the desire for novelty, and a willingness to look deeply into what's before us.

Ebullience, the overflowing fullness of spirit that revels in a *wish to surprise,* seems to help.[3] New ideas seem to bubble forth from people like that. Abbot Suger was one such person, a fun-loving cleric who liked to stay up until the middle of the night telling stories and who was the driving force behind a twelfth-century revolution in Western architecture.

The need to adapt and *look for novelty* can also make people creative. That's especially a challenge for the young. They'll have to make their own way, and they won't do so by aping their elders. If they're painters, they'll want to break with the past, like the band of talented friends who formed the Pre-Raphaelite Brotherhood. What had preceded them was largely played out, and they gave English art a new vigor.

Finally, there are the outsiders, the creative people who aren't members of the club and who *look deeply* into the things that everyone else accepts. Like Wittgenstein, they're sometimes immigrants, and like him, they're sometimes gay. They might not belong to any church, or they might be the deeply religious believers in a secular age. They're often radical in their politics, but they might also be reactionary conservatives like Evelyn Waugh, whose beliefs cut against

the grain. In the late nineteenth century, they were the aesthetes who looked to the sense of beauty for ideas on how to live.

When we think of creativity, we're usually thinking of the arts. In what follows, therefore, we'll look at architects, painters, and writers of the twelfth and nineteenth centuries. What they all had in common was their creativity – and the curious figure of John Ruskin (1819–1900) peering and pontificating over their shoulders.

Seek to Surprise

Modernity has been invented many times. Philip Larkin thought that things got started in 1963, "between the end of the 'Chatterley' ban and the Beatles' first LP." Virginia Woolf observed that "on or about December 1910 human character changed." For patriotic reasons, Frenchmen and Americans prefer dates in the eighteenth century. But I go back to the first part of the twelfth century and the invention of the Gothic, when creative cathedral builders announced the dawn of a curious and inquisitive Northern European civilization.

Things were happening elsewhere. In China, the Song dynasty invented gunpowder, issued paper currency, and created a standing navy. In Spain, Maimonides wrote *The Guide for the Perplexed* to reconcile the Jewish Bible with Aristotelian philosophy. In Spain, too, the commentaries of Ibn Rushd (Averroes) were the bridge by which Aristotle was reintroduced to Latin Christendom. In Baghdad, the Abbasid dynasty established the "House of Wisdom," and the Muslim world became an intellectual center for science,

medicine, and philosophy. In world history, Northern Europe had been a backwater, but during the first half of the twelfth century it experienced a medieval renaissance.

Trade increased, especially with the Byzantine and Arab worlds, and there was a marked rise in the standard of living. New plants – including roses – were introduced, and sugar made its first appearance as a sweetener. Money came to replace property as the most basic form of wealth, and new towns arose as serfs moved to the cities. The center of the cities, where people gathered to meet friends, conduct business, or worship, were the cathedrals, which were being rebuilt in a new style named after the Gothic invaders who had brought down the Roman Empire. Like those invaders, the new cathedrals would bring a close to the Romanesque architecture, with its semicircular arches, of the sixth to the eleventh centuries.

In an essay on "The Nature of the Gothic" in *The Stones of Venice*, John Ruskin praised the twelfth-century cathedrals. There are two polar styles of architecture, he thought, one mechanical and incurious and the other Gothic and curious. The mechanical style, which he called servile, is top-down and does not allow for discretion or artistic expression by the inferior workman. Its buildings are simple in design and unadorned with anything that suggests superfluity. Ruskin thought that Romanesque was mechanical, but he never lived long enough to see the full development of mechanical architecture, in twentieth-century modernism. The more a building is mechanical, the more its plan can be reduced down to a simple formula, like New York's Seagram Building and the other box-buildings of Mies van der Rohe.

Ruskin's second style of architecture was the Gothic, which is inventive and extravagant in its details and surprises

the viewer. Were it wholly nonmechanical, its cathedrals would have fallen down, as several of them did. When Notre Dame remained erect after its roof burned, we were thankful that its builder knew something about engineering. There was probably a good engineer behind every twelfth-century cathedral, at least the ones that stayed up. The builders must also have recognized that the Gothic pointed arch, which was borrowed from Islamic architecture, drew weight downward, unlike the rounded Romanesque arch that drew weight outward, and that Gothic windows could therefore be much larger than Romanesque ones.

Twelfth-century engineering was limited, however, and mostly came down to basic geometry and the distance between columns. It didn't tell the builder how thick the respond columns should be, how high the towers could reach, or how to place large stained-glass windows in the skeletal, upper-story clerestories. That was mostly a matter of intuition and experimentation, like the flying buttresses built to support the walls of Notre Dame.

Somehow, the cathedrals got built, and they represented a revolution in aesthetics, one that unleashed the creative spirit of artisans and craftsmen. This made the Gothic democratic, said Ruskin, unlike the severely simple Greek and Roman architecture that left no room for the individual workman's strength or weakness. But if the Gothic was democratic, it was also hierarchic. It was the product of a high culture, which Ludwig Wittgenstein likened to "a big organization which assigns each of its members a place where he can work in the spirit of the whole."[4] Top to bottom, each workman contributed to the cathedral's creation, but at the very top of the hierarchy was the Church.

The first great Gothic cathedral was the twelfth-century

Basilica of Saint-Denis in the suburbs of Paris. We don't know the identity of its master sculptors, its Rick Harts, but we do know its true creator. He was Abbot Suger (1081–1151), a supreme ecclesiastical administrator, author, and statesman. The Church can boast of many pious and holy saints, but it also owes much to a different kind of cleric, people like Suger, whom Kenneth Clark thought more closely resembled a nineteenth-century railway baron than St. Francis of Assisi. And while Suger was not an artist himself, he was the next best thing: a visionary collector.

Suger made his abbey wealthy, acquiring new properties and improving its existing ones. Then, like a Gilded Age magnate, he spent it on art. The original Romanesque cathedral at St. Denis dating from 775, was too small and dilapidated, and Suger began to build over it. Beginning around 1135, he collected masons, stonecutters, and sculptors from across Europe, and gold and gemstones with which to adorn its sacred vessels and crosses. He discovered local stone quarries and, with the help of passage money paid to Saracen pirates, brought marble columns from afar. He then enlisted the entire community, pious nobles and common folk alike, to haul the columns up to the church.

He began with the western façade, with its two towers, and the narthex immediately inside the doors, and then oversaw the three great doorways meant to represent the gates of heaven. On colonnettes flanking the bronze doors were statues of the ancient Kings of Israel, both to welcome the faithful and to remind them of the sacerdotal kingship of the French monarchs. For the first time, a rose window was opened above the center doorway, the model for later rose windows at Notre Dame and Chartres.

Suger then turned to the cathedral's far side, with the

main altar, the choir, and the double ambulatory and chapels behind it. Though he wasn't responsible for the new style of architecture, he did ask that his church be light infused and saturated with imagery and was rewarded by a master builder who defied gravity and pushed almost to the limit the new skeletal style of construction, with its uninterrupted row of windows in the choir (replaced after 1231). Repeated in all Gothic churches thereafter, this became the hallmark of the Gothic and gave the worshiper an image of what paradise might be like.

The Gothic was an architecture of fancifulness and surprise, said Ruskin. He might have added that it's one that rewards our curiosity. That alone doesn't produce great art, mind you. Surprise is a necessary but not a sufficient condition of art, and what more is needed is something that reveals the hidden secrets of the human condition. That was how, when the lights of the Age of Reason failed, the Gothic's darkness and shadows inspired a romantic rebellion and religious revival against Enlightenment unbelief. In *Notre-Dame de Paris* (*The Hunchback of Notre Dame*), Victor Hugo reminded his readers that there was a great cathedral in their city. It had been desecrated and forgotten. Look at it, he said. It's important. For François-René de Chateaubriand (1768–1848), the Gothic inspired a sense of mystery and religious awe. In the preface to the first edition of the *Genius of Christianism* he wrote that, after visiting a cathedral, "I wept, and I believed."

Gothic cathedrals unite the elements of surprise and awe, of curiosity and rapture, that together are the source of the beautiful, and we owe them to the creativity of a few twelfth-century artisans and churchmen. They knew that great art seeks to capture the promise of a paradise that fulfills our dreams, and whose portal is the grave.

Look for Novelty

In the nineteenth century the Gothic had the badge of novelty, and it inspired a passion for all things medieval. At Oxford, John Henry Newman commissioned a series of biographies on the early saints. With his novels, Sir Walter Scott took his readers back to the twelfth century and so captured everyone's imagination that Mark Twain blamed the Civil War on him. In Britain, Young England enthusiasts pored over that monument to chivalry, Kenelm Digby's *Broad Stone of Honour*, and organized the 1839 Eglington Tournament, a medieval fair where a costumed Knight of the Swan challenged the Knight of the Golden Lion to battle.

Young England rejected the free market principles that they thought had destroyed premodern social bonds and reduced personal relations to what Thomas Carlyle (and later *The Communist Manifesto*) called "cash-payment."[5] These ideas were taken up by John Ruskin and Benjamin Disraeli, and in 1848, the year of Revolutions, a group of young English painters adopted them and displayed their contempt for conventional Royal Academy art by calling themselves Pre-Raphaelites. It wasn't that they knew much about Raphael, but before him was – the medieval! It was a propitious time for a youthful rebellion, since the only memorable contemporary painter was J. M. W. Turner, the hero of John Ruskin's *Modern Painters*, and he was an eccentric recluse.

Unlike Turner, the new painters were joiners, and they united in a Pre-Raphaelite Brotherhood and a mission. They added PRB to their signatures, gave up swearing and drinking, and proposed to rescue fallen women. They represented life as they saw it, without sentimentality, and portrayed

unwashed English men and women in vivid colors and showing intense emotion. All of this was entirely novel.

Of the original seven members, John Everett Millais was nineteen, Dante Gabriel Rossetti was twenty, and William Holman Hunt was twenty-one. A precursor and fellow traveler, the twenty-seven-year-old Ford Maddox Brown, was invited to join them but never did.

Rossetti was an Anglo-Italian poet, the brother of another poet, Christina Rossetti. He was about five feet seven with hair down to his shoulders and drooping eyelids, and wholly un-English in his interests and manners. He could recite poetry twenty pages at a time and was endlessly curious about everything going on in the arts. If painting was the coming thing, why, he'd be a painter too, and he made Maddox Brown teach him the art. His early paintings were inspired by medieval themes, but in 1860 he married his model, the sickly Elizabeth Siddal, and his later paintings featured heavy-lidded "stunners" that conveyed the Victorians' sense of morbid and forbidden sexuality.

Lizzie Siddal was tall and freckled, with flowing, deep red hair. She was also consumptive, and her illness had not been made better when she posed for Millais's *Ophelia* and was made to lie fully clothed in a bathtub in wintertime. Millais had oil lamps placed under the tub to keep it warm, but the lamps went out, and she caught a severe cold.

She was the opposite of the ebullient Rossetti – passive, withdrawn, and unresponsive, depressed and often ill. She began to take laudanum to ease her pain, and it was an overdose of this that killed her. Rossetti had neglected her for

other women but was so distraught at his wife's death that, as an act of expiation, he placed a book of manuscript poems in her casket.

Many years later, Rossetti decided that he wanted to return to poetry. The problem, however, was that his best poems lay underground in Highgate cemetery. It would be a desecration from which any gentleman would shrink, but then Rossetti wasn't a gentleman, and in the most ghoulish act in English literature, he had her grave dug up to retrieve the poems. They were well received, but Rossetti later wrote that on no account should he be buried at Highgate.

———

The Arab tribesman who ventured to the Dead Sea in the mid-1850s was treated to the curious sight of a tall, bearded Englishman in eastern garb, easel in hand and sitting under an umbrella, observing a dying goat on the salty beach. The animal's eyes are glazed over from exhaustion and thirst as he stumbles over the bones of animals that have died before him. Beyond are the purple mountains of Moab in Jordan. The goat was the scapegoat, the sacrificial animal of the Bible, and the man was Holman Hunt.

Of all the members of the Pre-Raphaelite Brotherhood, Hunt was the most religious. He wanted to paint scenes from the Bible and, for the sake of authenticity, was curious to see the Holy Land for himself. And so he traveled to the most remote parts of the country, in the company of an Arab guide and a near-dead goat. On the Day of Atonement, a goat representing the sins of the community would be driven into the desert to die. For a devout Christian like Hunt the goat represented Christ, the Lamb of God who

takes away the sins of the world. But the reference was lost on the viewers, and in his autobiography, Hunt recounted what a French art dealer thought of it:

Gambart, the picture-dealer, was ever shrewd and entertaining. He came in his turn to my studio, and I led him to The Scapegoat. *"What do you call that?"*

"The Scapegoat."

"Yes; but what is it doing?"

"You will understand by the title, Le bouc errant.*"*

"But why errant?*" he asked.*

"Well, there is a book called the Bible, which gives an account of the animal. You will remember."

"No," he replied, "I never heard of it."

"Ah, I forgot, the book is not known in France, but English people read it more or less," I said, "and they would all understand the story of the beast being driven into the wilderness."

"You are mistaken. No one would know anything about it, and if I bought the picture it would be left on my hands. Now, we will see," replied the dealer. "My wife is an English lady, there is a friend of hers, an English girl, in the carriage with her, we will ask them up, you shall tell them the title; we will see. Do not say more."

The ladies were conducted into the room. "Oh how pretty! what is it?" they asked.

"It is The Scapegoat,*" I said.*

There was a pause. "Oh yes," they commented to one another, "it is a peculiar goat, you can see by the ears, they droop so."

The dealer then, nodding with a smile towards me, said to them, "It is in the wilderness."

The ladies: "Is that the wilderness now? Are you intending to introduce any others of the flock?" And so the dealer was proved to be right, and I had over-counted on the picture's intelligibility.[6]

The painting fared no better with the reviewers. One of them thought that the only thing of interest was the deposit of salt, while the *Times* reported that the goat bore a remarkable likeness to Lord Strafford de Redcliffe.[7] Because of its hidden message, the critics did not know what to make of it. But it is still a masterpiece.

Millais had entered the Royal Academy at ten, in short trousers and patent leather shoes, his hair in long curls, already the most promising young artist of his day. When he was twenty, he painted *Christ in the House of His Parents*, showing Christ as a child of seven or eight holding up a bleeding hand cut in Joseph's carpenter's shop, the image of the wound on the cross. His cousin, a slightly older and worried John the Baptist, looks on, bearing a basin that recalls Salomé's platter. The Pre-Raphaelites were universally condemned in the press as conceited innovators who had rebelled against the axioms of good taste, and Charles Dickens wrote that Millais's Christ child was a hideous boy in a nightgown.[8]

It was a highly damaging attack, but just at that moment Ruskin wrote a letter to the *Times* to defend them, and in time came to adopt them. As the author of *Modern Painters*, he spoke with an undisputed authority, and if he said that the Pre-Raphaelites had created "the foundations of a school of art nobler than anything the world had seen for three hundred years,"[9] no one was going to argue with him. He befriended them, visited their shops, and plied them with suggestions. He was ten years older than Millais, and when he suggested that the younger man visit Scotland with him and his wife, Effie, it seemed the most natural thing in the world.

The Ruskin marriage was less than successful, however. Their wedding night had been a disaster, seemingly because Ruskin was revolted by Effie's pubic hair, and he proposed that the two of them abandon the idea of sex for five years. In Venice, on their honeymoon, he left her alone while he poked around churches and wrote *The Stones of Venice*. But as odd as he was, Effie was entirely normal, and in Scotland she fell in love with the tall, slim, and handsome Millais. She determined to end her marriage to Ruskin and returned to her parents in England. The marriage was annulled on grounds of impotence, notwithstanding Ruskin's offer to prove the contrary before the open court, and Effie and Millais were married the following year. For forty-one years they had a highly respectable marriage, producing eight children, and when Queen Victoria made her husband a baronet, Effie became Lady Millais.

The Pre-Raphaelites were soon out of fashion. Before very long, most of them had moved on. By the 1880s Millais was making between thirty thousand and forty thousand pounds a year painting the grand figures of the day – Gladstone, Disraeli, and Cardinal Newman. Seeing the eighty-year-old Newman hesitate before mounting a chair, he exclaimed, "Come, jump up, you dear old boy." But in their day the Pre-Raphaelites had produced some of the greatest of English paintings, and even the lesser-known members of the school could boast of masterpieces, people such as Henry Wallis (*The Death of Chatterton*), John Brett (*The Stone-breaker*), Arthur Hughes (*April Love*), and Ford Maddox Brown (*Work* and *The Last of England*).

In their time the Pre-Raphaelites battled against the friv-

olous art of the day. They gave us, as creative artists always do, a novel kind of art, one that in their case broke with the grand manner of Italian and French paintings. Possibly influenced by the discovery of photography, their paintings were hyperrealistic, down to stray wisps of hair. As Renaissance painters did with their tempura on plaster, the Pre-Raphaelites would lay a white ground on their canvasses and, before it dried, paint on top of this with fine brushes. They also used the new chemical shades produced in Germany to get the deep purples of *The Scapegoat*, and the brilliance of their colors was like nothing that had previously been seen. Their creativity and curiosity had led them from the trodden path, but they also had the kind of genius without which novel departures in art are devoid of interest.

Look Deeply

In addition to artists, writers may also display their creativity with their willingness to take on new styles and themes, as Tom Wolfe did with his hyperkinetic prose about NASCAR drivers and hot rods ("The Kandy-Kolored, Tangerine-Flake Streamline Baby"). Pascal's *Provincial Letters* were just as innovative and are as fresh and easy to read as something published last week. Near the end of his life, Pascal was asked why he hadn't taken a more elevated tone. "Had I written in a dogmatic style," he answered, "only scholars would have read the letters, and they did not need them."[10]

In the 1860s and 1870s a new writer arose with a mannered style so remarkable that it's given us an adjective: Pateresque. This describes the perfumed, overripe prose of Walter Pater (1839–94), as purple as the mountains in *The*

Scapegoat and as luscious as a hothouse orchid. We have walked through the Louvre and glimpsed the Mona Lisa behind a crowd of tourists, not closely attending to it. But Pater described her face in so lyrical a manner that William Butler Yeats reproduced Pater's words as a free verse poem:

> *She is older than the rocks on which she sits;*
> *Like the Vampire,*
> *She has been dead many times,*
> *And has learned the secrets of the grave;*
> *And has been a diver in the deep seas,*
> *And keeps their fallen day about her;*
> *And has trafficked for strange webs with*
> *Eastern merchants.*[11]

For most of his professional life, Pater was an Oxford don. Short and ugly as a pug, living with his cat and his two sisters, he did not make friends easily.[12] He was shy and withdrawn and so nervous when he spoke in public that his friends strained to listen to him. Did you hear me? he asked Oscar Wilde after a lecture. "Heard you? No! We overheard you." But he was the oracle of the aesthetic movement, the person to whom its leading figures would repair for inspiration and introductions. He introduced Oscar Wilde to Lionel Johnson (1867–1902), the dark angel of fin-de-siècle decadence, and it was Johnson who introduced Wilde to the man who would become his lover and ruin, Lord Alfred Douglas.

Had Pater not been gay and living at a time when Oscar Wilde's same-sex desires earned him a sentence of hard labor, he might have turned out differently. As it was, his friendships were very likely platonic, homosocial rather than homosexual,[13] and he channeled his emotions into the

most refined aesthetic experiences. He couldn't read Edgar
Allan Poe in the original English, he said, but only in Baude-
laire's French translation.[14]

It's easy to think him a sad prisoner of a repressive soci-
ety, but Pater didn't see himself that way or think himself
incurious. Just the opposite: he saw things that others had
missed, and in his essay on Leonardo da Vinci's *Mona Lisa*,
he showed how the curious and observant critic can pene-
trate more deeply into a work of art. He urged his readers to
break any habits they might have formed to search out new
experiences. "What we have to do is be for ever curiously
testing new opinions and courting new impressions."[15]

Pater's ideas about art represented a crucial break from
John Ruskin's earnest moralizing. "Go to nature," Ruskin
had said, "in all singleness of heart, and walk with her labo-
riously and trustingly, having no other thought but how
best to penetrate her meaning, rejecting nothing, selecting
nothing, and scorning nothing."[16] So approached, art would
inspire an elevated and solemn feeling that mimicked reli-
gious emotion and conveyed a moral message. But Pater
dismissed the moralizing and thought that Ruskin's "nature"
was much overrated. What mattered instead was the viewer's
aesthetic sensations. In *The Renaissance*, he wrote that life
gives us only a limited number of moments to live, and our
time on earth should be devoted to the pursuit of aesthetic
ecstasies that mimic heavenly raptures. To burn with that
"hard, gemlike flame ... is success in life."[17] Then, in his novel
Marius the Epicurean, Pater said one should "keep the eye
clear by a sort of exquisite personal alacrity, ... to discriminate
ever more and more fastidiously, ... to meditate much on
beautiful visible objects, ... [and] to keep ever by him if it
were but a single choice flower, a graceful animal or sea-shell,

as a token and representative of the whole kingdom of such things."[18]

Pater's books became the bible of the late nineteenth-century aesthetic movement. William Butler Yeats said that, while Rossetti influenced all its writers subconsciously, it was to Pater that they looked for their philosophy.[19] Following him, people like Wilde and James McNeill Whistler held that the real concern of art is beauty and not morality. That's what "art for art's sake" meant.

Ruskin saw the challenge to his theory of art and wrote a devastating review of one of Whistler's nocturnes, a dreamy painting of the Thames at night. "I have seen, and heard, much of Cockney impudence before now," he wrote, "but never expected to hear a coxcomb ask two hundred guineas for flinging a pot of paint in the public's face." The sneering and impudent Whistler immediately sued Ruskin for the injury to his reputation.

Whistler might have suffered a reverse when his obscure painting was mistakenly brought into court upside down. But he quickly recovered. Ruskin's lawyer asked him how long it took him to finish one of his paintings. A couple of days, he answered. A couple of days, and you ask two hundred guineas for it! "No. I ask it for the knowledge I have gained in the work of a lifetime."[20]

The jury found Ruskin liable, but awarded only contemptuous damages of a farthing, the smallest British coin. The trial bankrupted Whistler, but he wore the coin on his watch chain and wrote a witty and scathing account of the episode in *The Gentle Art of Making Enemies* (1890). For Ruskin, however, the defeat was traumatic. He was ordered to pay costs of £384 and resigned from his position as the Slade Professor of Fine Arts at Oxford.

After his marriage was annulled Ruskin never remarried, but when he was thirty-nine, he fell for the ten-year-old Rose La Touche. Eight years later, he proposed to her, but her family kept them apart, and when she died at twenty-seven, a heartbroken Ruskin suffered a mental collapse from which he never entirely recovered. Yet throughout, unless as often happened his mind was clouded by madness, he remained curious, about painting, architecture and ornament, society and economics, and as he grew old, he regretted that, fitted as he was to explore farther shores, a regret he had never imagined, of things necessarily left undone, now tormented him:

My own feeling, now, is that everything which has hitherto happened to me, or been done by me, whether well or ill, has been fitting me to take greater fortune more prudently, and do better work more thoroughly. And just when I seem to be coming out of school – very sorry to have been such a foolish boy, yet having taken a prize or two, and expecting to enter now upon some more serious business than cricket, – I am dismissed by the Master I hoped to serve, with a – "That's all I want of you, sir." [21]

All of the people I have described were great artists who knew that creators cannot copy what others have done. If all you want is a copy, cameras can do that better than any artist, and that was the punch line of the 1997 film *Bean*, where the hapless Mr. Bean defaces *Whistler's Mother* and saves himself by substituting a photo of the painting. But the more anything looks machine made, the less it looks like art. Walter Benjamin (1892–1940), the German Jewish essayist, explained why originality matters in *The Work of*

Art in an Age of Mechanical Reproduction. While a work of art might easily be reproduced, the copies necessarily diminish the aesthetic aura of the original, to the point where nothing of art and the creator's aesthetic authority remains. The copy lacks the authority of the original, the badge of curiosity and creativity upon which art depends.

BE OPEN TO THE WORLD

THE WORLD IS a garden, and curiosity is its key. But if there's a natural desire to explore what's out there, there is also a natural desire to stay at home. Some people think they've seen it all already and that their indifference signals their superiority. They might think, with Pascal, that what they'd find would prove disappointing. The interior life, whether of aesthetic experience or of contemplation, might seem of greater interest. These are arresting ideas, but they lead us away from the world, and they're snares for curious people to avoid.

Don't Be Jaded

The nineteenth century was a time of enormous economic growth. Beginning around 1790, the Industrial Revolution transformed British and French society, and from 1860 to 1900, real British wages doubled. People lived longer, were

better cared for, traveled farther and in greater comfort, and were better educated. Companies were incorporated, slavery was abolished, and Western countries expanded their franchise and became democratic. Lord Brougham memorably described the new middle-class voters as

the genuine depositaries of sober, rational, intelligent, and honest English feeling.... If they have a fault, it is that error on the right side, a suspicion of State quacks – a dogged love of existing institutions – a perfect contempt of all political nostrums.... Grave – intelligent – rational – fond of thinking for themselves – they consider a subject long before they make up their minds on it; and the opinions they are thus slow to form, they are not swift to abandon.[1]

That's not how they looked to the writers, however. They despised the New Men made rich by the Industrial Revolution and scorned Brougham's enfranchised voters. All that good sense meant nothing to them, and dandies like Charles Baudelaire ridiculed democracy and the rights of man.[2] When they looked about, what the literati saw were William Blake's dark satanic mills populated by moral lepers, people like Victor Hugo's Thénardiers in *Les misérables*, and they wanted no part of it. They were bored and made a cult out of incuriosity as a sign of their refined sensibilities and aristocratic superiority.

Boredom was a great theme in the late eighteenth and nineteenth centuries, from Byron's "Prisoner of Chillon," who regained his freedom with a sigh, to Ivan Goncharov's *Oblomov*, who seldom leaves his room. The Savoyard Xavier de Maistre was placed under house arrest and came up with a travelogue titled *Voyage around My Room*, which the Coronavirus brought to mind. Even in hustle-and-bustle America,

Herman Melville's "Bartleby, the Scrivener" wanted to with-draw from the world. When he's asked to do something, he always responds, "I would prefer not to." But it was in France that boredom became a literary genre.

There, people born around 1800 were called the *enfants du siècle*, the children of the century. They had missed all the excitement of the French Revolution and Napoleon and lived in an unromantic age. Nothing of interest had been left for them, and like Julien Sorel, they bitterly resented this. When we first see him, in Stendhal's *The Red and the Black*, he's perched on a rafter, hiding from his father and reading about Napoleon. A friend berates him for seeming sad. That's not *bon ton*, explains the friend. It shows that you've failed at something, that you're inferior. Instead, you must seem bored. That way you show that you're superior to people who try to please you.[3]

The sense that time was out of joint gave boredom a new name: the *mal du siècle* – the illness of the century. After the eighteenth century's robust Enlightenment certitudes had proven false, after religious faith was lost, its sufferers felt an emptiness and aristocratic melancholy. Then the illness crossed the channel and infected English writers. In *The Picture of Dorian Gray*, Oscar Wilde's eponymous hero chances to come across a copy of that breviary of fin-de-siècle decadence, *The Yellow Book*. In it he reads a novel without a plot, about a young nineteenth-century Parisian aesthete, Jean des Essseintes, who dedicates himself to a life of the senses that shuts out the world. The book was *Against Nature*, Joris-Karl Huysmans's *À Rebours*.[4]

Huysmans's little book describes how, after tiring of lov-ers and prostitutes, Des Esseintes retires from the world to cultivate his sensibilities. He had experienced whatever Paris

had to offer, and travel was pointless since his imagination could summon up the same sensations that the vulgar world of actual experience could supply. He plans a trip to Britain, buys a guidebook, and from novels recalls his impressions of London's mud and soot. The packet boat across the channel, the fog of London, the steak and kidney pie, the Stilton cheese, the taste of Guinness – he brought all that to mind and, having done so, saved himself the trip.

Nature had had its day, and what remained was the pursuit of inner sensory experience. Ugliness would cause Des Esseintes physical pain, but colors artfully arranged and sumptuously chosen would enthrall him. For each liqueur in his cabinet he conceived a musical sound, with crème de menthe as the flute, kirsch as the trumpet, whisky as the trombone, and Bénédictine as a minor and Chartreuse a major key; and for his private pleasure he'd sip a little of each and compose silent melodies. "One hardly knew at times whether one was reading the spiritual ecstasies of some mediaeval saint or the morbid confessions of a modern sinner," said Dorian Gray. "It was a poisonous book."[5] It was a grand refusal to whatever the world might offer and to any form of curiosity.

The contempt for the vileness of ordinary life, the morbid love of excess, where could that lead but to a bullet in the brain – or what was equally drastic, a visit to the Jesuits at Farm Street and reception into the Catholic Church? That was the path taken by many of the British fin-de-siècle aesthetes, people such Ernest Dowson, Aubrey Beardsley, and Lionel Johnson. William Butler Yeats visited Johnson at 5:00 P.M. but found that he never rose before 7:00 and would spend the rest of the night reading the Church Fathers, writing, and drinking. "As for living," he said, "our

servants will do that for us."[6] He carried on brilliant conversations with Cardinal Newman and the famous men of his time, but all of these were imaginary. He is thought to have died from a fall from a bar stool.

The erotic drawings of Aubrey Beardsley enjoyed a vogue in the 1960s. They were elegant, sensual, and merciless, finely drawn black figures against a sea of white. Oscar Wilde ridiculed Beardsley, but one day the young artist brought the older man some of his drawings. "Aubrey, I have made a mistake," said Wilde. "You are a great artist." At that, the high-strung Beardsley burst into tears.[7]

Beardsley was a recluse. Alone with his drawings, he shut out the world. He hated walking outside and when in Dieppe refused to look at the sea. He liked large, deserted rooms when no one was there and was almost friendless. Before dying of consumption in 1898 he converted to Catholicism and, on his deathbed, wrote his publisher:

> *Jesus is our Lord and Judge*
> *I implore you to destroy all copies of Lysistrata and bad*
> *drawings.*
> *By all that is holy all obscene drawings*
> *Aubrey Beardsley*
> *– In my death agony*[8]

He was not yet twenty-six.

Wilde himself died two years later. "If I were to survive into the twentieth century it would be more than the English people can bear," he wrote. When he was released from Reading jail, some old friends visited him and were surprised to find him as chipper as ever. He appeared with a flower in his buttonhole, talking and laughing, looking better than he

had when he went to prison two years before, thanks to its treadmill. From jail he had written to Farm Street to ask whether he might retire there. But as his friends waited, the reply came from the Jesuits. They had turned him down flat. At this Wilde broke down and wept bitterly.[9] On his deathbed, however, he was visited by a priest and received Extreme Unction.[10]

Huysmans also repented of his ways and rejoined the Church. Twenty years after *À Rebours* first appeared, he wrote a new preface in which he confessed that religious conversion was the only solution to his book's diabolical perversity. He had wearied of mundane pleasures and was no longer curious about anything save the desire and pursuit of the whole, whether in art or in God.

There was a logic to this. Like Pascal, whom he greatly admired, Huysmans had come to the end of the road. If this world offered nothing of interest, only the next world mattered. Between the man who had renounced diversions and the jaded aesthete, there was the same affinity that Charles Péguy described when he wrote that "the sinner is at the very heart of Christianity. Nobody is so competent as the sinner in matters of Christianity. Nobody, except the saint."[11]

That's fine if you're a saint. But for everyone else, the aesthete's incuriosity is a dead end.

You're Probably Not Called to the Contemplative Life

The contemplative opens himself to divine love and shuts out everything except the adoration of God. That demands a complete lack of curiosity about the world, but the contemplative tells us that his *vita contemplativa* is superior to a

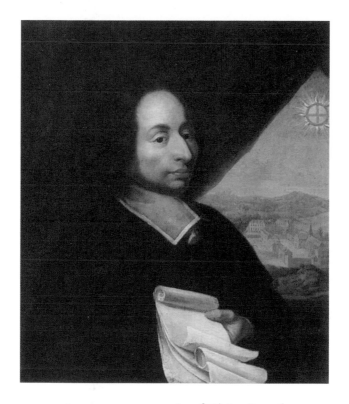

Anonymous portrait of Blaise Pascal.
In the background, Port-Royal-des-Champs.

Source: Wikimedia Commons.

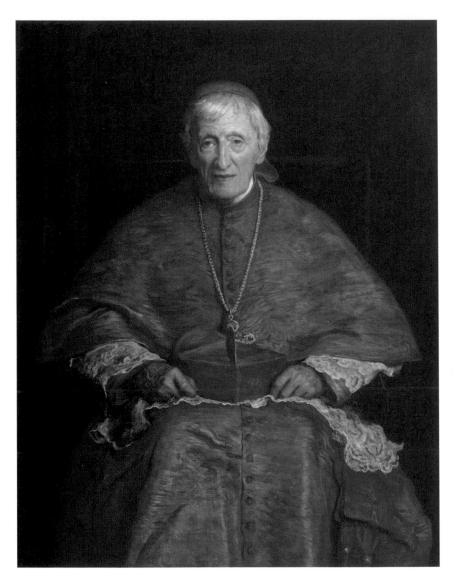

"Come, jump up, you dear old boy."
John Everett Millais, *Cardinal Newman*, 1881.
Source: Wikimedia Commons. *Credit:* National Portrait Gallery.

Upper Choir, Basilica of St. Denis.

"A remarkable likeness of Lord Strafford de Redcliffe."
William Holman Hunt, *The Scapegoat*, 1854.

"The Christ child was a hideous boy in a night-gown."
John Everett Millais, *Christ in the House of His Parents*, 1849 50.
Source: Wikimedia Commons. *Credit:* Tate Britain.

Aubrey Beardsley, *Lysistrata*, 1896.
Source: Wikimedia Commons. *Credit:* Victoria & Albert Museum.

"There is only one serious philosophical problem,
and that is suicide." Albert Camus, 1957.

Georges de la Tour, *Joseph the Carpenter* (detail), 1642.
Source: Wikimedia Commons. Credit: Musée du Louvre.

vita activa.[12] Perhaps so. But his search for a personal relationship with God excludes the world around him, and no one is more incurious.

The Trappist monk Thomas Keating is a famous modern contemplative. In his "centering prayer" he asks his readers to bring themselves to the center of their being, where they will experience the presence of God who indwells within them. In his cell, with nothing but a bed, desk, and chair, his shoes and laundry bag, Keating would close his eyes and focus on a single sacred word, clearing his head of all other thoughts and embracing silence. When other thoughts impinged, he would gently return to the sacred word.[13]

The most famous contemplative in history was Thomas a Kempis, a fifteenth-century monk whose *The Imitation of Christ* has been translated into fifty languages and is often thought the most influential Christian devotional book after the Bible. In *Against Nature*, even Des Esseintes praised its message about withdrawing from the world. In my boarding school, it was read in the refectory as we fought over meals of Spam.

Kempis was born in Germany around 1380 and, when he was eighteen, joined an order devoted to the teachings of St. Augustine. It preached humility and the primacy of faith over reason, in opposition to St. Thomas Aquinas's intellectualized belief and his incorporation of Aristotelian philosophy into Catholicism. In the following centuries, the order's followers included the Augustinian friar Martin Luther and the Augustinian-inspired Jansenists.

Kempis preached that intellectual pursuits were snares that led one away from the desire to imitate Christ. All that is required of us is faith and a sincere life, and curiosity can be a dangerous distraction. A simple and humble inquiry

into God's commandments is allowable, but that doesn't require a study of Thomas Aquinas or Aristotle. "What will it avail thee to dispute learnedly about the Trinity if thou lack humility and thus displease the Trinity?... I had rather feel contrition than know the definition thereof."[14]

Christ Himself praised the contemplative life and its superiority to mundane concerns. He came to Martha's house with His disciples, but while she busied herself serving her guests, her sister Mary didn't help. She just sat at Christ's feet and adored Him. This irked Martha, who asked Christ to tell Mary to get off her duff. But while Christ praised Martha for her work, He told her that Mary had chosen the better part.[15]

Well, yes, but one can still feel some sympathy for poor Martha. She works her fingers to the bone, and that's all the thanks she gets? J. F. Powers's *Morte D'Urban*, winner of the 1963 National Book Award, is a story about another Martha. Father Urban is the ultimate clerical fixer, a gifted glad-hander and fund-raiser for the Order of St. Clement. But compared to with-it orders like the Dalmatians, the Clementines are a sad lot. If they stood out at all, it was for their habit, which lacked pockets, since St. Clement had thought that pockets, not money, were the root of all evil. And then, after a humdrum executive meeting, Urban is unexpectedly told that he's been elected the order's new provincial.

Those who elected him, the younger members of the order, thought that their day had come, that the money would now start rolling in, that there'd be a new radio god in town to rival Bishop Fulton J. Sheen. They're quickly disappointed, however, because Father Urban has become shy and retiring. His big donor has turned out to be a rat, and after being struck on the head by a golf ball he has persistent, crippling

headaches. He stays in his room and doesn't want to meet visitors. The *Morte D'Urban* is his death to the world and withdrawal to an incurious and holier internal life.

Or to the Stoic One Either

Stoicism was a sophisticated philosophy in classical Greece and Rome whose followers believed in the nobility of a virtuous life. As a corollary, they preached that any punishment meted out for following the path of virtue, and indeed all misfortunes whatever, should be met with indifference. As stoicism is understood today, however, the first meaning is forgotten and only the corollary remembered.

The stoic is the athlete who plays through pain, uncomplaining. He is the businessman who picks himself up after a financial crash. He is Conrad Hensley in Tom Wolfe's *A Man in Full.* Hensley loses his job and ends up in jail, where he's mistakenly sent a book of sayings by Epictetus, a second-century Stoic. From the book Hensley learns to be serene and confident in the face of the worst that life throws at him.

What upsets us, wrote Epictetus, are not the things that happen so much as how we react to them. But since we can't shape outside events, there's no point in being troubled by them. We should concern ourselves only with the practice of virtue and pay no attention to things we can't control. As our passions (*patheia*) are the source of our unhappiness, the best life is one without passion (*apatheia*). "Never say about anything, 'I have lost it,'" said Epictetus, "but only 'I have given it back.' Is your child dead? It has been given back. Is your wife dead? She has been given back."[16]

In game theory, that's called a min–max strategy: choose

your preferences so as to *min*imize your worst case (*maxi*-mum loss) scenario. But if that's how to react to the worst case, it also tells you to invest less emotion in the good things before the worst case happens. If you can bear the loss of your wife so easily, how much did you care about her when she was alive? It's no accident that *apatheia* became the word *apathy* in English. At a higher level, the Stoic sage might even reach the stage of *ataraxia*, or pure mental equanimity and tranquility, where he is superior to and devoid of all passions.

That's obviously not conducive to curiosity. If it's all a matter of indifference, there isn't much point finding out about things. But then there aren't many stoics around, people who are prepared to suck things up. In an age of microaggressions and lawsuits for hurt feelings, when we're incapable of tolerating differences in opinion, there's seldom been a time when people bruise quite so easily.

DON'T BE SMUG

SMUG, SELF-SATISFIED people aren't curious about what they ought to do. They don't feel the need, because they're sure they're right. They don't have to think about how they might have wounded other people, and they don't have to examine their own motives. And so they glide happily along, in the eternal sunshine of the spotless mind. Except they're really spotted, as we all are, and with greater curiosity they'd see this and live better lives.

Moral people are curious people, about others, about themselves. They'll remember all the mean and ignoble things they've managed to suppress. What's even harder to remember are the sins of omission – not the things we've done but the things we should have done.

Be You Perfect

Few moral teachings are so deeply embedded in Western culture, or so conspicuously ignored, as Christ's Sermon on

the Mount.[1] We remember the Beatitudes and too easily imagine that they promise us a future payoff. Blessed are the merciful, for they shall obtain mercy. Blessed are the peacemakers, for they shall be called children of God. It's all too easy to think that this describes us. The problem is that the rest of the sermon was a warning against smugness. It was a call to live an impossibly saintly life. Love your enemies. If someone strikes on the right cheek, turn the other cheek. Be you perfect, even as your Heavenly Father is perfect.

Christ offered the same counsel of perfection to the rich young man who wondered whether he should do anything more than follow the commandments. Indeed, yes, said Christ. If you want to be perfect, sell all you own and give to the poor, then come and follow Me.[2] No wonder the disciples were dismayed. Who, then, can be saved? they asked.

Churchmen tried to make sense of this by distinguishing between two kinds of acts. First, there are things we ought to do because we are required to do them. That comes down to following the Ten Commandments and the less precise imperatives of a moral life: to be unselfish, fair-minded, kind, and so on. Second, there are things on top of these, things we're not required to do that go beyond the call of duty but are still good to do. This was called supererogatory virtue, from that which is above (*super*) what is due (*erogare*).

Thomas Aquinas gave an example of supererogatory virtue in a comment about the famine-stricken city of Rhodes. A ship laden with grain arrives, and because people are starving, the captain can sell the food at a very high price. He knows that other ships, loaded with grain, will arrive tomorrow, but he doesn't tell the Rhodians this. If he did, they wouldn't pay those high prices; they'd wait one extra day. Is

the ship captain legally obliged to share his information? Cicero thought yes, but Aquinas disagreed. He defended what amounted to insider trading. In market transactions, a seller doesn't have to disclose what he knows. All the same, if he did, "it would be exceedingly virtuous on his part."[3]

E. M. Forster made the same distinction in *Howards End* (1910), contrasting the repellant Henry Wilcox to the more curious and morally aware Margaret Schlegel. While not positively immoral, Wilcox is brutish, condescending to women, and indifferent to what might be asked of him apart from a narrowly conceived sense of legal duty. Nevertheless, Margaret decides to marry him and make him a better man. But she soon recognizes that she can't make him morally curious. "He simply did not notice things, and there was no more to be said."[4] We're all a bit like Wilcox and carry on our business without thinking overmuch about counsels of perfection.

Whatever his failings, Wilcox epitomizes a worldly wise *vita activa*. He knows where the deals are, which company is about to go belly-up, what to order at Simpson's-in-the-Strand, and how to tip the carver. To moral questions, he brings a lawyer's clarity and also his limitations. By contrast, Margaret understands morality's necessary messiness:

Life's very difficult and full of surprises. At all events I've got as far as that. To be humble, to be kind, to go straight ahead, to love people rather than pity them, to remember the submerged — well, one can't do all these things at once, worse luck, because they're so contradictory. It's then that proportion comes in — to live by proportion. Don't begin with proportion. Only prigs do that. Let proportion come in as a last resort, when the better things have failed, and a deadlock.[5]

Indefinable yet accessible, supple and not circumscribed, Margaret's code reveals the sense of curiosity that is the mark of a conscientious person who tries, as best as any of us can, to be perfect.

Is Incuriosity the Root of All Evil?

There's a YouTube video that illustrates how our minds can fool us. It's called the "hollow mask illusion," and it shows a Halloween mask facing us. The mask is then rotated on its axis, so that we come to see the hollow back side of the mask. The front side is convex and pointed outward. The back side is concave and pointed inward. But when the face is rotated, we perceive both sides as convex and facing us. Our minds are playing a trick on us.

We see what our minds process us to see. We have a mental bias toward convexity and see the hollow side of the mask facing toward us. In the same way, signs of other people's distress are like concave images that we process away. They ask a response from us, and that's too upsetting to be faced. We don't recognize a plea for help; we turn away from the homeless person on the street. The idea that we might be asked to do something to help them is simply too painful. And so we're led to become morally incurious. It's more like a mental than a moral lapse.

But then every moral lapse might be a mental one. That's what Socrates thought. In the *Protagoras*, he argued that, although there is evil in the world, one never consciously chooses to do wrong. Knowledge "will not allow a man, if only he knows the good and the evil, to do anything which is contrary to what his knowledge bids him do."[6] When you

know what's good for you, that's just what you'll do, and when you see someone doing something wrong, he's really trying to do good and simply doesn't know that it's bad for him. Wrongful behavior is always an intellectual error. So ignorance is the root of all evil and is cured by curiosity about the good.

The classic example of this was Mary Beth Whitehead's change of heart in the *Baby M* litigation of thirty years ago. Mrs. Whitehead agreed to be artificially inseminated for a fee of ten thousand dollars in a surrogacy contract which specified that she would give up the child at birth to a child-less professional couple. She entered into the contract knowing just what she was doing. She wanted the money, and she also wanted to give the other couple "the gift of life." She did not think she would regret her decision. But when the child was born, Mrs. Whitehead was a very different person. She realized she could not part with her child. She surrendered it but soon became suicidal. She received permission to see the child and fled with it a thousand miles away, where she lived in hiding until the police found her three months later. Had she known how she'd feel after the child was born, she would never have entered into the surrogacy contract.

No man is so different from another as he is from himself, from one time to another, said Pascal.[7]

What Socrates was denying was the possibility that we might know what's good for us but fail to act on it because we're weak willed. We might be problem drinkers, binge eaters, or drug users. We might be the child whose preferences are all in the present and the prodigal son for whom the spendthrift trust was invented. We know we're choosing badly but lack the strength of will to stop ourselves. That's a fault. But it's not an intellectual error that curiosity might

have cured. Rational choice has nothing to do with it, because the impetuous person's impulses kick in too quickly for his reason to intercede.[8] Socrates didn't agree. People who are weak willed are simply ignorant about their own good, he thought. They prefer short-term gains to greater long-term losses, and that's an error in calculation.

We don't have to decide whether Socrates was right. But if he was, and if ignorance about the good is the root of all evil, the remedy is more curiosity. And even if he were wrong, we'd be morally improved with a greater curiosity about where we go wrong.

How the Self-Deceived Are Incurious

"Nothing is so difficult as not deceiving oneself," said Ludwig Wittgenstein.[9] Not that that's always a bad thing. The only people with an accurate notion of what others think of them are the clinically depressed, and that's not a way to live. Better to believe that you're well liked and respected, if the goal is to get out of bed in the morning. Then there's scrupulosity, where we think we're worse than we really are, and that's also a form of self-deception, one to which Wittgenstein was prone.

Mostly, however, self-deception hides from us our vices, not our virtues, and that looks like a double sin. The fault is a wrong in itself, and it's an even greater wrong when the incurious person fails to recognize it in himself. From Pascal to the present, that's been a favorite theme of French moralists.

The greatest novel on the subject is Albert Camus's *The Fall* (*La chute*). Jean-Baptiste Clamance hangs about an

Amsterdam dive to tell strangers of his sins and man's fall. He had been a highly successful defense lawyer, perfectly pleased with himself and entirely in harmony with life. He defended widows and orphans without fee and preened in his moral superiority. But then one day, walking on a bridge, he sees a slim young woman leaning over the railing. He passes her by but, fifty yards later, hears the sound of a body striking the water. He stops and from the river hears a cry, repeated three times. He knows he is called on to save her but remains motionless. Then, slowly, he walks away. He tries to put it out of his mind, but the incident stays with him, and in time he comes to realize that all his pretended virtues were really vices. "Modesty helped me to shine, humility to conquer, and virtue to oppress."[10]

Unless you see something of yourself in Clamance, you've missed the point. For each one of us, there's a person we were meant to rescue and whom we failed to save.[11] We might see ourselves as essentially decent people, but with more curiosity, we'd look more closely and recall some of the less pleasant things we've done. The French essayist Michel de Montaigne held himself to a mirror and reported that

every sort of contradiction can be found in me, depending on some twist or attribute: timid, insolent; chaste, lecherous; talkative, taciturn; tough, sickly; clever, dull; brooding, affable; lying, truthful; learned, ignorant; generous, miserly and then prodigal.[12]

We're a bit of a mess, neither wholly good nor bad, and we can't pick and choose only the good stuff and pretend that that's our nature.

There's a good bit of self-deception around, where we're in error about ourselves. We indulge in wishful thinking and

believe something is true when it's really not. The husband thinks that his wife always loved him best, only to learn otherwise in James Joyce's *The Dead* and John Ford's *The Man Who Shot Liberty Valance.* Similarly, a person might know what he's done but fail to recognize that everyone else faults him for it. We're all heroes of our own private movie, but it screens to an audience of one.

With self-delusion, we too easily think ourselves virtuous. We're all guilty of that, and the people with the greatest sense of self-worth are often the nastiest people we know. That's what Pascal thought. "There are only two kinds of men," he wrote. "The just who think themselves sinners and the sinners who think themselves just."[13]

DON'T OVERREACH

I F YOU'RE NOT HAPPY about the way things are, it wasn't always so bad. Our first age was golden, wrote Ovid, and then we lived in peace and didn't have to work. The earth gave us all the food we needed, and we feasted on rivers of milk and nectar. But that ended, and what succeeded were painful new ages, of silver and bronze, and finally a hard age of iron when all was wickedness, fraud, and covetousness. Piety lay prostrate, stepmothers poisoned their children, and the earth dripped with slaughter.

In *Works and Days*, Hesiod explained what had happened. It was a woman, Pandora, who did it. When Prometheus stole the fire from the gods to give it to man, Zeus was angered and vowed revenge. He ordered Hephaistos to fashion a woman, beautiful as a goddess, out of clay. Athena dressed her and taught her how to weave, Aphrodite gave her all her charms, and the Graces adorned her with golden necklaces. When they were finished, they named her Pandora, meaning "the gift of all things."

Hermes brought her to the brother of Prometheus. With her came a jar, which Prometheus said must be kept closed. But, being curious, Pandora opened the lid, and all the evils of the world quickly flew out. She tried to close it, but it was too late, and they could not be recaptured. So if we must break our backs in labor and fall prey to disease, blame Pandora's curiosity.

The point of the story, like that of Eve in the Bible, is that curiosity should sometimes be resisted, that knowledge isn't always good for us. There are good and bad risks. Before indulging our curiosity, we need to look for warning signs that tell us to stay away. Don't overreach, when this looks like presumption or hubris. And don't be a voyeur and look at things you're not supposed to see.

Don't Be Presumptuous

In his best-known essay Albert Camus compared man's fate to that of Sisyphus, the Greek hero who had displeased the gods and whom they condemned to perform a laborious and pointless task. Perhaps Sisyphus had it coming to him, however. He had ratted on Zeus, who ordered Death to chain him to a rock. But, craftiest of men, Sisyphus asked Death to show him how the chains worked, and when he did so, Sisyphus trapped him in them. Then, when Sisyphus was about to die, he told his wife not to perform the funeral rites. That way, when he got to Hades, he'd persuade the gods to release him in order to have someone perform the rites for him. And that's what happened. Except that, once back on earth, Sisyphus refused to return to Hades. The gods had finally had enough, and as a punishment for his

impiety and many tricks, he was condemned to roll a heavy ball up a hill, only to have it roll back down when he got to the top, and to repeat this forever.

Sisyphus displeased the gods through his presumption, by dealing with them as though they were his equals. Prometheus had done the same, in stealing the fire of the gods and giving it to man. Sisyphus was duly punished, and Zeus had Prometheus chained to a rock for all time, with an eagle eating his liver.

Those are terrible punishments, given that presumption was a lesser offense in Greek mythology. It's more or less what you'd have expected, when the gods so often interfered in human affairs, for example, by softening the heart of Achilles when he refused to perform the funeral rites for Hector. There was also upward mobility, when mere humans were permitted to marry a goddess, as Sisyphus did in wedding the Pleiad Merope. You're bound to get ideas when your father-in-law is Atlas and your sister-in-law is Calypso. Prometheus himself was a demi-god, a Titan, and Zeus's escapades with women like Leda were the scandal of Olympus. Not surprisingly, the Greeks weren't very upset when a mortal tricked the gods. Odysseus had done so on a regular basis.

Presumption is quite a different matter in the Judeo-Christian tradition, which takes divinity more seriously. God is not mocked, says the Bible,[1] and anyone who laughs at Him gets a quick comeuppance. That's what happened when He told the hundred-year-old Abraham and the ninety-year-old Sarah that they would have a son. Hearing this, Sarah laughed. "After I am grown old and my lord is an old man, shall I give myself to pleasure?" But God wasn't about to let this go and asked Abraham why Sarah had laughed. Afraid of displeasing God, Sarah denied she had done so,

but God answered, "Nay: but thou didst laugh."² When
someone laughs at you, you remember it.

Presumption has a special meaning in Christianity. It's
the sin of cheap grace, of assuming that one will be saved
without having to keep the commandments, and that's an
unforgiveable sin. It's also the sin of rebelling against God,
of presuming an equality with Him, as Satan had done.
"How you are fallen from heaven, O Lucifer," wrote Isaiah.

> *Thou saidst in thy heart,*
> *I will ascend to heaven;*
> *I will exalt my throne above the stars of God*
> *I will sit in the mountain of the covenant, in the sides*
> *of the north*
> *I will ascend above the height of the clouds*
> *I will be like the most high.*
> *But yet thou shalt be brought down to hell,*
> *Into the depth of the pit.*³

Satan doesn't stay in hell, of course. He tempts Christ in
the desert and enters a fiddle contest in Georgia. In the
book of Job, God asks him where he's been, and Satan
answers, "From going to and fro in the earth, and from
walking up and down in it."⁴ He gets around.

He was there in Eden, at the Fall. God had placed Adam
in a paradise of pleasure, with "all manner of trees, fair to
behold, and pleasant to eat of: the tree of life also in the
midst of paradise: and the tree of knowledge of good and
evil."⁵ He and Eve were permitted to eat the fruit of the first
tree, which would give them health and immortality, but not
of the second tree. "For in what day soever thou shalt eat of
it, thou shalt die the death."⁶ The knowledge of good and

evil was forbidden them. In the Judeo-Christian tradition, presumption is a sin of curiosity, of wanting to know too much.

But why was that wrong? Shouldn't we want to know the difference between right and wrong? If we wanted to be adults, we'd want to leave the world of innocence. So why did God punish Adam and Eve?

There are three possible answers. First, God doesn't have to explain Himself to us. That's what a Jansenist like Pascal would tell you, and that was the message about theodicy – the God and evil problem – in the book of Job. God permits Satan to visit evil upon the blameless Job to test his faith. And so his servant brings Job the message that his children have been killed and his cattle destroyed. Job himself is covered with sores. He refuses to curse God, but still asks Him why He permitted this to happen. In answer, God emerges from out of a whirlwind to tell Job that he lacks standing to question his Creator. "Wilt thou also disannul my judgment? Wilt thou condemn me, that thou mayest be righteous?"[7] If Adam and Eve were forbidden to eat from the tree, it's enough that God commanded this.

Second, the order was a ban on presumption. It was Satan's sin when he rebelled, and it was how, in the form of a crafty serpent, he tempted Eve. Eat of the tree, he said, and "your eyes shall be opened: and you shall be as Gods, knowing good and evil."[8] And when she ate the apple, Eve was presumptuous, as Sisyphus, Prometheus, and Satan himself had been. For this, Adam and Eve could be blamed, even before they knew about good and evil. In their state of innocence, one wrong was still possible, and that was the wrong of presumption.

It's the third answer that is the most interesting. If the

serpent could tempt Eve, that's because she was created as a curious being, one who could be tempted. The instinct of curiosity was there first, before the Fall. We might have remained in the garden had God created an incurious Eve. But would anyone have wanted an ancestor without the spark of curiosity? Man is a curious animal, and we wouldn't want it otherwise, even knowing we'd be expelled from the garden. Curiosity is a *felix culpa*, a happy fault.[9]

We're a questioning animal, with a spark of rebellion. The Greeks made a hero of Prometheus because he took man's side against the gods, and the Modern Prometheus (the subtitle of Mary Shelly's *Frankenstein*) pushes back against superstition for the betterment of man. In the Jewish Bible, Sarah laughs at God and Abraham bargains with Him over the destruction of Sodom, but God makes of them the founders of His chosen people. He enters into a covenant – really a contract – with them, as thought they were His equals and not people to be ordered around. He made them in His image, and we're to infer that He wanted something better from them than childlike innocence. He wanted us to be curious. As He was about us.

All the same, there are limits to where we should let our curiosity lead us. William Wordsworth said that nature never betrayed the heart that loved her, but taking this literally can get you in trouble. Nature is indifferent to our fate and can have nasty surprises in store for the excessively curious. If we needed a reminder, filmmaker Werner Herzog provided it in his 2005 documentary *Grizzly Man*.

The film tells the story of Timothy Treadwell, an environmentalist with romantic ideas about the most dangerous bears in the forest. He and his girlfriend chose to live among grizzlies in Alaska and approached them with food. The

animals had their own ideas about dinner, however. A bear ate both of them, and their semi-digested remains were found afterward, along with a horrifying film of the attack from Treadwell's camera. As he discovered, wanting to know too much can be foolishly dangerous.

Avoid Hubris

Satan rebelled against God, and Adam and Eve disobeyed His command. Hubris is a lesser offense and takes the form of aiming too high, of wanting to do or know more than we should. That was the story of the Tower of Babel. Once man learned how to make bricks, he began to build. And what the builders in Shinar had in mind was not Georgian cross-halls but rather a tower "the top whereof may reach to Heaven." God had other ideas, however. The builders spoke a single language, and to confound their plan, God made them speak different languages so they couldn't understand each other.

The biblical warning about hubris used to be taken as a ban on buildings higher than nearby church steeples. In New York, for example, the tallest structure for many years was Trinity Church at the foot of Wall Street. Then, in 1890, a taller skyscraper was built near City Hall to house the *New York World*, and Edward Glaeser calls this "the true start of the irreligious 20th century."[10] Soon other skyscrapers followed, symbols of American materialism, towers built "up to the sun, brick and rivet and lime."[11] That's why the World Trade Center, a few blocks from Trinity Church, must have seemed a fitting target for the 9/11 terrorists.

At Shinar, the builders' curiosity got them in trouble. Curiosity can do that to you, if you want to know more

than you should, and that was the message in several Alfred Hitchcock movies. In *The 39 Steps*, a music hall artist, Mr. Memory, astounds his audiences with his amazing feats of memory. He's really employed by the 39 Steps, a group of spies who want to sneak a secret British military formula out of the country and give it to a hostile foreign power. Mr. Memory is given the task of memorizing the formula, but before he can leave England he appears onstage to ask the audience to stump him with a question. In the audience is our hero Richard Hannay (Ronald Coleman), who asks him, "What are the 39 Steps?" Realizing that their plot is blown, one of the spies shoots Mr. Memory. He was *The Man Who Knew Too Much*, the title of two other Hitchcock films.

That was also the theme of Christopher Marlowe's *Tragical History of Doctor Faustus*. Having learned everything there is to know about philosophy, medicine, and law, and repelled by the Bible, Faustus's curiosity leads him to black magic. He wants to know too much. His Good Angel pleads with him to save his soul, but his Bad Angel beguiles him with the promise of godlike powers. So Faustus summons up the devil, with whom he barters his soul in exchange for the devil's service. For twenty-four years he has a good run, meeting Helen of Troy, mocking the pope, but when his time is up, he is dragged away to hell for wanting to know "more than heavenly power permits."

That was a common theme in the Middle Ages. In the seventeenth century, however, scientific learning gained a new respectability.[12] Francis Bacon had argued that received truths should be tested empirically, a challenge the Royal Society soon took up, and Pascal and Isaac Newton showed how the new learning could coexist with the deepest religious beliefs. But that didn't put paid to the offense of hubris.

Sometimes there have been false starts, like the alche-
mists who sought to turn lead into gold. We're apt to mock
them, but Giordano Bruno was one of their number (though
he was burned at the stake for something else). Isaac New-
ton was also an alchemist, and when John Maynard Keynes
acquired a large number of Newton's papers, he found them
full of alchemical experiments. "Newton was not the first of
the age of reason," concluded Keynes. "He was the last of the
magicians."[13] Keynes, of course, knew that the experiments
wouldn't work. But then, you never know unless you try,
and when German scientists discovered nuclear fission in
1938, we learned that one element could in fact be trans-
formed into another, when uranium is bombarded with neu-
trons. That was a more dangerous discovery.

Nuclear fission releases enormous amounts of energy,
and when American scientists learned of the discovery, they
realized that it could be employed to make nuclear weapons.
The Germans had pioneered fission. Could they also be
working on a nuclear bomb? In August 1939, Albert Einstein
wrote to President Roosevelt to warn him of a possible Ger-
man bomb and to urge that the government back a nuclear
weapons program. FDR gave this his OK, and by the end of
the war the Manhattan Project (as it was called) employed
130,000 people and cost thirty billion in today's dollars.
A new city was built at Oak Ridge, Tennessee, where scien-
tists enriched uranium to produce weapons-grade U235,
while the bomb itself was designed in Los Alamos, New
Mexico. The atomic age began on July 16, 1945, when the
first bomb was successfully tested at Alamogordo, New
Mexico. A few weeks later, two atomic bombs were dropped
on Japan, killing 350,000 civilians in Hiroshima and Naga-
saki. Japan surrendered six days after the second bomb.

To head up the Los Alamos Laboratory, the government appointed J. Robert Oppenheimer. Born to a wealthy New York family in 1904, Oppenheimer had the most privileged of upbringings. His parents rented the eleventh floor of 155 Riverside Drive, overlooking the Hudson River, and adorned the apartment with a Renoir, a Picasso, and three Van Goghs. Their son attended Harvard and, after graduating, studied with Ernest Rutherford at the Cavendish Laboratory and with Max Born in Germany. At twenty-three he received a PhD from the University of Göttingen and, returning to the United States, took up a joint appointment at Harvard and Caltech.

He had the self-assurance that comes from being the smartest person in the room. At age nine he asked a cousin to ask him a question in Latin, to show he could answer in Greek. To read the *Bhagavad Gita* in the original, he taught himself Sanskrit. He wrote poetry, loved the metaphysical poets, and chose "Trinity" as the code name for the first atomic blast from Donne's Holy Sonnet XIV ("Batter my heart, three person'd God"). Awaiting the test explosion at Alamogordo, he brought out a copy of Charles Baudelaire's *Fleurs du mal* and began to read it.[14]

He cast off ideas like sparks from a Fourth of July sparkler, and his ability to synthesize what others thought and point toward answers made others shy. But a close friend in high school sensed in him the hubris that bears the seeds of its own destruction.[15] The gods had punished Prometheus, and Oppenheimer would be punished too, though the wound was largely self-inflicted.

The Los Alamos scientists didn't have any qualms about building the bomb when they thought that they were in a race with Werner Heisenberg and the scientists of the Third

Reich. But when Germany was defeated, and the war with Japan continued, the moral questions were less clear. On one hand, bombing Japan might cut short the war and save many thousands of American lives. On the other hand, the Japanese really didn't have an atomic program themselves, and many thought they might surrender if they saw a demonstration of the bomb before it was dropped on a civilian target. Still, when the bombs were dropped and Japan surrendered, there was a vast wave of relief. Most newspapers in the West expressed their joy over the war's end. But not Camus. In *Combat*, he wrote that a mechanical civilization had arrived at the ultimate degree of savagery.[16]

Despite his increasing concerns about an arms race and nuclear war, Oppenheimer stayed with the program to the end of the war. But by October 1945 he'd told President Truman that he felt he had blood on his hands. Years later, when asked how he felt when the bomb was first tested, he reached back to the *Bhagavad Gita* and, in a voice of infinite sadness, recalled Vishnu's words: "Now I am become death, the destroyer of worlds."[17]

When the war was over, and Oppenheimer was revealed to be the chief scientist behind the atomic bomb, he became a celebrity. His face was on the cover of *Time*, and *Scientific American* opined that "modern Prometheans have raided Mount Olympus again and have brought back for man the very thunderbolts of Zeus."[18] But the Trinity project was almost Oppenheimer's last foray in the world of science.[19] From physics he turned to politics and, as a Washington insider, became a founding member of Big Science, along with people like Vannevar Bush and James Conant. Like them, and like Camus, he wished to see a regime of international

control over atomic energy.[20] But those hopes were dashed when the United States and Russia began their arms race after the war.

Oppenheimer was anything but a pacifist but nevertheless refused to join physicist Edward Teller in building a hydrogen bomb. Teller thought his bomb could produce an explosion equal to one hundred million tons of TNT and wipe out three thousand square miles.[21] Oppenheimer didn't think a bomb that size was feasible, and in any event, he didn't want to take part in what he thought amounted to genocide.[22]

Teller was right about the H-bomb's destructive power. On its first test, it entirely vaporized Elugelab Island in the Pacific. The blast was eight hundred to one thousand times more powerful than Hiroshima and lifted eighty million tons of earth and seabed into the air, to be deposited as fallout all over the world. The fireball from the blast was three miles wide, and the heat from it was felt thirty miles away.[23] Look for the island today on Google Maps, and all you'll find is a crater a mile in diameter.

In the 1930s Oppenheimer had joined every communist front group he could find, and Teller thought that his colleague's refusal to join in the H-bomb project was colored by his politics. He told J. Edgar Hoover's FBI that a lot of people thought that Oppenheimer was taking orders from Moscow,[24] and with tips like that the FBI thought they had another Soviet spy on their hands. They tapped Oppenheimer's phone, bugged his house, and collected thousands of pages of raw data about his fellow-traveling past and his personal life. Matters came to a head in 1954 when a hearing was held to strip Oppenheimer of his security clearance. Oppenheimer had hoped that people would recognize his

basic loyalty, but instead he was devastatingly cross-examined by the hearing's counsel, Roger Robb, and his failings painfully exposed. When the hearing was over, Oppenheimer's clearance was revoked.

What doomed Oppenheimer was the supercilious manner in which, ten years earlier, he had lied to a security officer, Lieutenant Colonel Boris Pash, whom he considered his inferior. Pash had asked Oppenheimer about possible Russian agents who had approached him, which Oppenheimer covered up with what he described as a cock-and-bull story. That led to the following exchange with Robb:

ROBB: *Did you tell Pash the truth about this thing?*
OPPENHEIMER: *No.*
ROBB: *You lied to him?*
OPPENHEIMER: *Yes.*

When asked why he had lied again and again, Oppenheimer answered, "Because I was an idiot."[25] During the ordeal, he sat hunched over, wringing his hands and looking white as a sheet. When it was over, Robb said he felt sick himself. "I've just seen a man destroy himself," he told his wife.[26] Afterward, Oppenheimer was a broken man. His hair turned white, and he lost all his former high spirits and liveliness.

The Los Alamos scientists had discovered the hidden secrets of the atom, but in the process they created bombs that could wipe out mankind. So far, we've managed to avoid a nuclear conflagration, but Oppenheimer still paid for his hubris. His curiosity had made him one of the most eminent scientists and thinkers of his day, but taken too far, curiosity tempts God, nature, or man to punish our arrogance.

Don't Play Forbidden Games

The greatest movie on the subject of curiosity is François Truffaut's *Jules et Jim* (1962). It's also the greatest film of all time, a lot of people will tell you.

Jules and Jim meet in Paris in 1912 and become the closest of friends. Jules is Austrian, docile, and shy. Jim is French, adventurous, and the alpha of the pair. They share a passion for literature and the arts and a love for the same woman, Catherine. They first glimpse her face in a slide show of sculptures from an Adriatic island, a statue of a woman with brilliant eyes and a calm and voluptuous smile. Thunderstruck, the two leave immediately to see it for themselves and, once there, gaze upon it for an hour. "Had they ever seen such a smile? Never! And if they did? They'd follow it."

Soon after, Jules arranges a dinner for Jim and three women. One of them is Catherine, who has the statue's face and smile. Jules senses that everything has changed. The friends have traded and shared their girlfriends, "but not this one, Jim. OK?" Catherine is closer in spirit to Jim but is won over by Jules's tenderness and agrees to marry him.

The two men join their respective armies in the First World War, and when it is over, Jim travels to Germany to see Jules and Catherine. Jim is now a foreign correspondent tasked with reporting how Germany is faring postwar. Jules is a botanist who is writing a book about dragonflies. One day, he thinks, he might become literary and write a love story – except that all the characters would be insects. Jules recognizes his tendency to overspecialize:

Jules: *I envy your versatility, Jim.*
Jim: *Oh me, I'm a failure. What little I know I owe to my professor, Albert Sorel. "What do you want to become?" he asked me. A diplomat. "Do you have a great fortune?" No. "Could you, with some appearance of legitimacy, add to your name a more celebrated or illustrious name?" No. "Then forget about diplomacy." What can I become, then? "Curious." That's not a career. "That's not yet a career. Travel, write, translate. Learn to live anywhere. Begin immediately. The future belongs to those who choose curiosity as a profession. The French have spent too long ignoring the rest of the world. You'll always find a newspaper to pay for your escapades."*

Like Jim, Catherine is curious. She needs adventure and risk. The world is rich, she thinks. One can sometimes cheat a little. In her case, satisfying her curiosity means taking lovers, and one of them wants to take her from Jules, with whom she no longer sleeps. For his part, Jules can accept the lovers but not the possibility that Catherine might leave him. He tells this to Jim, whom he permits to become Catherine's lover so long as he is permitted to remain with them.

The three embark willingly on their experiment. There are too many rules, says Catherine, and we need to start over at zero and rediscover them. Jim agrees. Jules doesn't quite but is prepared to follow where they lead. And for a while their lives are idyllic. The Promised Land is in view. And then the Promised Land rebounds away. Jim and Catherine want to have a child but fail. Jim continues to see his French mistress when in Paris, and Catherine seeks revenge with her lovers.

There are limits to where curiosity might take us. It's fine

to want to rediscover the laws for human life, thinks Jim, but it's more practical to conform to the existing ones. We played with the sources of human life. We met them in armed combat, lost, and now roll in their waves.[27] At the movie's end, Catherine is rejected by Jim and kills both of them by driving off a bridge. Jules has them cremated and interred in Père Lachaise cemetery. Catherine had wanted her ashes spread to the wind from a high hill, but it was not permitted. Conventional morality had exacted its revenge on an excessive curiosity.

Truffaut's film won over an audience of boomers who, like Catherine, wanted to start over again from zero. Germaine Greer said that "it was an instant hit with girls like me, francophile, penniless and non-monogamous."[28] For film critic Pauline Kael the movie was a statement about modern feminism. Catherine was a bit mad, but she was also "part of a new breed – the independent, intellectual modern woman, so determined to live as freely as a man that while claiming equality she uses every feminine wile to gain extra advantages, to demonstrate her superiority, and to increase her power-position."[29]

The film encouraged the boomers' forbidden games, the infidelities and the drugs. Like their generation's poet, Leonard Cohen, they searched for transcendent epiphanies and looked for the card that is so high and wild they'd never need to deal another. But they failed to recognize the film's message about the lessons of the heart and the impossibility of reinventing sexual morality, until they returned to the established rules of marriage, children, and mortgages – those, at least, who were still able to do so.

Don't Look at Forbidden Things

Michael Powell was one of Britain's greatest filmmakers. With his codirector Emeric Pressburger, he gave us such classics as *One of Our Aircraft Is Missing* (1942), *A Canterbury Tale* (1944), and *A Matter of Life and Death* (1946). And then, in 1960, his career was effectively over. He had produced and directed a film about a voyeur called *Peeping Tom*, a critical success but a movie that filled audiences with revulsion.

The voyeur sees things he wasn't meant to see. It usually doesn't end well. King David looked on Bathsheba by chance, when she was bathing. She was beautiful, and he had her brought to him and then polished off her husband by sending him into battle to be killed (2 Samuel 11:2–17). For his sins, the prophet Nathan rebuked him, and the Lord punished him. Another voyeur, Actaeon, fared worse still. While hunting, he happened to see Artemis (the Roman Diana) as she bathed. She saw him and told him that if he spoke again, he'd be turned into a deer. But then he saw his dogs and called out to them and was immediately transformed into a deer. He ran into the forest, but his dogs chased him and tore him to pieces.

Even regular news is often Page Six voyeurism today. Some of it is innocent. The doings of Kim Kardashian are an amusing diversion, and no one gets hurt, least of all Kardashian. If you've been on a reality show, you're not trying to hide things. But it's different when embarrassing failings are exposed for no better reason than to satisfy our taste for voyeurism. Boris Johnson had a row with his girlfriend, and

a neighbor taped the yelling and called the cops. They told the neighbor no one had been harmed, but he still relayed the information to an anti-Johnson newspaper. The neighbor explained that he felt he needed to share things. Afterward, however, he complained about people who called him a rat. "I would ask that you leave private citizens alone," he said.[30]

We're especially curious about the seamy side of life, public rows, marital scandals, and executions. Sometimes we try to veil this. The United States is one of the very few highly developed countries to retain capital punishment, but we've banned public executions – the last one was in 1936.

The ban requires an explanation. Some think public executions would be cruel to the condemned man. Others, who oppose the death penalty, would welcome public executions. If we could watch them, they say, we'd want to abolish capital punishment. That's not been our experience, however. At the 1936 execution, some twenty thousand people showed up in little Owensboro, Kentucky, to witness it, and there were hanging parties the night before. While the body was still dangling on the rope, the crowd swarmed over it and tore off the hood.[31] If public executions are banned, it's not because they'd upset people; rather, it's because we're too curious and would enjoy them too much. And that would degrade us. Some curiosities are ignoble.

Don't Let the Police Get Too Curious

Our personal spaces have been shrunken by the internet. Do a web search for sneakers, and soon you'll find Nike ads popping up on Facebook. Look for a book on Amazon, and you'll get suggestions about similar books to buy. That can

be annoying, but it's nothing like the loss of privacy when the state can spy on us. The policeman's curiosity can be carried too far.

Philosopher Jeremy Bentham (1747–1832) didn't think much of privacy, or at least didn't think that prisoners in jail deserved any. He designed a prison in which a single guard might observe hundreds of prisoners, in what he called an all-seeing "panopticon." The jail would be constructed in a circle, with each cell facing the guard at the very center, so that he could see each prisoner at a glance. He couldn't see them all at once, since he'd have to turn around, but they knew they could be observed at any time.

The panopticon has become famous as a metaphor for the intrusiveness of the state in modern society. In *Discipline and Punish*, philosopher Michel Foucault (1926–84) argued that, like Bentham's devilish prison, modern society creates a docile citizenry through its schools, factories, and military. That overstates things, but modern technology points toward forms of social control that Foucault could not have imagined. Today, ubiquitous closed-circuit TV cameras are used by police to see who's been at a crime scene. The District of Columbia has 540 CCTV cameras at street corners, to catch people who run red lights and satisfy the city's rapacious desire for traffic fines. But they're also spying on hundreds of thousands of ordinary drivers and pedestrians. That's a remarkable loss of privacy, but it's nothing compared to London's five hundred thousand cameras or the more than four million across the United Kingdom.

The American Civil Liberties Union reports on how camera surveillance has been abused. In Michigan, rogue cops used the information to stalk women and track estranged spouses. In Washington, D.C., a top-ranking cop found out

who was frequenting a gay club and tried to blackmail its married patrons. But it's really in China where the curiosity of the police and public officials tramples on personal and political liberty.

There are six hundred million CCTV cameras in China, about one camera for every two citizens. They exchange real-time information with government databases, and with the assistance of the country's sophisticated facial recognition software, China expects to be able to identify everyone, everywhere, within three seconds of anything happening. The degree of control over people's lives exceeds that of any country at any time – more than the panopticon, more even than George Orwell imagined in his dystopian *1984*.

China is curious about its citizens. It has created a "social credit system" that ranks people according to good and bad behavior. Bad behavior includes reckless driving, buying too many video games, and putting your trash in the wrong garbage bin. It also includes criticism of the Communist Party. The sanctions for bad behavior show how deep the techniques of control can be in a modern totalitarian state. People with low social credit scores are publicly shamed. Their internet speeds are reduced, they're denied good jobs, and they're banned from air or train travel. Their children are kept out of prestige schools, and their dogs can be taken from them.

I fear governments that are so curious.

CHAPTER TWELVE

REALIZE YOU'RE KNOCKING
ON HEAVEN'S DOOR

W E BOOMERS have not been a popular generation with those who came before and those who came after us. In the 1960s, our elders called us hippies and thought we were spoiled brats. They've passed on, that Greatest Generation, and today the millennials and zoomers complain that we cling to our jobs and won't make room for them, except as unpaid interns. They say we've saddled them with massive government debt loads and with educational loans that have made them debt slaves. In the contest among generations, we grabbed all the swag for ourselves and left little for the next generation. And what was especially resented was how, throughout, we took ownership of the spirit of the age – the *Zeitgeist*.

In the 1960s we were a youth movement that demanded to be heard, that marched on the Pentagon, that occupied campus administration buildings. Then, in the 1970s, we

mellowed, with the Band and the Eagles, and read Charles Reich's *The Greening of America*. In the 1980s we rebounded as yuppies. We became investment bankers and M&A lawyers and elected Ronald Reagan. Thereafter we ascended to political power, not always wisely, truth be told. But we ushered in a civil rights revolution for minorities and women and left an indelible mark on all succeeding generations.

Now, having dictated the fashionable trends, the beliefs that everyone is supposed to have, for the last fifty years, we'll have one last crack at defining our culture. And what we'll impart is a curiosity about death. Until now, we've seen it as something that happens to other people. As for ourselves, thoughts of death are veiled by the distractions, the plenitude of modernity. Our emails, apps, and internet addictions absorb us, and even our language shies away from the fact of death. We say that another person has "passed," as though he's wandered into another room. The French say that a person has "disappeared," as though it's a big game of hide-and-seek. As for our own death, we imagine it's like a big sleep. But it's not like that at all. Instead, we're going to be annihilated.

Do you have some treasured possession? A string of pearls? The watch your father gave you? Imagine how you'd feel if a thief had stolen it. But the greatest of thieves is Death, for he'll rob you of everything.

Have you broken things you'd like to fix? A lamp? A relationship? Yourself? There will be no waking up after you die, no chance to fix the things you've broken. "The last act is bloody," wrote Pascal. "We die, we're covered with earth, and that's it forever."[1] Unless, for better or for worse, there's an afterlife.

We've seen Facebook accounts go dark and old friends

and lovers go the way of all flesh, and we're beginning to realize that the same thing will happen to us. As that thought hits home, we'll start thinking about the Four Last Things: Death, Judgment, Heaven, and Hell. We'll forget our political causes and remember our lies, betrayals, and general meanness. And even as we've always insisted that what we think is what everyone should think, I await a curiosity about what happens upon death and a new religious awakening. And that will be my generation's final gift to the *Zeitgeist*. After the sex and drugs and rock 'n' roll, after experiencing every old vice and inventing a few new ones, only one thing remains, and that is a religious revival and a return to conventional morality. It's happened before, when the children of England's Regency rakes invented the Victorian Age, and there is no reason to think it can't happen again.

Be Curious about Death

There isn't much point being Catholic if you've not learned what sex has to do with death, and in school we'd connect the two with a story about how a couple had faced the Four Last Things. They were making out in the back seat of a car when it was struck by a semi. One moment they're having sex, the next moment they're before a Heavenly Judge, and a moment thereafter they're in hell. For all eternity.

And what's that like? In case you missed Guillermo del Toro's *Hellboy*, or weren't reminded by Hieronymus Bosch's *The Garden of Earthly Delights*, there's the Hellfire Sermon in James Joyce's *A Portrait of the Artist as a Young Man*. With a mortal sin on his soul, Stephen Dedalus attends a retreat at his Jesuit school, where he's told what would await him if

he were to die that night. Sent to hell, he'd be there alone, on burning coals, separated forever from anyone who ever cared for him, surrounded by vile fiends in a vast, stinking sewer. "The blood seethes and boils in the veins, the heart in the breast glowing and bursting, the bowels in a redhot mass of burning pulp, the tender eyes flaming like molten balls."[2] And if you're an Irish Catholic like Stephen, you'll probably think you deserve it.

Sermons like that can make you morbidly curious about sin and death. For Blaise Pascal, it made earthly diversions seem trivial, compared to a different kind of curiosity about heaven and hell. Nothing irritated him more than people who pass their lives without wondering what would happen to them in eternity. To him, they seemed like monsters of incuriosity.[3]

Incurious or not, we are forced to choose, said Pascal. We must either believe in God or not. You say that you're agnostic, that you don't know whether to believe or not? That's already a choice.[4] You must necessarily take sides, he said, and this is what made him required reading for existentialists, the post–Second World War intellectual movement identified with Camus. After the collaborators, after the people who had sat things out during the Occupation, the existentialists insisted on the primacy of making choices.

The problem is the uncertainty about our fate. Pascal saw salvation as very nearly a lottery. If you died with a mortal sin on your soul, like the teenagers making out in the car (and he was an altar boy too!), you were necessarily consigned to hell. Or you might get lucky and die in a state of grace, immediately after obtaining absolution for your sins and receiving Communion, and that's a ticket to paradise. That's what happened to Pascal, but it's also what happened

to notorious sinners such as the "Merry Monarch," Charles II.

Charles died in 1685, bled so much by his doctors that he bled out. Before dying, he asked his brother to be kind to his mistress, Nell Gwyn. "Let not poor Nelly starve." But he had also asked a priest to administer the last rites of the church. He had God's own luck, like the man in *Camden's Remains* who died on a fall from his horse and who, on the way down, asked for forgiveness. "Between the stirrup and the ground, I mercy sought, I mercy found."

Luck is another word for *grace*. If you're lucky, thought Pascal, God will favor you. He favored Charles, but not the teenagers in the car. It was all up to Him. He can choose when we'll die and whom He wants to save. It's like Anton Chigurh's coin toss in Cormac McCarthy's *No Country for Old Men*. Call it correctly, and you get to live. And you have to call it. In the Coen Brothers film, Chigurh tells the store-owner to flip a coin:

CHIGURH: *You need to call it. I can't call it for you. It wouldn't be fair. It wouldn't even be right.*
STOREOWNER: *I didn't put nothin' up.*
CHIGURH: *Yes you did. You been putting it up your whole life. You just didn't know it. You know what date is on this coin?*
STOREOWNER: *No.*
CHIGURH: *Nineteen fifty-eight. It's been traveling twenty-two years to get here. And now it's here. And it's either heads or tails, and you have to say. Call it.*

Pascal and the Jansenists thought that God's grace is indeterminate, like the coin toss. We don't earn our way into heaven by our good works, and we can't even perform a morally good act without an infusion of grace, which He

awards to some and denies to others. And when He decides
to grant His grace, we are powerless to resist it. So it all
comes down to His choice.[3]

It's like our choices about whom to befriend. You might
know of a perfectly decent person, kind, gentle, a totally
good egg. And you're not obliged to like him. So, too, with
God, in His decision about whom to "justify" and admit to
heaven.

You might not like that. You might think that by virtue
of your admirable political views, you've earned your way
into heaven, if there is a heaven. Or you might think you're
so noble that God is required to justify you. But what makes
you think you have a vote in the matter?

If Pascal were right, God might show his grace not only
to the just but also to "justified sinners" like Charles II or
Oscar Wilde. Similarly, God might deny His grace to the
"unjustified saint," the person who has lived his life accord-
ing to the dictates of the highest moral code but who is
nevertheless denied salvation. She is Jean Racine's *Phèdre*,
whose sin of loving her stepson was compelled by the gods
and not a moral flaw. He's also Scobie in Graham Greene's
The Heart of the Matter, a Catholic who commits suicide
knowing that he will be damned for it but believing in the
circumstances that sacrificing his soul is the most moral
thing he can do.

Some think that Jansenism is inconsistent with the idea
of a loving God. They're wrong. Rather, it's inconsistent
with the idea that God is bound to love *you*. You might be a
perfect little saint, but he still might not care for you. That's
what you get if, as Leszek Kolakowski put it, *God Owes You
Nothing*.[6] And that's what Pascal believed. "Men are saved or
damned, according to whether it pleased God to choose

them to give them this grace, from amongst the corrupt mass of men, who with justice He might have all abandoned."[7] All is grace.[8]

Jansenists like Pascal saw the religious and ethical realms as entirely distinct. As a theological movement, the Jansenists were crushed in the late seventeenth century by Louis XIV and a succession of popes. That only drove the movement underground, however, and given Pascal's place in French culture, Jansenism could never disappear, and with film directors such as Robert Bresson (*Au hazard balthasar*) and Eric Rohmer (*My Night at Maud's*), it remains an important element in what it means to be French. In North America, Jansenism's moral message, its condemnation of moral laxity and belief in our essential sinfulness and unworthiness, defined the Church until well into the 1960s, and you'll find it today in *No Country for Old Men*. As long as we have Cormac McCarthy's sense of underserved fate, which is to say, of tragedy, Jansenism will always be with us.

Be Curious about Life

Tony Judt called Albert Camus the Pascalian of our time.[9] Camus was deeply influenced by Pascal, whom he thought the greatest of French thinkers. Pascal overwhelms me, he said, but added that "I am not converted."[10] If Pascal was curious about death, Camus would be curious about life.

Both men were obsessed with the idea of death and grace. But unlike Pascal, Camus took man's side against God. All those people denied grace, he asked, what happens to them? Pascal thought that a child who dies without being baptized would not be saved, and Camus could not accept

this. "We need to take account of what Christianity had ignored: the claims of the damned." That, he said, would be the key to all his writings.[11]

Camus' best-known essay, "The Myth of Sisyphus," begins "there is only one really serious philosophical problem, and that is suicide."[12] In Catholic teaching, that's an unforgiveable sin. Suicides are damned, and Camus would take their side. Yes, but what makes suicide a philosophical problem? Today we'd call it a psychological one. Or a religious one. Hamlet rejected suicide only when he wondered what would happen after death, that undiscovered country. ("Ay, there's the rub.") So where does philosophy come in? Camus's answer was to turn things around. It's not suicide that's the problem; rather, it's the decision to stay alive in an absurd world that for him was without intrinsic meaning.

Maybe things are always a little absurd, but nothing could have prepared Camus for the fall of France in 1940. It was bad enough to see the *feldgrau* uniforms in his favorite cafés, but worse still was the way his heroes so readily adapted to German rule. One of them was André Gide (1869–1951), liberal, ironic, gay, and generally thought the greatest French author of the last century. But during the Occupation, even Gide found himself able to come to terms with totalitarianism. In 1941 he employed a gardening metaphor to explain how, crude as they were, there was something to be said for the Nazis. "Have you noticed, at times when you were gardening, that the only way for preserving, protecting and safeguarding what is exquisite, what is best, was to suppress what is less good? You know this cannot happen without giving the impression of cruelty, but that this cruelty is prudence."[13] As for Hitler, "we might reproach him for the means he employed for Germany's recovery, we

might be indignant about his cruel and iniquitous summary trials … but without them could he have gotten the stupefying results that have made him the master of the actual situation?"[14] André Gide, *hélas.*

We are apt to think that, during the Occupation, Paris was a city under siege, that people lived furtive and miserable lives. And so it was, if one was Jewish. For others, and especially the intellectuals, it was very nearly *la vie en rose*, the place to be. Paris in 1942, the year Camus's *The Stranger* was published, was the city of Gide (Nobel Prize, 1947), François Mauriac (Nobel Prize, 1952), Camus (Nobel Prize, 1957), Jean-Paul Sartre (Nobel Prize, 1964), and Jean Anouilh (shortlisted for a 1962 Nobel). It was the city of comfortable conformists and outright collaborators, people such as Jean Cocteau (Académie Française), Henri de Montherlant (Académie Française), Louis-Ferdinand Céline, Jean Giraudoux, and Colette. In painting, Picasso, Henri Matisse, André Derain, and Georges Braque; in film, Arletty ("my heart is French but my ass is international"), Sacha Guitry, and Jean Marais; in music, Arthur Honegger, Maurice Chevalier, Edith Piaf, and Tino Rossi; in psychiatry, Jacques Lacan; in dance, Serge Lifar; in haute couture, Coco Chanel. Paris, plausibly, not bombed-out London, not even New York with all its emigrés, was the center of Western culture.

Then there was the presence of death, felt everywhere at the time. Camus wrote "The Myth of Sisyphus" in exile. He had moved from French Algeria to Paris in March 1940, two months before it fell to the Germans. To escape them, he fled south, along with two or three million of his compatriots, with the manuscript of *The Stranger* in the car's trunk. The next day, the Germans marched down the Champs-Élysées. In a time of war and national humiliation, death

and the release offered by suicide were on the minds of many Frenchmen.

Many of Camus's compatriots carried little packets of sedatives with which to kill themselves. Walter Benjamin was one of them. He had moved to Paris when the Nazis seized power in Germany and, like Camus, fled south when Paris fell. He arrived at the Spanish border, but the Guardia refused to admit him and told him they'd send him back to France. When they came for him the next morning, he was dead.[15]

Camus himself was ill. He was tubercular, and his illness seemed to him a death sentence. His notebooks were full of tales of how people had faced death, bravely, or at least with indifference. He told of a woman who had lived in a flat upstairs from him. She seemed friendless and would sometimes ask the concierge to invite her in for supper, for what little warmth this would offer. Finally, she threw herself off her balcony, and her last words were, "At last!"[16] The desire to kill himself never quite left Camus.[17]

As a student, Camus wrote a thesis about St. Augustine, his countryman who had also found death a troubling philosophical problem. When he was young, and before his conversion to Catholicism, Augustine had had a close friend of his own age. When his friend was ill, Augustine stayed by his side, but when Augustine left him for a few days, the fever returned, and he died. Augustine was plunged into a deep depression and, in mourning his friend, struggled to understand death. "I had become to myself a vast problem."[18] Paul Landsberg said that Augustine's encounter with mortality, and his inability to find an explanation for death, represented the birth of existentialism.[19]

Like St. Augustine and Pascal, Camus struggled to under-

stand the fact of death, and his novel *The Fall* told a story to make the point. A little Frenchman sent to Buchenwald approaches the Nazi clerk with a complaint. He's not supposed to be there, he says. The clerk laughs. "But you see, sir," says the little man, "my case is exceptional. I am innocent."[20]

We know the man will die. So will we all, no exceptions – even though, like the Frenchman, we don't understand why. We are mere passers-by in the floating opera, tourists in the Airbnb of life, taking up a little space between the eternity before we were born and the one after we die. We are like Sisyphus, he said, condemned by the gods to repeat a laborious and pointless task, over and over again, forever. Pascal's idea of the human condition was no better. "Let us imagine a number of men in chains, and all condemned to death, with some of these men having their throats cut every day in sight of their fellows, and that those who remain recognize their own fate in that of their companions and, as they wait their turn, staring at each other full of sadness and without hope."[21] And can you explain why any of this should be?

Despite this, Camus said that Sisyphus enjoyed the drudgery. That might seem puzzling, but you'll find an explanation in the Bible's puzzling story about the angel who fought with Jacob. The angel came to him when he was alone, and the two wrestled all night long. In the morning Jacob saw he could not win.[22] In Delacroix's painting, Jacob struggles furiously, but the angel resists him effortlessly and seems to dance sensually with him. The encounter was meant to buck up Jacob's courage when he later met Esau, but at the same time it revealed his helplessness when matched against God and His angels.

Struggling with an angel might seem impious as well as hopeless. Nevertheless, the Bible praises Jacob for doing so.

When it's over, the angel tells him that his name will hence-forth be "Israel," meaning "contends with God." Even against impossible odds, struggling is a positive good, for only a struggle can bring us the joy for which we all search in life. Joy, not happiness, is the ultimate desideratum.

Camus wrote that Sisyplus was *heureux*. That's usually translated as "happy," but I think he meant "joyful." Happiness is a passive state of contentment. It's not even experienced in the present so much as remembered at a future time. We don't say, "I am happy," but we might recall an earlier time when we were happy. We remember how, years before, we schlepped our child around from school to music lessons and think, "Yes, I was happy then." But at the time, what we were thinking about was how to beat the traffic.

To the extent that we're content, we're incurious. When social scientists measure happiness levels, they ask people to report on their sense of well-being. They're asked, "overall how satisfied are you with your life these days?" measured on a scale of 0 to 10.[23] But if you're satisfied, you don't go forth in search of something new. You have all you need, and there might even be something a little contemptible about your happiness. Baudelaire knew the type. "I am sorry for you," he said to one of them. "You are so easily satisfied."[24] By contrast, the search for joy implies a struggle, a *vita activa* and a curiosity about new experiences.

Joy is as different from contentment as a laugh is from a smile. The satisfaction of an appetite might bring us pleasure but not heart-cleansing joy. Simple contentment is a minimal goal: it plays it safe; and a life spent in the pursuit of contentment is banal. But the quest for joy is heroic: it takes risks. It is willing to give offense, to court a rebuff, to play with fire, like Pascal's night of fire.

As a young man, Pascal had been a perfunctory Catholic, but when he was older, he experienced an ecstatic encounter with God, "in the year of grace, 1654, Monday 23 November, from about half past ten in the evening till past midnight." He described this in a memorial that he sewed into his clothes and that was discovered only on his death. He had written "FIRE" across the top of the page, and then "Joy, joy, joy, tears of joy."

Neither Pascal nor Camus saw much of intrinsic value in what the world had to offer. But while Pascal was curious about what happens after death, Camus was curious about what happens before death. In what he fancied was an absurd world, life could still be lived nobly and joyously, and we'd deprive ourselves of this by suicide. Being aware of the meaninglessness of life and nevertheless enjoying it is to revolt, and the revolt gives life its value. To revolt is to shake your fist at fate. You know you must perish, and yet you refuse to accept this as just.

Camus thought that the struggle to extract joy from life is living, indeed, living to the maximum. Before the war he had enjoyed a happy, hedonistic existence, playing football and sunning himself at the beach. During the Occupation he was an active member of the Resistance and the editor-in-chief of *Combat*, the underground Resistance newspaper. After the war he began a cycle of "Promethean" works exalting man's revolt and became the face of Left Bank French existentialism, arguing with Jean-Paul Sartre at the Café Flore and carrying on affairs with pretty young actresses. He had the *vita activa* of which a generation of young men dreamed, and when he died, at age forty-four in a car crash, it was the kind of death for which the intensely romantic yearn.

Camus and Pascal were both on to something. Camus

was right about the importance of making choices, and Pascal was right about why we need to do so. The problem isn't suicide. Instead, it's why we're impelled to get out and do something, anything. Sometimes the choices are heroic, sometimes not. But in either case we're a curious animal and itch to do something, whatever may come of it, and the enjoyment comes from scratching. What we can't stand is being bored.

The really serious philosophical problem isn't suicide. It's boredom and its antidote, curiosity, and what they tell us about life.

THE INCURIOUS

INCURIOSITY ISN'T the same thing as boredom. It's more like the exact opposite. By definition, boredom is unsatisfying and prompts a desire to escape to a more exciting world. However, some people don't seem to feel the twitch of boredom, and these are the incurious. Sometimes they've simply trained themselves to specialize in their narrow domain. Others, like the religious contemplative, have given up on new experiences and ideas. Incuriosity might be a genetic trait. And then sometimes we'd all like to escape from an over-bright or too-loud world.

The Specialist

If you want to get ahead, it makes sense to burrow down and specialize. You'll have to narrow your scope, and that's what Max Weber told a group of would-be scientists. If you want to be well known, you have to dedicate yourself to

your subject. "We know of no great artist who has ever done anything other than devote himself to his art and to that alone."[1] And by implication, be incurious about anything else. The pianist Glenn Gould agreed. A famous eccentric and a recluse, Gould denied that he was antisocial; rather, "if an artist wants to use his mind for creative work then self-discipline, in the form of cutting oneself off from society, is a necessary thing."[2]

Malcolm Gladwell even made a mathematical rule of this. If you want to be really good at something, you have to spend ten thousand hours at it. It's not just brains or height; it's paying your dues to your profession, putting in the hours in practice or as an apprentice. For most of us, that's seven or ten years of work dedicated to mastering a particular skill, be it the violin, securities law, or junior-level hockey. There are no shortcuts, no royal roads, just slogging away longer and harder than anyone else, if you want to be a star. It's why freshly minted lawyers are required to bill eighty hours a week as associates at big law firms. Gladwell even showed how his rule predicted that children born in the early months of the year were more likely to make it to the NHL. Among thirteen-year-olds, the child born in January will be bigger and stronger than one born in December, because he'll be ten months older. He'll therefore get more ice time, and the extra practice will carry over when he's fifteen and pay off for the rest of his career.

Physicians know this as the Dunning–Kruger effect. As an intern, the newly qualified MD assumes direct responsibility for his patients, and that's an intimidating experience. But he soon becomes comfortable with this and is excessively self-confident. With a little more experience, however, he comes to recognize how much he has to learn, and his

self-confidence craters. Only after years of further study and experience, including eighty-hour workweeks in the hospital during residency, does his confidence return – this time well earned.

The Socratic notion that the wisest man recognizes his own ignorance, and that self-confidence comes only after we've paid our homage to our craft, is a familiar one. With years on the job, we master our subject and are comfortable at it. We begin to fly at cruising speed. We enter into what psychologist Mihály Csikszentmihályi calls the "flow," the zone where we're oblivious to time, where the drummer is in the pocket, the essay writes itself, and the clay tugs at the sculptor's knife. It was simply a matter of putting in the hours, specializing in one thing and shutting other things out. That was how Whistler charged for his paintings: not for the time it took him to paint something but for the knowledge gained over a lifetime.

It's a question of balance. On one hand, there's such a thing as overspecialization, where you shut out the rest of the world and become a bore. That's an occupational hazard for academics like Richard Porson (1759–1808), a classics don who had the habit of chasing students around with a poker if they didn't know their Horace.[3] His learning isolated him from his colleagues, however. He would listen to them for a while in silence and then pounce on them with his terrible memory. With nonclassicists, he had little time for the social niceties. One evening, two visitors arrived at his room and announced they had come to see him. Porson said nothing but ordered that two candles be brought. When they arrived, he said, "Now then, gentlemen, you will see me better." For the incurious pedant, there's little to be gained from talking to other people.

That's one extreme. The other is the person who refuses to specialize and tries to know everything. His breadth of interest is admirable, but he's apt to end up as a dilletante who gets nothing done, who's a jack-of-all-trades and a master of none. Too much curiosity might even be the sign of an impending crack-up, as it was for Major Ben Marco (Frank Sinatra) in *The Manchurian Candidate* (1962). He had been brainwashed, and now he's having nightmares about his repressed memories. Sitting alone, in a room full of books, disheveled and drinking, he's visited by his superior officer. My God, where did you get all the books? he's asked. I have a guy pick them out for me, at random, Marco answers. "I'm just interested, you know [picking up books], in *Principles of Modern Banking,* the *History of Piracy, Paintings of Orozco, Modern French Theatre, The Jurisprudential Factor of Mafia Administration,* the novels of Joyce Cary, *Ethnic Choices of the Arabs.* Things like that." His superior fixes Marco with a stare and promptly orders him on indefinite sick leave.

I saw *The Manchurian Candidate* when it was first released and loved that reading list. That's the kind of person I want to be, I thought, with interests as broad as that. I hated the idea that I might have to focus on a single topic. And so I flitted from one topic to another, trying each in turn. That's how teenagers are. As I grew older, however, I began to focus on only a few things. When you're a grown-up, Marco's reading list is a sign that you don't have an integrated personality and are about to fall apart. It's nice to have broad interests, but there's such a thing as too much curiosity.

Could Major Marco really have been interested in all those books? More likely, he wasn't. When something interests you, you follow it up. You pick a topic, like piracy, and you read whatever you can find about it – famous pirates,

privateering, the law and economics of piracy, *Treasure Island*. That's where real curiosity leads you, and along the way you give up on modern banking. Marco wasn't really curious. He was simply bored and needed a spell of sick leave.

So there's a *juste milieu*, between curiosity about your particular calling and curiosity about the world beyond that. That's not a surprise. Most everything is a question of a *juste milieu*. Except perfection.

Legal Blinders

Lawyers are supposed to be methodical, studious, and careful, not creative. Same thing with accountants. A creative bookkeeper is the guy who's going to put you in jail. So lawyers and accountants tend to be incurious. Somehow the medical profession seems to have overcome this. Oliver Goldsmith, Tobias Smollett, John Keats, Anton Chekov, and Somerset Maugham were all doctors. And whom do we lawyers have? John Grisham. We're trained to use words but not to care about other people the way doctors do. Perhaps that's what made the difference.

There's something else. Doctors are asked to stay on top of new developments through their medical journals. My father, I regret to say, was somewhat lax about this and thought that there were few illnesses that couldn't be cured by a neat little amputation. He was old school. We lawyers are also old school, or at least are asked to adhere to precedents, to wear blinders. It's called *stare decisis*, which means that courts should consider themselves bound by their past decisions. Since there's nothing new under the sun, anything that comes up today is bound to have been the subject

of past litigation, and *stare decisis* is therefore an injunction against innovation. In the words of F.M. Cornford's *Microcosmographia Academica* (1908), nothing should ever be done for the first time.

Where courts innovate, they'll typically try to cover their tracks by distinguishing inconvenient prior decisions or by extracting an encompassing principle from disparate and apparently unconnected cases. That is how the smartest of judges, Lord Denning in Britain or Skelly Wright in the United States, discovered a general principle of bargaining unfairness (unconscionability) from what seemed like stray bits of jurisprudential DNA, cases on expectant heirs and rescue at sea. Less sophisticated judges simply make up new law out of whole cloth.

In either case, it's the innovators who are hailed as judicial heroes. Those who stand in the way of reform are mocked as mechanical "formalists" who fail to recognize the indeterminacy of common law rules as well as their hidden ideological biases. The formalists had thought that their rules were politically neutral and derived from abstract and reasonable principles, but left-wing scholars, such as Morton Horowitz and Duncan Kennedy, charged that they were arbitrary and had simply favored a rising capitalist class.

Horowitz and Kennedy taught at Harvard Law School when I was there, but I didn't notice them. Nor did many other students. Among the brilliant minds on the faculty, they didn't stand out. But occasionally, I'd hear about an exciting young professor, scarcely older than we were. "He talks about love in class!" a friend exclaimed. The teacher was Roberto Unger, and he told his students that legal systems were to be judged according to how they fostered self-liberation and empathy for others.

It was easy for law students to sympathize with Unger, or to heed the call from Horowitz and Kennedy to junk formal legal rules. Those old rules were often confusingly arcane, and the formalists who adhered to them seemed like obtuse stick-in-the-muds when compared to teachers who invited you to remake the world. But the rule of law assumes that a distinction should be drawn between law and politics, and if the anti-formalists were right, it would be all politics, all the time – and the uncertainty this would create would impose a cost on bargainers who expect that their contracts will be enforced and on businessmen who rely on our laws and regulations.

Incurious though they are, the formalists at least defend the rule of law. There are worse things than being a bore.

The Acedic

Next comes acedia, from the Greek *akedia*, the person who is without *kedia* or "care." As a distinct vice, acedia was first identified in the fourth century by the desert monks, and it meant something like boredom. It nearly made it onto the list of the Seven Deadly Sins and then was merged with sadness (*tristitia*) by Saint Gregory the Great and finally dropped for sloth.[4]

The monks didn't invent boredom, of course. There was never a time when people weren't bored, and it was a favorite theme for the classical writers of antiquity. People will gad about from one idle pursuit to another, from one town to another, wrote Seneca, simply to avoid the *taedium vitae*, the tedium of life. What the monks added was something new, however: the idea that boredom was a sinful distraction

from the incurious, contemplative lives to which they had dedicated themselves.

The desert monks blamed acedia on the *dæmon meridianus*, the noonday devil who whispers to the monk that his life of prayer and contemplation is pointless and futile. Here you are, says the Evil One, alone in your cell, without fellow monks, while outside the whole world beckons. So tempted, the monk steps out to see the sun, which at noon seems not to move, and wonders whether time has stood still. Will it never be time for dinner? he asks himself. In his spiritual dryness, prayer is impossible, and he is wholly without resources. He sinks into despair and hopeless unbelief.

John Cassian, born around A.D. 360, lived for a time with the desert monks and described how acedia works. It makes a monk

disgusted with his cell, and also disdainful and contemptuous of the brother who live with him or at a slight distance, as if being careless and unspiritual. Likewise it renders him slothful and immobile in the face of all the work to be done within the walls of his dwelling: It does not allow him to stay still in his cell or to devote any effort to reading. . . . Next he glances anxiously here and there and sighs that none of his brothers is coming to see him.[5]

The desert monks lived without prescribed rituals and with precious little food, in communities forty to sixty miles south of Alexandria. Each had a separate hut, set apart from the others, and they shared worship only on Saturdays and Sundays. Apart from that, they lived in silence, alone and often in oppressive heat. Little wonder that this bred boredom, resentment, despair, and a desire to chuck it in. Fat chance we'd put up with it. Instead, we'd harken to the

voice that tells us to pack it up, and if that voice had a name, it would be "Curiosity" and not the "Noonday Devil."

We don't hear much of monkish acedia today, and there aren't many monks around. But it's as if, said Chateaubriand, when the Revolution suppressed the monasteries, threw down their walls, and expelled the monks from their cells, it didn't destroy acedia; rather, the monks took it with them and it spread like the plague to society at large, to the *enfants du siècle* and the jaded aesthetes. Under names like *alienation*, it became for Marxists the way in which the modern economy had replaced the craftsman who had owned the product of his labor with a proletariat that was nothing more than an appendage of the capitalist's machinery. It was also the inability to feel pleasure that travels under the name of *anhedonia* (the original title of Woody Allen's *Annie Hall*). For Camus, acedia was the way in which *The Stranger's* Meursault was disconnected from life. "Today my mother died. Or perhaps yesterday, I'm not sure." That's how the novel begins, as if the day when it happened mattered more than what had happened.

A special kind of acedia is associated with the malaise of modernity. The root word of *acedia* in Greek was *kedia*, meaning "care," but the related word *kedeia* referred to the care owed to the dead and the prescribed funeral rights to be performed. The dead body was to be covered with earth, that it not be eaten by stray dogs. If this was done, the shades of the deceased could cross the river to the Elysian Fields and join those who had gone before them. Otherwise, said Virgil, the shades would remain stranded in limbo for as long as a hundred years, "holding out their hands in longing for the farther shore."[6]

In the ancient world, religion was a family affair, and the

funeral rights were a ritual of transmission meant to ensure the repose of the dead.[7] The child performed them for his father and expected that his own children would do the same for him. Or else a sister might perform them for her brother, as Antigone did for Polynices, knowing she'd be put to death for doing so. The family, and not the individual, was the basic unit of society. The deepest bond was created though membership in the *patriazein*, the family religion, in which the oldest male guarded the sacred fire and departed ancestors were revered as gods.

The family religion survives today when we honor our parents and repay them by taking care of our children, and when repeated this family compact binds all generations. Families are weaker today, however, and the sense that we're cut off from them can also result in acedia. The best modern account of this is Evelyn Waugh's *Sword of Honour* trilogy. Guy Crouchback has a loving father, but his wife has left him, and as a Catholic, he is unable to remarry and have children. All sense of enjoyment has drained away and left aridity and a death wish in its place. He's neither happy nor sad but burned out and indifferent. He lives comfortably in a castle on the Italian coast, a life that would be idyllic for most of us, but he wants nothing and seeks nothing. He does not suffer. He no longer knows what that is. He is without curiosity.

His English-speaking neighbors are gross vulgarians who cheat the locals, but the Italians nevertheless think them *molto sympatico*. Crouchback alone, who shares their faith and speaks their language, is a stranger to them, as he is to himself. "Into that wasteland where his soul languished he need not, could not, enter. He had no words to describe it. There were no words in any language. There was nothing

to describe, merely a void."[8] *Sword of Honour* is wonderfully comic, but it's also the most painful and chilling record of an incurious soul lost to acedia.

Can the acedic be blamed for his sadness and his incuriosity about the good things in life? If acedia and sadness are just feelings, they don't seem wrongful; they're just there. In that case, dropping acedia for sloth in the list of Deadly Sins makes sense. When action is called for and the slothful fail to act, that's a form of action and blameworthy. But as simple feelings, sadness and depression aren't like that. When no action is taken, condemning someone for his feelings seems like blaming a person for being short.

Thomas Aquinas disagreed and argued that acedia is a sin of ingratitude for all that life has to offer.[9] When we compare our lives to those of our parents and grandparents, we who have everything they lacked, it seems a little contemptible to be sad. They had had wars and the Great Depression and dreamed of the kind of life we enjoy today. They sacrificed for us, and we repay them by moping? Aquinas was right. It's a sin.

Acedia is especially blameworthy because we have the means to snap out of it. That's been the subject of countless self-help books, including the first one in 1621, Robert Burton's *The Anatomy of Melancholy*. Over more than a thousand pages, Burton advised the sufferer on how to overcome the black bile of melancholy. For the lady unlucky in love, Burton suggested she talk to her girlfriends, who'll say that the boyfriend "is a hermaphrodite, an eunuch, imperfect, impotent, a spendthrift, a gamester, a fool, a gull, a beggar, a whoremaster, far in debt and not able to maintain her, a common drunkard, his mother a witch, his father hanged," and so on for another seventy-nine words[10] – which is what

girlfriends always tell each other, if asked about someone else's boyfriend.

Some self-help books are over the top, but in many cases the advice should be taken. In particular, physicians tell us that depression is related to a chemical imbalance in the brain and can be addressed with drugs, such as Prozac, that weaken serotonin inhibitors. If drugs can cure a serious case of depression, the person who fails to avail himself of them can be faulted for doing so. He's like a person who suffers from bipolar disorder and needs to take his meds to stay on an even keel, and who is responsible for the crazy stuff he does when he goes off them. For the depressive, it's even more necessary to use what pharmaceutical remedies are available, if (as medical experts tell us) untreated bouts of despair change our brain circuitry and make it harder to emerge from long-term depression. That's why Aquinas was right, and why the acedic may be blamed for his incuriosity.

The Autistic

So is the lack of curiosity a moral failing? Sometimes it is. In other cases, however, it's a chemical or genetically based psychological disorder.[11] The autistic child inhabits his own world, one that can be very far removed from other people, in whom he has little or no interest, and his lack of curiosity is beyond praise or blame.

There are degrees of autism, and the American Psychiatric Association now speaks of an encompassing autistic spectrum disorder or ASD. At the more normal edge is what used to be called the Asperger syndrome, a high-functioning form of ASD where people can seem almost normal. Several

of my friends have told me that they have Asperger traits, and had they not done so, I wouldn't have known. They were highly successful academics, and while they weren't gregarious, neither were they withdrawn. After they came out as "Aspies," I attributed their shyness, their reluctance to look me in the face, and their academic success to genetic causes. But that was probably the confirmation bias at work.

In society's recognition of their differences, people like my friends are enjoying an Aspie moment. There's Graeme Simsion's *The Rosie Project*, whose geeky and clueless Aspie hero, Don, recognizes that married men are happier and live longer and therefore decides it's time to marry. Unfortunately, his sixteen-page questionnaire for prospective mates unexpectedly repels women, until Rosie takes pity on him. On their first date Don tells Rosie that she seems quite intelligent for a barmaid. "The compliments just keep on coming," responds Rosie, whereupon Don reflects, "It seemed I was doing well, and I allowed myself a moment of satisfaction, which I shared with Rosie." A friend worries that he might find sex stressful. Not at all, responds Don. "It's just that adding a second person makes it more complicated." At the end of the book he moves to New York, where weirdness isn't a social handicap.

It's a mistake to think that people on the autism spectrum are uncaring. They might lack the intellectual ability to identify emotions in other people, but if you tell them that another person is upset, they'll feel upset too. With the help of Dale Carnegie, they can also be trained to improve their social skills, for example, by looking people in the face and not in the ear when you talk to them.

While Aspies are faulted for the perceived lack of emotional response, they don't want to change. They oppose

chelation therapy and worry that if ultrasound tests reveal their trait, they'll be aborted, as are children with Down's syndrome. Or exterminated, like the autistic children Dr. Asperger sent to Nazi death camps. They take pride in people like Steve Jobs, whose unusual ability to fix his attention on a single object seemed to place him on the autism spectrum. Autism is both a disability and a difference, and in curing the disability we'd also lose its advantages: the Aspie's remarkable attention to detail and the ability to concentrate for long periods on a narrow topic.

Their curiosity about their chosen field has made some of them rich and famous. In other cases, a fascination with matchbook covers, license plate numbers, or model trains doesn't pay dividends much valued by this world. In either case, their obsession with their chosen subject makes them incurious about other topics and other people. But if we're talking about genetic predispositions, they can't be blamed for this. Like Lady Gaga, they were born that way. For them, the lack of curiosity is natural and a counterexample to Aristotle's theory that curiosity is natural.

Anesthesia

George Berkeley (1685–1753), the philosophical Bishop of Cloyne, thought that man is necessarily a perceiving animal. *Esse est percipere*: to be is to perceive. If so, a nonperceiving person is a contradiction in terms. A nonperson. Nevertheless, we sometimes seek to escape from our perceptions with the anesthetic (that deadens *aisthesea*, or "perception") of sweet oblivion. We'd like a little less curiosity, please.

Sight

Eyes have a hunger that needs to be fed. There's even a psychological term for the fear of losing our vision: *scotomaphobia*. We think it's about the worst thing that could happen to us. When I was a child, I read that Louis Braille had been blinded by an awl, and from that I learned to be extremely careful with sharp tools. A partial eclipse cast its shadow over our town, and our teachers warned us against looking at the sun, lest it blind us. As they advised, I brought out a pail of water in which to watch the reflection of the eclipse.

We soon put childish fears aside, but then as we age, we confront the possibility of macular degeneration and retinal tears. Several years back, the vision in my left eye exploded from a tear, and until a retinologist patched it together with a laser, I couldn't use the eye. It was an anxious time. All I could see from the affected eye was black.

Black is the color that absorbs all visible light. The ninth plague of Egypt was a blackness so dark that it could be felt. The underworld was a place of darkness (*haidelos*) called Haides, after its reigning god. It was a sightless (*haides*) place, with the darkness of the tomb (*haidios*). In politics, black signifies danger and violence, like Mussolini's Blackshirts or the Black Bloc of the Antifa rioters. In war, the Black Flag announces that no quarter will be given and that prisoners will be shot. At Waterloo, Marshal Blücher told his German troops, "Raise high the black flags, my children. No prisoners. No pity."

When he was seventy-five, deaf, ill, and half-blind, Francisco Goya completed a set of Black Paintings. He lived

outside of Madrid in a house called the House of the Deaf Man and covered its walls with fourteen paintings. They were all in somber colors and showed ugly, evil-looking people at nighttime. One was of a witches' Sabbath. Another was of the Fates. In his dining room was a painting of Saturn, a nude madman with bulging eyes, gnawing on the headless and bloody remains of his son.

Because it reminds us of death, darkness is frightening. The gardener knows that a plant is dead when it turns black. When Father Damien, the missionary to the lepers on Molokai, contracted the disease, the bridge of his nose collapsed, his fingers merged with his knuckles into ulcerous sores, and his face turned purplish red. And still he lived. But one day he noticed that his hands had turned black, and he knew he must soon die.

Nevertheless, there are times when we'd prefer not to see. At death, there's an instinct to shut out the world and turn one's face to the wall, as Sweet William did in the Child ballad "Barbara Allen" and as the Beatles said they'd do in "You've Got to Hide Your Love Away." One might do so to pray, like King Hezekiah.[12] Or to wonder at the horror of pain and death, like Tolstoy's Ivan Illich. Or simply because the time to think of the world has passed. On his deathbed, French philosopher Alfred Le Pottevin said, "Close the window. It's too beautiful."[13] In due course, I'll find out for myself.

We don't want to see what will kill us. In a firing squad, the condemned man is blindfolded. In a hanging, a mask is placed over his head. When he was assassinated, Julius Caesar pulled his toga over himself. He at first tried to flee, then was driven to the statue of Pompey, which seemed to bleed from Caesar's wounds. Pompey had also covered his face when he was killed.

Dogs are said to know when they'll die, and some say they go off to be alone at that time. Perhaps that's like turning your face to the wall. Or there might be other reasons. They might feel weak and wish to hide from predators. You should never leave your dog then. That's the bargain you make with him. It's what I think he would want, to die seeing your face and feeling you with him. So it was with me, and the two dogs I have lost.

When Odysseus returned to Ithaca from twenty years of travels, he assumed a beggar's disguise to hide his identity. No one recognized him except his old dog Argos, who lay neglected on heaps of dung. As soon as the dog saw Odysseus, he recognized his old master. He was too old to move but dropped his ears and wagged his tail. Seeing him, Odysseus wiped away a tear. "But for Argos the fate of black death [*melanos thanatoio*] seized him, once he had seen Odysseus in the twentieth year."[14]

We fear being seen if we sin. In 1510 Hieronymus Bosch or one of his followers painted an image of *The Seven Deadly Sins* on a tabletop. The sins are in a circle and represent avarice, gluttony, sloth, lust, pride, anger, and envy. They're called deadly or capital sins, because they lead to other sins. Around the circle are roundels of the Four Last Things: death, judgment, heaven, and hell. The central circle resembles an eye, whose pupil is a half-length figure of Christ, seeing the sins of fallen humanity all around him. Beneath him, the inscription warns the viewer, "*cave, cave, deus videt.*" Beware, beware, God sees.[15]

The ancient Greeks and Romans were taught to beware when other people gazed at them. Perhaps they were giving you the evil eye. They might be wishing for your death. Or they might be envying you. In Latin, *invidere* means "to give

someone the evil eye." It also means to envy him, and *invidia* was the word for "envy." In both cases, the root word is *videre*, "to see."

Even now, we sense danger when people gaze at us. Test this by recalling what happens when you're stalled in traffic and sense that someone a car over has glanced at you. You immediately look at him. Your peripheral vision has taken over and warned you of a threat. The same thing happens when you look at the person in the next car and he looks at you. When that happens, both parties immediately look aside.

We profane sacred things when we gaze on them. The Holy of Holies was the part of the Temple in Jerusalem, separated by a veil, where the Arc of the Covenant was kept. No one could enter it except the high priest, and he only once a year, at Yom Kippur.[16] In synagogues today, the Torah is shielded from view behind an arc or tabernacle, except when it is brought out in a procession and read. There is a similar ritual in Catholic masses. During the consecration a bell is rung to signal that the members of the congregation should bow their heads, so as not to see the transubstantiation of the bread and wine. After communion, the consecrated host is reserved within the tabernacle, that it not be profaned. God Himself does not want to be seen. He is a hidden God, Isaiah's *deus absconditus*.[17]

Sometimes we see too much and want less stimulation, like the darkened paintings of Georges de La Tour (1593–1652). La Tour lived in Lunéville, a town on the border between France and Lorraine, during the Thirty Years War. It was a time when chateaux were sacked, churches were desecrated, and wolves dug up the graves. On September 30, 1638, the French abandoned Lunéville and burned it before

an advancing army. At midnight one could see as clearly as daytime, and the city was illuminated like a candle. Before then, La Tour had painted card cheats and cutpurses. Afterward he painted nocturnes, nighttime scenes of religious themes, lit by candlelight.[18]

A black-and-white film, made when it's so easy to do it in color, self-consciously announces its difference. It might want to evoke an earlier time, like Woody Allen's *Manhattan* (1979), when nothing was in color. It might want to tell you to pay attention to faces, as in *Liberty Valance*, where color would invite you to look at the background, and where you wouldn't see shadows. Or it might want to suggest a world of darkness, like the films noir from the 1940s or Ingmar Bergman's chiaroscuro *The Seventh Seal* (1957).

Thirty years ago, we discovered that those old black-and-white movies could be remade in color. Filmmaker Peter Jackson wonderfully brought some forgotten First World War film to life by colorizing it, in *They Shall Not Grow Old* (2018). But after a few best-forgotten failures, colorization never took hold. When a film might have been made in color, but wasn't, the director had made a different kind of film, one with a black-and-white integrity. If you colorized *The Man Who Shot Liberty Valance*, you'd have distracted the viewer from the film's tragic message, and colorizing *The Seventh Seal* would turn the film into a parody of itself. Colorization would overload the senses and cause us to miss what should have been noticed. "I stumbled when I saw," says blind Gloucester in *King Lear*. So do we all, when we see too much.

Hearing

There's a nightmare that used to be trotted out to frighten Catholic schoolboys. I don't know whether it still happens, but it went like this. A very serious nun would tell her class about a mysterious voice some of us might hear: the Call. It was from Christ, and it announced that we had a vocation (from *vocare*, "to call") and asked us to join a religious order.

Most of us wouldn't hear it, which meant that we'd end up as lay mediocrities. At best. Or else we might imagine we heard it, when really we didn't. In that case, we'd be frauds, like Frederick Rolfe, the author of *Hadrian VII*, miserably fooling ourselves and nobody much else, wisely rejected by the seminary and bitterly resenting it for the rest of our lives. But a precious few of us might be vouchsafed to hear an authentic Call. That's not to say that we'd be required to obey, but we'd be cursed if we didn't. We'd carry with us, forever, the knowledge that we had fled from the Hound of Heaven, that we had been marked to serve Him and had failed the test. But almost as dreadful was the possibility that we'd hear the Call and find ourselves unable to resist it. And what if the Call was not to the priesthood but to something even more frightening, a request to join a cloistered order like the Trappists?

The Trappists are, formally, the Order of Reformed Cistercians of Our Lady of La Trappe, a Catholic religious order that embraces a rule of silence and a life so austere that it led to accusations that its founder was a Jansenist. The monks weren't banned from speaking but were strongly encouraged to avoid idle talk. At meals they'd keep silent and listen as a holy text was read to them, perhaps from Thomas à Kempis.

Laughter was frowned on, and a sign language was used for the most basic of commands. If you were a normal, chatty ten-year-old, the possibility that you'd be ordered to become a Trappist would frighten the bejesus out of you.

In 1948, Thomas Merton wrote of how he decided to join the Order in *The Seven Story Mountain*. The book (entitled *Elective Silence* in the British edition) sold a million copies, and Merton became a popular celebrity, an unusual fate for one who had wanted to shut himself off from the world. It described an utterly secular boyhood and youth, a call to the religious life, and the terror Merton felt when the thought of becoming a Trappist first occurred to him. He wrote of how, on his first day, visiting one of their abbeys, he was wakened at 4:00 A.M. to follow the monks to the cloister. "The silence with people moving in it was ten times more gripping than it had been in my empty room."[19] It wasn't without noise, for the monks sang hymns and the monastery bells rang, and there was the liturgy of the mass. But there was next to nothing of the little conversations with which we get through the day. It's not hard to see why the book was so popular. It had hints of a dissolute youth, the frisson of a suspect and alien church, and the horror of an Edgar Allan Poe novel.

Evidently, I never heard the Call. But I can understand the attraction of periods of silence. Like most Americans, I'm surrounded by noise, from cars, from passing trains. Most cities have laws against people who are too noisy, and police enforce them. So that people can sleep, there are special rules about making too much noise after 10:00 P.M. But in Alexandria's Old Town and Georgetown, backyard conversations over drinks must compete with planes flying in and out of Reagan National Airport.

At times we'll seek to retreat from the sense of hearing, to lower the volume. On the Acela, the quiet car fills up quickly. *O beata solitudo!* But escaping from loud noise becomes harder and harder. At modern restaurants, it's difficult to hear the other person talk over all the noise. Pubs and bars encourage high decibel levels because that makes people drink more. We seem to have forgotten that over-loud music was one of those enhanced interrogation techniques used on al-Qaida prisoners of war.

Loud noise is annoying. And noisy and unpleasant people are called loudmouths. In middle school, the substitute teacher loses control of his class when he starts yelling, which his students will take as a sign to let themselves go. Sometimes it gets so bad that the principal has to step in. He'll retake control of the class through his intimidating presence and by speaking in a dangerously low voice.

In doing so, the principal will have mimicked how God stiffened Elijah's resolve. When Elijah had Baal's prophets killed, King Ahab's wife, Jezebel, ordered that he be killed himself, and Elijah fled to a cave in Mount Horeb. Then the voice of God came to him and ordered that he stand before the mountain. When he did so, God broke up the mountain with a great wind – but God was not in the wind. After the wind came an earthquake – but God was not in the earthquake. And after the earthquake, a fire – but God was not in the fire. And finally, after the fire, God, in "a still small voice," told Elijah to continue with his mission.[20] God's quiet command was all the more compelling because it showed Elijah that He did not need loud and dramatic trappings to communicate His wishes.

With a tragedy, foolish words would cheapen what we're meant to feel. With our closest companions, talking might

also detract from our sense of solidarity. In describing his friendship with his fellow pro-Dreyfusard Daniel Halévy, Charles Péguy wrote of how they had come to understand each other better in silence:

We were silent. Happy are they, two friends, who like each other enough, who so much wanted to please each other, who know each other enough, and understand each other enough,... who think and feel so much the same ... who savor the pleasure of being quiet together,... to walk silently along the silent roads. Happy two friends, who like each other enough to be silent together, in a silent country.[21]

There are places of silence, graveyards and dark Gothic cathedrals, where loud voices are not to be heard. There are also times when we're meant to be quiet, like the two-minute silence in Commonwealth countries on Remembrance Day, at 11:00 A.M. of the eleventh day of the eleventh month. In Israel, there's a two-minute silence on Holocaust Remembrance Day. At 10:00 A.M. an air raid siren sounds, and everyone stops what he's doing. If he's driving, he'll pull over to the side of the road.

We choose our holiday destinations around noise. Lives were quieter in days gone by, and people took their holidays in noisy cities: in London, Paris, or New York. But it's often too loud today, and we're more likely to want a change to something quieter. We love to get away to the mountains, and one reason is for the quiet. Mountaineering holidays were a nineteenth-century invention, and people discovered beaches at about the same time. Before then the sea was a dangerous place where people drowned and ships foundered. The beaches at Coney Island and the Lido in Venice

are less than two hundred years old. The Provincetown of Eugene O'Neill and Tennessee Williams was a twentieth-century town. Before then it had been a fishing and whaling center favored by Portuguese sailors. First came the noise, then came the escape to the mountains and the beaches.

In a world of silence, there is no one who speaks. But in a world with speaking, there are silences. Our conversations emerge from silence, from which they naturally arise and to which they return. "There is something silent in every word," wrote Max Picard. "And in every silence there is something of the spoken word, as an abiding token of the power of silence to create speech."[22] Prolonged silence might be a sign that a person is thinking about what was said and paying it the compliment of reflection. When speech is expected or called for and is denied, it might also be a rebuke. Silence can be cruel or tactful, insolent or respectful. Silence is dumb and silence is eloquent. Silence speaks.

The pauses in a conversation are like the intervals in music, when a note is allowed to fade. Many people were first introduced to J. S. Bach by Glenn Gould's 1956 recording of the Goldberg Variations, which in its extremely quick tempo was thirty-eight minutes long. Shortly before he died in 1982, Gould released a second recording of the piece, this time at fifty-one minutes. The difference was in the way the notes fell off with the slower tempo, as they did in the film of *Tous les matins du monde* (1991), where Marin Marias instructs his pupils that each note should end in dying.

In conversation, we use silence like a tool, like a drummer does, to hold our attention. The dramatic pause in a Harold Pinter play awakens the listener and tells him that the words have more than an ordinary significance. When he became prime minister, on May 13, 1940, Winston

Churchill told the House of Commons, "I have nothing to offer but blood [pause], toil [pause], tears [pause], and sweat." And then, "You ask what is our aim [pause]. I can answer in one word: victory [pause]. Victory at all costs [pause]. Victory however long and hard the road may be." President Roosevelt also used pauses to dramatic effect in asking Congress for a declaration of war against Japan on December 8, 1941: "Yesterday [pause], December 7 [pause], 1941 [pause], a date that will live [pause] in infamy." We cannot remember either speech without mentally adding in the pauses.

The intervals in speech are the secret behind comedy. It's easy to ruin a joke and a lot harder to make it work, and what is required is the sense of timing to capture the listener's attention. When the punch line is blurted out without a pause, the joke falls flat; but a highly successful comedian prolongs the gag and keeps his audience in suspense. He first holds back, drawing the audience to him in nervous expectation, and finally punctures the balloon at the moment of greatest tension. The pause announces that something wicked will come this way, and the reader hugs himself in delight as he waits for the dénouement.

Test that yourself. Look at the Biggus Dickus scene from *The Life of Brian*, then imagine reading the screenplay without any directions for how the lines are to be delivered. What is possibly the most hilarious four minutes in film isn't funny without the pauses. "He had a wife, you know . . ."

Formerly, readings were spoken aloud and were public acts, as they were when Virgil read his *Georgics* to the Emperor Augustus. The first person to read silently was St. Ambrose, the fourth-century Bishop of Milan, and this was so unusual that his parishioners would gather round to see him do it. There were names for this. *Lectio silencio*. Ambrosian reading.

St. Augustine visited Ambrose while he read and wrote that "his eyes ran over the page and his heart perceived the sense, but his voice and tongue were silent. . . . Very often while we were there, we saw him silently reading, and never otherwise."[23] Augustine admired Ambrose and learned to read silently. That was how he was converted. He had a cold. And a sudden desire to weep. From the other garden he heard a child say, "Take it, read it." So he picked up the Bible, opened it at random, and read the first thing he saw. Silently.[24]

The spoken word is experienced differently by the speaker, and that is why, in his advice to the free-thinker who wanted to overcome his unbelief, Pascal told him to move his lips when praying. He knew that the spoken prayer takes hold of one. Similarly, poems ask to be recited aloud. Otherwise they can never be memorized. We measure the words against our breathing and heartbeat and make them part of ourselves.

Compared to blindness, deafness is a lesser tragedy. Beethoven became deaf, but it did not prevent him from composing his Ninth Symphony. In his *Hymne de la surdité*, written to comfort Pierre de Ronsard on his deafness, Joachim du Bellay (1522–60) wrote that his friend would no longer hear false friends, angry instruments, a tempest, a donkey's braying, a preacher's boring sermon, the groans of a valet, or the conversation of a buffoon. "It's such a blessing," Evelyn Waugh said of his deafness. He used an antique ear trumpet, which he ostentatiously removed when someone began to bore him.

Pure silence will nevertheless make us uncomfortable. We are so used to ambient sounds that their removal is distressing, as I found on 9/11. Around 5:30 that afternoon my wife and I walked out to a hill, near our house, with views

of the Potomac and the Capitol. We could see and smell the smoke from the Pentagon, three miles away. And then we realized that there was complete quiet, all around us. No cars moved on the busy highway before us, or on I-495 a half mile away. And no planes flew. The FAA had grounded all of them. A long way away, we saw Air Force One, bringing George W. Bush at long last to Andrews Air Force Base. The silence of death was about us, and the absence of noise was eerie.

Pascal imagined an empty universe around him, whose eternal silence frightened him. And before there was anything, before the Creation, there was silence, unimaginable silence. Only God was there, and in the Gospel of John He was the *logos*. The Greeks would have understood this to mean "reason," but in the Latin Vulgate it was translated as *verbum* – the word. And that is how it has come down to us in English translations. In the beginning was the Word and a God who spoke the world into existence.

Touch

If we're shown something, we like to touch it. In museums, guards hang about the sculptures because of our instinct to finger them. Where there are no guards, we can indulge our need to touch an object to our heart's content. In Harvard Yard there's a statue of old John Harvard, whose left foot is the most touched object in the university. The toes of the boot have been polished to a bright sheen by students and tourists.

There are things we're not supposed to touch, however. Touching British royalty is a no-no, if you're British. When

Americans (Barak Obama, LeBron James) have done it, they've been faulted for gaucherie, but there's no reason why a British custom should bind Americans – apart from the fact that it probably creeps out the royals. The members of the royal family can touch us, of course. That's their prerogative. It used to be thought to heal illnesses. Scrofula, the king's evil, was supposedly cured by the king's touch. Queen Anne touched Samuel Johnson for scrofula in 1711, and in France Charles X tried to revive the custom before he was booted by the 1830 French Revolution. Marc Bloch, the French historian, devoted a whole book to the subject.

In the plague year of 2020 we learned how to do without the sense of touch. But even before then, there were things we weren't supposed to touch. When the Ark of the Covenant was brought to Jerusalem, the oxen stumbled, and Oza (or Uzzah) steadied it with his hand. But the Jews had been ordered not to touch it, and Oza was immediately killed for his sacrilege.[25]

In church services, the introvert learned to dread the moment when the priest said "Let us offer one another a sign of peace." All of a sudden, your neighbors look at you and offer to shake hands. "Peace be to you," they say, and hold out their hands. The wretched extrovert will walk two pews over in case he hasn't shaken hands with a score of people. With practice, you can learn, at just the right time, to turn to the person who's busy with the fellow one over and get away without touching anyone, while at the same time sending the signal that the failure to shake hands is a matter of infinite regret. If you do have to shake hands, bringing out the hand sanitizer afterward is considered bad form.

There are things we touch simply because everything tells us not to. Before he died, Christ washed the feet of his

disciples.[26] Peter resisted. You'll never wash my feet, he said. But Christ insisted, and when he had washed all their feet, he explained what he had done. You are meant to serve people, he told his disciples, and if I am the Lord and have washed your feet, you should do the same for others, to cleanse them.

In Catholic churches, the ceremony of washing of feet is performed on Holy Thursday, the day before Good Friday. If it's been done to you, as it has been to me by a priest, you'll understand Peter's sense of acute embarrassment. There's no greater symbol of servitude by the priest or feeling of unworthiness by him whose feet is washed. On Holy Friday, Pope Francis always washes feet, generally of prison inmates and migrants.

Father Damien touched the lepers he cared for on Molokai. One day he upset a kettle of boiling water on his bare foot, and when he felt no pain, he knew he had become a leper himself. Princess Diana is remembered by gays for shaking hands with an AIDS patient in 1987. This was at a time when people were first dying from it, and no one knew how HIV was spread. People thought that a simple touch might be enough to catch it, and so those who had the disease would die alone, untouched. But Diana visited a hospital wing devoted to the disease and, without a glove, shook hands with a patient. Today this might seem unremarkable, but more than thirty years ago, it sent a powerful message that the sufferer should not be abandoned.

Until the 1920s, placing an infant in an orphanage was usually a death sentence. The children didn't die from a lack of food or medical attention. Instead, it was the lack of touching and interaction with caregivers.[27] In a horrifying and possibly apocryphal 1944 study, newborn babies were split

into two groups. Twenty were touched by nurses, twenty not. In the latter group, nurses were told to attend to the basic needs of the babies, feeding and changing them for example, but not to touch or look at them any more than they had to. After just four months, half of those babies had died.

You're twice as likely to die in a hospice than in a hospital. Medicare will cover the expense, but only if you have less than six months to live and doctors have stopped trying to cure you. So you go there to die, and you know it. For the very elderly, whose friends are all dead and whose family has gone, the only link with other people may be the hospice caregiver, who is encouraged to touch her patient. The last touch.

Taste and Smell

Taste and smell are lesser senses, but they're still an important part of what it means to be alive. In *The Decline of the American Empire* (1986), filmmaker Denis Arcard chronicles the final days of a French Canadian libertine dying of cancer. Knowing he has only a few days left, his friends and former mistresses gather round him. From Italy, old friends bring him bottles of Brunello di Montalcino and some *tartufo bianco*. But he turns them down. He can't taste the wine or smell the truffles. His friends exchange knowing glances. If that's where things are, it's obviously time to pull the plug.

There's no great mystery about how to satisfy our sense of taste. It involves a lot of butter and cream, rich sauces and all the things in the Julia Child cookbook. Or it's the macaroni pie in Lampedusa's *The Leopard*, with its sugar and cinnamon, the sliced ham, chicken and truffles and glistening

meat juices. Except nobody cooks like that anymore. Instead, we're treated to Keto diets (no carbs) and Paleo diets (no bread, sugar, or dairy). We boast about how bad our dinners taste. It might be for reasons of health, but it's still an example of anesthesia.

With odors, there's seldom much opportunity for anesthesia. We stop smelling when we stop breathing. Mostly we never notice that we smell anything. Exceptionally, there'll be a pleasant smell, the odor that announces the arrival of a good meal, the smell of food on the grill, of freshly baked bread. There's the smell of lilac and honeysuckle in the springtime. If we do smell something, however, it's probably unpleasant, and the word odor is synonymous with a bad smell. On the heath, Lear asks for an ounce of civet, a perfume that at full strength is repulsive, and, when Gloucester offers to kiss his hand, says, "Let me wipe it first, It smells of mortality."

THE DEATH OF CURIOSITY

THERE ARE PERIODS in history when we seem to make a leap and shake off the fetters that bind us. We embrace new ideas and new ways of living. The first half of the twelfth century was like that. So was the Renaissance. Both periods were marked by an outpouring of energy and a heightened curiosity to try new things, or to rediscover things that had been forgotten. But there have also been periods of incuriosity and dullness, when nothing seemed to change and the ways of life seemed fixed and immovable. That was how the Victorian era seemed to Matthew Arnold, where he saw himself "Wandering between two worlds, one dead / The other powerless to be born."[1]

Today we also live in an incurious time. On the extremes, Trump-haters and Trump-lovers shriek past each other, like furious apes locked in a cage. But it's mostly the rage-filled progressives who are to blame. In 2020, they made curiosity about anything other than Black Lives Matter or the pandemic seem sinful. They've tried to banish risk and fault

the risk-taker for his negligence or toxic masculinity. They've descended into incurious ideologies and bitter partisanships that permit them to ignore the harms imposed on others. Finally, they've shrunk the space of things that are supposed to matter and given up caring about the most fundamental questions of life and death.

The heroes of curiosity we saw in earlier chapters have become villains for incurious progressives. The soldiers who fought their enemies, the explorers who opened the West, the missionaries who converted the pagans, are figures of scorn. Blaise Pascal, St. John Henry Newman, even Albert Camus have been canceled, along with all of Western civilization, and replaced by a parade of intersectional victims. But it cannot last. However worthy you might think the progressives' causes, they'll bore you in time, unless you're wholly without a spark of curiosity.

Trying to Banish Risk

When we boomers were young, we double-dog-dared each other to do risky things. We climbed up on roofs, fell out of trees, and broke our arms. For sport we played with BB guns and threw firecrackers at each other. When our parents were bored with us, they threw us out and told us to "go play." It was great fun, but parents today risk being arrested if they do that.

Alexander and Danielle Meitiv dropped their six- and ten-year-old children off at a playground at 4:00 P.M. and told them to be home at 6:00. When the children hadn't returned by 6:30, the Meitivs became anxious. It turned out that the police in liberal Montgomery County, Maryland,

had picked them up two blocks from home and driven them to Child Protective Services. Before the children were released, the Meitivs had to sign a safety plan that prohibits them from leaving their children unattended.[2]

We're being told that unsupervised play amounts to child abuse, and it can invite social workers to snatch the children. Play activities are limited to things like the soccer matches to which parents bring their kids and then watch on the sidelines. When I've observed the games, they look like cheerless affairs for everyone. What they lack is the unstructured play in which kids make and break their own rules, where they explore the world without parents looking over their shoulders, and where they learn that joy is the child of curiosity.

It's not as if things are any more dangerous today; rather, the attitudes toward risk-taking have changed. We've allowed the fearmongers to make the most trivial slights seem oppressive. The wrong word triggers an anxiety attack, while a microaggression leaves psychological scars. The bully's taunts, which used to be a character-building rite of passage for children, are now regarded as a crime that calls for a federal response. Traditional masculine virtues of stoicism and competitiveness, such as we saw in chapter 2, are seen as the vices of dominance and aggression, and the American Psychological Association's guidelines for dealing with boys and men now present masculinity as a medical problem.[3] When almost anything can get you into trouble, the message is that curiosity should be resisted.

Coupled with this are the zero-tolerance norms of liberal lawmakers that have led to absurd and counterproductive efforts to banish any form of risk, such as the ban on

the use of DDT to control for diseases spread by mosquitos. DDT is an organic compound, and it isn't a hazard to man or beast. It's saved millions of lives, and the National Academy of Sciences reported that five hundred million people between 1950 and 1970 would have died from malaria but for DDT.[4] But environmental alarmists who ignore the scientific evidence have politicized the debate, and this has resulted in a ban, with the result that malaria is returning, especially in Africa. There are now half a million malaria deaths each year.[5]

America's judges and trial lawyers have also done their part by turning perfectly safe activities into actionable civil wrongs. The Above the Law website lists some of the more frivolous lawsuits of recent years. An eight-year-old boy was sued by his aunt for a "careless" hug. A woman sued FedEx after she tripped over a package left on her doorstep. A woman was hit by a dinner roll and sued the restaurant. There's no evidence that your cell phone will give you cancer, but that hasn't stopped the trial lawyers from suing over it. News media coverage fueled fear of a national cancer epidemic caused by overhead power lines, and while there was no evidence to back this up, it nevertheless ended up before a judge. In the end, most of the crazy claims fail, but it's a big casino if they succeed, and according to two scholars, this has turned the American civil justice system into a demented slot machine of judicially sanctioned theft.[6]

It's also placed a damper on the inventive and harmless activities of curious businessmen. When you're sued, it's a defense if you can show that all you're doing is what everyone else does, and that amounts to a presumption that anything new is dangerous. There's safety in dull conformity,

and it's the person who strikes out with a novel product or technique who is going to be dinged. That in turn amounts to a tax on innovation and curiosity.

Walling Off People Who Disagree with You

Harvard political scientist Robert Putnam sparked a huge debate about the disappearance of social groups in *Bowling Alone*, first a magazine article in 1995 and then a book in 2000. What the title referred to was the decline in bowling leagues: formerly one bowled as a member of a club, but now one bowls alone. What made people (including non-bowlers) take the book seriously was the wealth of empirical evidence Putnam presented about declining membership in clubs of all kinds, from high points in the 1950s and early 1960s.

That's made us lonelier, said Putnam, and it's undermined our democracy by weakening the social groups that participate in politics. If Putnam is right, it's also made us a more partisan and incurious country. In the past, people were more likely to join churches, clubs, and other organizations where people disagreed about politics. You'd find yourself debating issues with congregants at your church and synagogue, and because they were fellow worshipers, you couldn't hate them for supporting the wrong party. With the rise of the "nones," and the fall-off in attendance at religious institutions, there's less of that today. We also self-segregate in our social media platforms. Scroll down your friends list in Facebook and ask how many of them disagree with you about Trump or impeachment. If the answer is not many, you've walled yourself off from dissenting views.

That might be the rational thing to do, if expressing your views can get you canceled. A recent poll revealed that 77 percent of staunch conservatives think that the political climate prevents them from speaking their minds. The only Americans who don't self-censor are the strong liberals.[7] That's not surprising. They're the ones doing the canceling.

It's even gotten in the way of romance. Love really isn't blind, and we do sort ourselves out according to our tastes, but in the past, politics mattered less. It wasn't uncommon for husband and wife to cancel out their spouse's vote at the polls. That's much less likely to happen today. In response to their customers, major dating platforms eliminate matches of people with incompatible politics. OK Cupid is one such site, and 72 percent of its female members said they could not date someone with strong political opinions that were the exact opposite of their own.[8] Conservatives don't stand much of a chance on OK Cupid, and even self-styled moderates fair poorly, lest they be Trump supporters in disguise. People have even been known to "wokefish": to pretend they're progressive in order to get a date.

The Ideologue

Ideologies are systems of belief about the future. Marxist ideologues believe that communism will usher in a golden age that puts paid to an alienated and selfish iron age of capitalism. Libertarian ideologues, who have vastly more going for them, believe that people flourish best with free markets and a minimal state. Since the future is uncertain, both sets of predictions await the kind of evidence that would prove them worthy of belief. The more they resist

such evidence – the more they are indifferent to facts – the more they look like pure ideologies. At the limit, an ideology is a mental shortcut that economizes on the search for evidence and shuts down curiosity.

In 1973, confronted with five decades of communism's slave labor, police terror, and mass starvation, Marxist historian E. P. Thompson (1924–93) asked, "What is fifty years to an historian?" He was an ideologue. So was another Marxist historian, Eric Hobsbawm (1917–2012), who at the end of his life could accept that fifteen or twenty million people had died under Lenin and Stalin. If that's what was necessary to create a socialist state, it was worth it. Both men had something like a computer's trash folder in which to discard unpleasant data that didn't fit with the model.

In the last century, a good many people agreed with Thompson and Hobsbawm. Jean-Paul Sartre was one of them, and so were many of France's leading intellectuals. They were unsparing in their criticism of Western democracies and wholly forgiving of communist terror. "The question is not to know whether one accepts or rejects violence," said philosopher Maurice Merleau-Ponty, "but whether the violence with which one is allied is 'progressive' and tends towards its own suppression or towards self-perpetuation."[9] That was written in 1947, when anyone but the pure ideologue knew better. In *The Opium of the Intellectuals* (1955), Raymond Aron – a classmate of Sartre and Merleau-Ponty at the superprestigious École normale – described the communist promise of a just and classless society as nothing more than "an illustration in a children's picture book."[10]

Ideologies are fatally attractive, however. The Aroniste in France and the nonideological American conservative try to think policies through to their remote consequences. That's

never easy. You'll want to have studied law, economics, and sociology. By contrast, ideologies ignore facts that get in the way. And so we have today's social justice warriors who are interested only in destroying the heteronormative white patriarchy or the libertarian whose answer to every policy question is "shrink the state."[11]

Were matters not so serious, the ideologue might be funny. There's a holdup in the Bronx, Mr. Libertarian, what should we do? "Shrink the state." Brooklyn's broken out in fights, Mr. Libertarian, what should we do? "Shrink the state." The libertarian is Henri Bergson's machine-man in his little book *Laughter* (1900), and we'd do well to laugh him out of his idée fixe.

Libertarians are few in number, and the ones I know haven't lost their general sense of curiosity. For progressives, by contrast, politics seems the all-encompassing ground of their being and shuts out any interest in other things. Viewers of CNN or MSNBC appear to have had the curiosity gene removed at birth, so repetitive are the politics. In the *Washington Post*, ideology dominates the main, metro, style, sports, and book review sections, for readers with an all-consuming desire for an anti-Trump message and an incuriosity about anything else.

No one should be more curious than the young, but they've been betrayed by America's colleges, which is where curiosity goes to die. Curious people need the freedom to experiment with new ideas, as one might try on new ties before a mirror. That's not going to happen if the woke police stand ready to pounce at any deviation from their radical orthodoxy. Victimhood has been weaponized and turned into a tool of oppression by the flint-eyed progressives on campus and their enablers on college administrative staff.

What an ideology offers is a first cut at a problem, a simple rule to get one started. Sometimes this is positively evil (the Nazi's Jewish "problem"). Sometimes it's absurdly histrionic, like William Jennings Bryant's bimetallism ("you shall not crucify mankind on a cross of gold"). Occasionally, as with libertarians, it might even rest on a useful intuition about what's to be done, and then it's dangerous only when it substitutes for and shuts out a more detailed and balanced view of the equities on either side. When these are ignored, the social justice warrior becomes a fascist, and the libertarian can seem heartless. In either case, they're incurious.

The Partisan

The ideologue has a model and is incurious about facts that don't fit it. The partisan takes a side and is incurious about what might be said for the other side. He filters that away, or he permits himself to believe a lie, as Walter Duranty did. Duranty was a *New York Times* reporter who was treated to a bubble-wrapped tour of the Soviet Union and dutifully reported that accounts of mass starvation in the 1930s were just a big "scare story."

Malcolm Muggeridge thought that Duranty was the biggest liar he had ever met, and the *Times* subsequently expressed its embarrassment at having published his stories. But Duranty's willed unbelief was common among Western visitors sympathetic to the Soviet Union. Muggeridge told of the games he and other reporters played to show up their credulity. "Persuading church dignitaries to feel at home in an anti-God museum was too easy to count. So was taking lawyers into the People's Courts." But the game turned serious

when, on a Party-sponsored visit to a new dam, he observed a half-eaten chicken leg thrown from a railway car and saw how the peasants on the platform rushed to grab it.[12]

There's an emotional cost to dumping the victims into the trash folder. It's easier if we permit ourselves to think that they deserve what they get. The two great partisan gaffes in recent American politics came when presidential candidates revealed their contempt for people on the other side. In 2012 Mitt Romney was taped at a Republican fundraiser, where he said that 47 percent of Americans "are dependent upon government, who believe that they are victims, who believe that government has a responsibility to care for them, who believe that they are entitled to health care, to food, to housing, to you name it." And they were going to vote for Obama no matter what. Then, in 2016, Hillary Clinton told us what she thought of the deplorables. "Racist, sexist, homophobic, xenophobic, Islamophobic, you name it."

America's poor need the assistance of a generous welfare state, but they didn't think they'd get it from a person who thought they were "takers" sponging on the 53 percent of Republican "makers." Similarly, American's middle classes had been hammered by policies that shipped jobs offshore, admitted immigrants to compete away their jobs, and seen their schools worsened. They were dying from the diseases of despair, social isolation, drug and alcohol poisonings, suicide, and chronic liver disease, but they knew they wouldn't get any sympathy from a person who thought they were deplorable.

Romney told us he enjoyed firing people. Hillary Clinton crowed that her enemies were irredeemable. We can take a savage joy in our contempt for others, and Thomas Aquinas

said that one of the special joys of heaven will be the ability to observe the torments of the damned in hell.[13] But apart from the hatred, partisanship is also a vice of intellectual sloth. It frees a person from incurring the costs of caring about other people, of learning about how his policies might harm them. Curiosity imposes informational burdens, from which partisanship offers an escape. That makes incuriosity a strong default.

With today's partisanship, we increasingly live in bubbles that isolate us from people with different political opinions. We're incurious about people on the other side, what they're like and what they're thinking. Why bother, if we think they're mean and selfish? Or just stupid? We're asked to take sides and to revel in our hatred for those on the wrong side. But we can't do that without betraying the truth. Like Camus, the honest man is always a party of one and curious about what might be said on the other side.

The Loss of Transcendence

As a child, John Stuart Mill was force-fed an education in the classics, history, logic, economics, and geometry. At three he began to learn Greek, and by ten he could read Plato with ease. In his teens he was writing essays for learned journals. He wasn't permitted to play with other children or to join in their games. And then at twenty, he suffered a mental breakdown.

He had adopted his father's utilitarian principles and supported political reforms that promoted the greatest happiness for the greatest number. Had they been enacted, he assumed he'd have been made happy. But then he suddenly

realized that this wasn't so. "Suppose that all your objects in life were realized," he asked himself,

that all the changes in institutions and opinions which you are look-ing forward to, could be completely effected at this very instant: would this be a great joy and happiness to you?" And an irrepress-ible self-consciousness distinctly answered, "No!" At this my heart sank within me: the whole foundation on which my life was con-structed fell down. The end had ceased to charm, and how could there ever again be any interest in the means? I seemed to have noth-ing left to live for.[14]

Credit Mill with curiosity, to have posed that question. It's no longer asked, because of the way in which our culture tells us to focus upon political causes and ignore everything else, so that today we'd answer Mill's question with a yes.

Mill's sense of not being at home in the world has been suppressed by an obsession with the public policies a state should adopt. Support them and you're good, oppose them and you're bad. Social justice churches and synagogues become accomplices when religious messages are supplanted by political causes. They might quote Deuteronomy 16:20, "justice, justice, you shall pursue," but political justice defines only a very small part of what we owe each other. By focus-ing overmuch on political justice, we've trivialized more important moral requirements, such as the duty to be kind to others and forgiving of their offenses, virtues largely absent in our hyperpartisan world.

We have seemingly internalized the last proposition of Wittgenstein's *Tractatus.* Not only can't we speak of the mysteries of life and death but we can't even think of them. We've shut out thoughts that aren't truth-functional, that

can't be said to be either true or false, and excluded things Wittgenstein thought of far greater importance.

Mill's depression lifted, but not through any political reform. Instead, it was Wordsworth's poetry and the joy of music that brought him around. That might be harder today, since our culture has become so politicized. We're bound up in all-devouring political dramas, with Margaret Atwood's feminism and Toni Morrison's novels about racial injustice, and not given a breathing space from earnest politicking. What's missing from our culture is a sense of transcendent experience, of heavenly ecstasies and tragic losses.

There are no tragedies in sensible policy papers about tax reform or in thoughtful law review articles. And there is no tragedy when a play merely addresses a social injustice. A tragedy cannot be made whole by progressive legislation. In the *Oresteia* of Aeschylus, Agamemnon's wife, Clytemnestra, takes a lover and kills her husband when he returns home from the Trojan Wars. But as George Steiner notes, the play wasn't about the need for permissive divorce laws.[15] Instead, tragedies tell us of things that cannot be remedied. Jean Anouilh's *Antigone* must die because the play is a tragedy. "Her name is Antigone, and she must play her role right to the end."

Perfect justice excludes the possibility of tragedy. Christopher Marlowe's *Doctor Faustus* wasn't really a tragedy. Faustus got what he deserved. There's no tragedy when good people are saved and bad people are condemned to hell. When that happens, the moralist has simply arranged things nicely.

What tragedy requires is the sense that, even when every demand for justice is met, life will still break your heart. Like Virgil's Aeneas, we mourn for the *lacrimae rereum*, tears in the nature of things.[16] Herman Melville's *Billy Budd* is a

tragedy because Billy will hang even though he is morally innocent. He is a scapegoat to the inflexible Articles of War, and scapegoats are tragic because the person or animal did not deserve to die. Holman Hunt understood this, as did the ancient Greeks. Tragedy was *tragōdia*, the song of the *tragos*, the scapegoat sacrificed during the feast of Dionysos. That was when plays were performed, and in 458 B.C. the *Oresteia* was declared the best tragedy at that year's Dionysia.[17]

What tragedy requires is the Jansenist's unjustified saint, the person who doesn't deserve his fate and who cannot be rescued from it. That is why Racine's *Phèdre* is the perfect tragedy. His Phèdre is damned, but not for anything she had the power to change. As such, she testifies to the teachings on the indeterminacy of God's grace that Racine learned as a student at a Jansenist school.

The Jansenists saw the theater as an occasion of sin, and Racine broke with them when he wrote for the stage. He took a cynical mistress whom he was forced to share with others. His success on the stage inspired rivals; his personal life invited ridicule. And then, with his greatest play, he made amends with his old teachers. In the play's introduction, Racine wrote that "the slightest faults are severely punished, and the mere thought of crime is regarded with as much horror as the crime itself." With his *Phèdre*, he expressed the hope that it might reconcile the stage with a sect that was celebrated for its piety and doctrines, an unmistakable reference to the Jansenists.[18]

Racine sent a copy of *Phèdre* to Antoine Arnauld, the Jansenist leader. When Racine learned that Arnauld admired the play, he hastened to the older man's door and, before a crowd of people and in tears, knelt before him, who, kneeling in turn, embraced Racine.[19] Thus reconciled to his

Jansenist teachers, Racine asked that he be buried at their abbey. That was why, when Louis XIV ordered the abbey razed to the ground in 1711, and the tombs were opened, the remains of France's greatest playwright were eaten by stray dogs.

That was a cultural debacle. So is every retreat from the questions Racine posed about the fate of Phèdre. In *Real Presences* (1986), George Steiner argued that a great culture must necessarily offer a response to the tragedy of death. It might find this in religious belief, which is a wager that some meaning can be extracted from the brute fact that we will die.[20] But what happens to a culture, wondered Steiner, when its artists and writers have lost their religious faith in an afterlife? What happens when death no longer requires an explanation, when we don't notice God's absence or feel His presence? We'll then have a very different kind of literature, thought Steiner – the politicized novels of Atwood and Morrison.

Camus tried to find a way out in his idea of revolt. He put death at the center of his writings and left us with a myth about a struggle against gods in whom he did not believe. His reflections on death and suicide were his response to God's absence, and in that sense, both he and Pascal were God-haunted. Take away the gods, and there's no revolt.

Our culture asks us to anesthetize our curiosity about what awaits us on death, and Camus's revolt against our fate. But I am more optimistic than Steiner. Even as God made Eve curious, I think that the incuriosity of modernity will ultimately prove unsatisfying. We were created as curious beings and will always seek answers, especially to the most fundamental questions of our existence. And that, more than anything, is why curiosity matters.

Acknowledgments

I am grateful to the many people who've helped me: to Larry Arnn, Mark Bauerlein, Dan Bonevac, Angelo Codevilla, David DesRosiers, Hans Eicholz, Frank Furedi, Charlie Goetz, Allen Guelzo, Rob Koons, Pierre Lemieux, Tom Lipscomb, Dan McCarthy, Jim Piereson, Stephen Presser, Al Regnery, Rusty Reno, John Samples, Martin Wooster, and my old friend Bob Tyrrell.

James Bowman and Deal Hudson read the manuscript through, and because of them this is a very different book from the one I began writing. My colleague Joyce Malcolm gave valuable suggestions, as did my friend Kevin Gutzman.

My daughter Sarah Buckley and her husband, Nick Mark, read the manuscript and gave me many helpful nudges.

I also thank George Mason's Scalia Law School for its generous support; Deborah Keene, Esther Koblenz, and Peter Vay at the Scalia Law Library; and José Coradin for tech support.

My heartfelt thanks to everyone at Encounter Books: to Nola Tully, Executive Director of Operations; to the production team of Amanda DeMatto and Mary Spencer; to the marketing team of Sam Schneider and Lauren Miklos; to Holly Monteith for her superb editing; and especially to Roger Kimball.

Finally, and as always, my most heartfelt thanks go to my wife, Esther Goldberg.

November 2, 2020

Selected Bibliography

Adams, John. *Discourses on Davila.* Boston: Russell and Cutler, 1805.

Adams, John. *Revolutionary Writings 1755–1775.* New York: Library of America, 2011. Adams I.

Adams, John. *Revolutionary Writings 1775–1783.* New York: Library of America, 2011. Adams II.

Ainslie, George. *Breakdown of Will.* Cambridge: Cambridge University Press, 2001.

Aquinas, St. Thomas. *Summa Theologica.* http://newadvent.org/.

Arendt, Hannah. *The Human Condition.* 2nd ed. Chicago: University of Chicago Press, 1998.

Aristotle. *Metaphysics.* Books I–IX. Cambridge, MA: Loeb Classical Library, 1933.

Aristotle. *Nicomachean Ethics.* Translated by H. Rackham. Cambridge, MA: Loeb Classical Library, 1939.

Arnold, Matthew. *"Culture and Anarchy" and Other Writings.* Edited by Stefan Collini. Cambridge: Cambridge University Press, 1993.

Aron, Raymond. *The Opium of the Intellectuals.* Translated by Terence Kilmartin. Garden City, NY: Doubleday, 1957.

Attali, Jacques. *Blaise Pascal ou le génie français.* Paris: Fayard, 2000.

Atwood, Margaret. *Survival: A Thematic Guide to Canadian Literature.* Toronto: Anansi, 1972.

Augustine. *Confessions.* Translated by Henry Chadwick. Oxford: Oxford University Press, 1991.

Ayer, A. J. *Language, Truth and Logic.* London: Victor Gollancz, 1958.

Baby M, In re. 537 A.2d 1227 (N.J. Sup. Ct., 1987).

Baler, R. D., and N. D. Volkow. "Drug Addiction: The Neurology of Disrupted Self-Control." *Trends in Molecular Medicine* 12 (2006): 559–66.

Ball, Philip. *Curiosity: How Science Became Interested in Everything.* Chicago: University of Chicago Press, 2012.

Barnes, Annette. *Seeing through Self-Deception.* Cambridge: Cambridge University Press, 1997.

Baron-Cohen, Simon. *Autism and Asperger Syndrome.* Oxford: Oxford University Press, 2008.

Baron-Cohen, Simon. *The Science of Evil: On Empathy and the Origins of Cruelty.* New York: Basic Books, 2011.

Bartley, W. W. *Wittgenstein*. London: Quartet Books, 1974.

Baudelaire, Charles. *Œuvres complètes*. Paris: Gallimard, 1975.

Bazzana, Kevin. *Wondrous Strange: The Life and Art of Glenn Gould*. Oxford: Oxford University Press, 2004.

Becker, Ernest. *The Denial of Death*. New York: Free Press, 1973.

Begun, Michael W. "The Neuroscience of Despair." *The New Atlantis* 43 (2014): 81–98.

Bell-Villada, Gene H. *Art for Art's Sake: How Politics and Markets Helped Shape the Ideology and Culture of Aestheticism 1790–1990*. Lincoln: University of Nebraska Press, 1996.

Benjamin, Walter. *The Work of Art in an Age of Mechanical Reproduction*. Translated by J. A. Underwood. London: Penguin, 2008.

Benson, A. C. *Walter Pater*. New York: Macmillan, 1906.

Bergson, Henri. *Le rire*. Paris: PUF, 1940.

Bernanos, Georges. *Œuvres romanesques*. Paris: Gallimard, 1961.

Bickel, Alexander. *The Least Dangerous Branch*. Indianapolis, IN: Bobbs-Merrill, 1962.

Bird, Kai, and Martin J. Sherwin. *American Prometheus: The Triumph and Tragedy of J. Robert Oppenheimer*. New York: Knopf, 2005.

Birley, Anthony. *Marcus Aurelius: A Biography*. New Haven, CT: Yale University Press, 1987.

Blazer, Dan G. *The Age of Melancolia: Major Depression and Its Social Origins*. New York: Routledge, 2005.

Bloch, Marc. *Les rois thaumaturges*. Paris: Gallimard, 1983.

Bloom, Harold. *How to Read and Why*. New York: Scribner, 2000.

Bogost, Ian. *Play Anything: The Pleasure of Limits, the Uses of Boredom and the Secret of Games*. New York: Basic Books, 2016.

Boutroux, Émile. *Blaise Pascal: le genie français*. Paris: Le Mono, 2016.

Brasillach, Robert. *Écrit à Fresnes*. Paris: Plon, 1967.

Brasillach, Robert. *Notre avant-guerre*. Paris: Livre de poche, 1992.

Brown, Frederick. *Zola: A Life*. New York: Farrar, Straus, and Giroux, 1995.

Brox, Jane. *Silence: A Social History of One of the Least Understood Elements in Our Lives*. Boston: Houghton, Mifflin, Harcourt, 2019.

Bruneau, Marie-Florine. *Racine: Le jansénisme et la modernité*. Paris: Corti, 1986.

Buckley, F. H., ed. *The American Illness: Essays on the Rule of Law*. New Haven, CT: Yale University Press, 2013.

Buckley, F. H. *The Morality of Laughter*. Ann Arbor: University of Michigan Press, 2003.

Buckley, F. H. *The Way Back: Restoring the Promise of America*. New York: Encounter Books, 2016.

Burton, Robert. *The Anatomy of Melancholy.* New York: New York Review of Books, 2001.

Cacioppo, John T., and William Patrick. *Loneliness.* New York: W. W. Norton, 2008.

Camus, Albert. *Carnets.* Paris: Gallimard, 1962.

Camus, Albert. "Le mythe de Sisyphe." In *Essais,* 89. Paris: Gallimard, 1965.

Camus, Albert. *Théâtre, recits, nouvelles.* Paris: Gallimard, 1962.

Carlyle, Thomas. *Past and Present.* Edited by Richard D. Altick. New York: NYU Press, 1965.

Carson, Shelley H. "Creativity and Mental Illness." In *The Cambridge Handbook of Creativity,* edited by James C. Kaufman and Robert J. Sternberg, 296. Cambridge: Cambridge University Press, 2019.

Casanova, Giacomo. *Histoire de ma vie.* Paris: Gallimard, 2013.

Cassian, John. *The Institutes.* Translated by Boniface Ramsey. New York: Newman, 2000.

Castiglione, Baldassare. *The Book of the Courtier.* Translated by Thomas Hoby. In *Three Renaissance Classics,* edited by Burton A. Milligan. New York: Scribners, 1953.

Chevalier, Jacques. *Pascal.* 1922. Reprint, Paris: Plon, 1950.

Clark, Kenneth. *The Gothic Revival: A Study in the History of Taste.* London: Constable, 1950.

Conisbee, Philip. *Georges de La Tour and His World.* New Haven, CT: Yale University Press, 1996.

Corbin, Alain. *A History of Silence.* Translated by Jean Birrell. London: Polity, 2018.

Cornford, F. M. *Microcosmografia Academica: Being a Guide for the Young Academic Politician.* Cambridge: Bowes and Bowes, 1908.

Csikszentmihályi, Mihály. *Flow: The Psychology of Optimal Experience.* New York: Harper and Row, 1990.

Damasio, Anthony R. *Descartes' Error: Emotion, Reason, and the Human Brain.* New York: Grosset/Putnam, 1994.

Damasio, Anthony R. *The Feeling of What Happens: Body and Emotion in the Making of Consciousness.* San Diego, CA: Harcourt, 1999.

de Chateaubriand, François-René. "Génie du christianisme." In *Chateaubriand: Essai sur les revolutions.* Paris: Gallimard, 1978.

de La Bruyère, Jean. *Les caractères.* Paris: PUF, 1994.

de Montaigne, Michel. *The Complete Essays.* Translated by M. A. Screech. Harmondsworth, UK: Penguin, 1991.

Denning, Lord. *The Discipline of the Law.* Oxford: Oxford University Press, 1979.

Descartes, René. *Philosophical Writings.* Translated by Elizabeth Anscome and Peter Geach. London: Nelson, 1966.

Digby, Kenelm Henry. *Broad Stone of Honour.* London: R. Gilbert, 1823.

Donoghue, Dennis. *Walter Pater: Lover of Strange Souls.* New York: Knopf, 1995.

Duckworth, Angela. *Grit: The Power of Passion and Perseverance.* New York: Scribner, 2016.

Durkheim, Émile. "Progressive Preponderance of Organic Solidarity." In *Emile Durkheim on Morality and Society: Selected Writings,* edited by Robert H. Bellah, 63–85. Chicago: University of Chicago Press, 1973.

Durkheim, Émile. *Suicide: A Study in Sociology.* New York: Free Press, 1951.

Edmonds, David, and John Eidinow. *Wittgenstein's Poker: The Story of a Ten-Minute Argument between Two Great Philosophers.* London: Faber and Faber, 2001.

Eliot, George. *Romola.* Oxford: Oxford University Press, 1994.

Ellman, Richard. *Oscar Wilde.* New York: Vintage, 1988.

Elster, Jon. *Alchemies of the Mind: Rationality and the Emotions.* Cambridge: Cambridge University Press, 1999.

Elster, Jon. *Ulysses and the Sirens.* Cambridge: Cambridge University Press, 1984.

Elster, Jon. *Ulysses Unbound: Studies in Rationality, Precommitment, and Restraints.* Cambridge: Cambridge University Press, 2000.

Epictetus. *Discourse, Fragments, and "The Enchiridion."* Translated by W. A. Oldfather. Cambridge: Loeb, 1928.

Escholier, Marc. *Port-Royal: The Drama of the Jansenists.* New York: Hawthorn, 1968.

Ezzell, Carol. "WHY? The Neuroscience of Suicide." *Scientific American* 288 (2003): 44–51.

Fann, K. T. *Ludwig Wittgenstein: The Man and His Philosophy.* New York: Humanities Press, 1967.

Fingarette, Herbert. *Self-Deception.* Berkeley: University of California Press, 2000.

Flowers, F. A., and Ian Ground, eds. *Portraits of Wittgenstein.* London: Bloomsbury Academic, 2016.

Forster, E. M. *Howards End.* New York: Knopf, 1991.

Foucault, Michel. *Discipline and Punish: The Birth of the Prison.* Translated by Alan Sheridan. New York: Vintage, 1995.

Friston, Karl, Philip Schwartenbeck, Tomas Fitzgerald, Michael Moutoussis, Timothy Behrens, and Raymond J. Dolan. "The Principles of Goal-Directed Decision-Making: From Neural Mechanisms to Computation and Robotics." *Philosophical Transactions: Biological Sciences* 369 (2014): 1–12.

Furedi, Frank. *Culture of Fear Revisited.* 2nd ed. London: Continuum, 2006.

Furedi, Frank. *How Fear Works: Culture of Fear in the Twenty-First Century.* London: Bloomsbury, 2018.

Fustel de Coulanges, Numa Denis. *The Ancient City: A Study of the Religion, Laws, and Institutions of Greece and Rome.* Mineola, NY: Dover, 2006.

Gaunt, William. *The Aesthetic Adventure*. London: Cardinal, 1975.

Gaunt, William. *The Pre-Raphaelite Tragedy*. London: Cardinal, 1975.

Gerson, Paula Lieber, ed. *Abbot Suger and Saint-Denis: A Symposium*. New York: Metropolitan Museum of Art, 1986.

Giannetti, Eduardo. *Lies We Live By: The Art of Self-Deception*. Translated by John Gledson. London: Bloomsbury, 1997.

Gide, André. *Journal II: 1926–1950*. Edited by Martine Sagaert. Paris: Gallimard, 1997.

Gilmore, Grant. *The Ages of American Law*. 2nd ed. New Haven, CT: Yale University Press, 2014.

Girouard, Mark. *The Return to Camelot: Chivalry and the English Gentleman*. New Haven, CT: Yale University Press, 1982.

Gladwell, Malcolm. *Outliers: The Story of Success*. Boston: Little, Brown, 2008.

Glaeser, Edward L. *Triumph of the City*. New York: Penguin, 2011.

Goldmann, Lucien. *Le dieu caché: Étude sur la vision tragique dans les Pensées de Pascal et dans le theater de Racine*. Paris: Gallimard, 1959.

Goodstein, Elizabeth S. *Experience without Qualities: Boredom and Modernity*. Stanford, CA: Stanford University Press, 2005.

Grazier, A. *Mélanges de littérature et de l'histoire*. Paris: Colin, 1904.

Greenblatt, Stanley. *The Rise and Fall of Adam and Eve*. New York: W. W. Norton, 2017.

Greer, Allan, ed. *The Jesuit Relations: Natives and Missionaries in Seventeenth Century North America*. Boston: Bedford/St. Martin's, 2000.

Gurstein, Rochelle. *The Repeal of Reticence: America's Cultural and Legal Struggles over Free Speech, Obscenity, Sexual Liberation, and Modern Art*. New York: Hill and Wang, 1996.

Helliwell, J., R. Layard, and J. Sachs. *World Happiness Report*. New York: Sustainable Development Solutions Network, 2018.

Hilton, Tim. *John Ruskin: The Later Years*. New Haven, CT: Yale University Press, 2000.

Holmes, Oliver Wendell, Jr. *The Essential Holmes: Selections from the Letters, Speeches, Judicial Opinions, and Other Writings of Oliver Wendell Holmes, Jr*. Edited by Richard Posner. Chicago: University of Chicago Press, 1992.

Horowitz, Morton. *The Transformation of American Law, 1870–1960: The Crisis of Legal Orthodoxy*. New York: Oxford University Press, 1992.

Horwitz, Allan V., and Jerome C. Wakefield. *How Psychiatry Transformed Normal Sorrow into Depressive Disorder*. New York: Oxford University Press, 2012.

Howe, Mark de Wolfe. *Touched with Fire: Civil War Letters and Diary of Oliver Wendell Holmes, Jr*. New York: Fordham University Press, 2000.

Huff, Toby E. *Intellectual Curiosity and the Scientific Revolution: A Global Perspective*. Cambridge: Cambridge University Press, 2011.

Huizinga, J. *The Waning of the Middle Ages: A Study of the Forms of Life, Thought and Art in France and the Netherlands in the XIVth and XVth Centuries.* London: Edward Arnold, 1924.

Hume, David. *A Treatise of Human Nature.* Oxford: Oxford University Press, 1967.

Hunt, William Holman. *Pre-Raphaelitism and the Pre-Raphaelite Brotherhood.* New York: Macmillan, 1905.

Huysmans, Joris-Karl. *Romans et nouvelles.* Paris: Gallimard, 2019.

In the Matter of J. Robert Oppenheimer. Washington, DC: U.S. Atomic Energy Commission.

Isaacson, Walter. *Steve Jobs.* Boston: Little, Brown, 2013.

Isorni, Jacques. *Le procès de Robert Brasillach.* Paris: Flammarion, 1946.

Jablonski, Nina G. *Skin: A Natural History.* Berkeley: University of California Press, 2013.

Jackson, Julian. *France: The Dark Years.* Oxford: Oxford University Press, 2001.

Janik, Allen, and Stephen Toulmin. *Wittgenstein's Vienna.* New York: Simon and Schuster, 1973.

Jay, Martin. "The Aesthetic Alibi." In *Salmagundi.* Saratoga Springs, NY: Skidmore, 1992.

Joyce, James. *A Portrait of the Artist as a Young Man.* New York: Knopf, 1991.

Joyce, James. *Ulysses.* New York: Knopf, 2000.

Judt, Tony. *The Burden of Responsibility: Blum, Camus, Aron and the French Twentieth Century.* Chicago: University of Chicago Press, 1998.

Kant, Immanuel. *Kant: Political Writings.* 2nd ed. Edited by Hans Reiss and H. B. Nisbet. Cambridge: Cambridge University Press, 1991.

Kaplan, Alice. *The Collaborator: The Trial and Execution of Robert Brasillach.* Chicago: University of Chicago Press, 2001.

Keating, Thomas. *Intimacy with God.* New York: Crossroad, 2013.

Kempis, Thomas a. *The Imitation of Christ.* Translated by George F. Maine. London: Collins, 1957.

Kennedy, Duncan. "Form and Substance in Private Law Adjudication." *Harvard Law Review* 89 (1976): 1685–1778.

Kenton, Edna, ed. *The Jesuit Relations and Allied Documents.* New York: Boni, 1925.

Ker, Ian. *John Henry Newman: A Biography.* Oxford: Oxford University Press, 1988.

Keynes, J. M. *The General Theory of Employment, Interest and Money.* London: Macmillan, 1973.

Keynes, John Maynard. "Newton the Man." In *The Collected Writings of John Maynard Keynes,* edited by Donald Moggridge and Elizabeth Johnston, 363–74. Cambridge: Cambridge University Press, 1972.

Kierkegaard, Søren. *Either/Or*. Translated by Howard V. Hong and Edna H. Hong. Princeton, NJ: Princeton University Press, 1987.

Kirzner, Israel. *Competition and Entrepreneurship*. Chicago: University of Chicago Press, 1973.

Klibansky, Raymond, Erwin Panofsky, and Fritz Saxl. *Saturn and Melancholy: Studies in the History of Natural Philosophy, Religion, and Art*. New York: Basic Books, 1964.

Knight, Frank H. *Risk, Uncertainty and Profit*. Ithaca, NY: Cornell University Press, 2009.

Koestler, Arthur. *Scum of the Earth*. New York: Macmillan, 1941.

Kolakowski, Leszek. *God Owes Us Nothing*. Chicago: University of Chicago Press, 1998.

Kuhn, Reinhard. *The Demon of Noontide: Ennui in Western Literature*. Princeton, NJ: Princeton University Press, 1976.

Lacan, Jacques. *Les quatre concepts fondamentaux de la psychanalyse*. Paris: Seuil, 1973.

La Jeunesse, Ernest, André Gide, and Franz Blei. *In Memoriam: Oscar Wilde*. Translated by Percival Pollard. Greenwich, CT: Literary Collector, 1905.

Laplace, P. S. *A Philosophical Essay on Probabilities*. Translated by F. W. Truscott and F. L. Emory. New York: Dover, 1951.

Lear, Jonathan. *Happiness, Death, and the Remainder of Life*. Cambridge, MA: Harvard University Press, 2000.

Lerner, Max. *The Mind and Faith of Justice Holmes: His Speeches, Essays, Letters, and Judicial Opinions*. New Brunswick, NJ: Transaction, 2010.

Leslie, Ian. *Curious: The Desire to Know and Why Your Future Depends on It*. New York: Basic Books, 2014.

Lottman, Herbert R. *The Left Bank: Writers, Artists, and Politics from the Popular Front to the Cold War*. Boston: Houghton, Mifflin, 1982.

Malcolm, Norman. *Ludwig Wittgenstein: A Memoir*. Oxford: Oxford University Press, 1958.

Malcolm, Norman. *Wittgenstein: A Religious Point of View?* Ithaca, NY: Cornell University Press, 1994.

Martin, Mike W. *Self-Deception and Morality*. Lawrence: University Press of Kansas, 1986.

McPherson, Miller, Lynn Smith-Lovin, and Matthew E. Brashears. "Social Isolation in America: Changes in Core Discussion Networks over Two Decades." *American Sociological Review* 71 (2006): 353–75.

Mele, Alfred R. *Autonomous Agents: From Self-control to Autonomy*. New York: Oxford University Press, 2001.

Mele, Alfred R. *Motivation and Agency*. Oxford: Oxford University Press, 2003.

Mele, Alfred R. *Self-Deception Unmasked*. Princeton, NJ: Princeton University Press, 2001.

Merleau-Ponty, Maurice. *Humanisme et terreur: essai sur le problème communiste*. Paris: Gallimard, 1947.

Merrill, Linda. *A Pot of Paint: Aesthetics on Trial in Whistler v. Ruskin*. Washington, DC: Smithsonian, 1992.

Merton, Thomas. *Contemplative Prayer*. New York: Doubleday, 1971.

Merton, Thomas. *The Seven Story Mountain: An Autobiography of Faith*. Boston: Mariner, 1998.

Mill, John Stuart. *Autobiography and Literary Essays*. Edited by John M. Robson and Jack Stillinger. Toronto: University of Toronto Press, 1981.

Monk, Ray. *Ludwig Wittgenstein: The Duty of Genius*. New York: Penguin, 1990.

Monk, Ray. *Robert Oppenheimer: A Life inside the Center*. New York: Doubleday, 2012.

Moore, G. E. *Principia Ethica*. Cambridge: Cambridge University Press, 1968.

Moran, Richard. *Authority and Estrangement: An Essay on Self-Knowledge*. Princeton, NJ: Princeton University Press, 2001.

Muggeridge, Malcolm. *Chronicles of Wasted Time: The Green Stick*. London: Collins, 1972.

Mukerjee, Madhusree. *The Land of Naked People: Encounters with Stone Age Islanders*. Boston: Houghton Mifflin, 2003.

Nabert, Natalie. *Tristesse, acédie et medicine des âmes dans la tradition monastique et cartusiene: anthologie des textes rares et inédits (XIIIe–XXe siècle)*. Paris: Beauchesne, 2005.

Nault, Jean-Charles. *The Noonday Devil: Acedia, the Unnamed Evil of Our Times*. Translated by Michael J. Miller. San Francisco: Ignatius, 2015.

Newman, John Henry. *The Works of Cardinal Newman: Apologia pro Vita Sua*. Edited by Charles Frederick Harrold. New York: Longmans, Green, 1947.

Newman, William R. *Newton the Alchemist: Science, Enigma, and the Quest for Nature's "Secret Fire."* Princeton, NJ: Princeton University Press, 2019.

Nicolson, Harold. *Diaries and Letters: The War Years 1939–1945*. Vol. 2. Edited by Nigel Nicolson. New York: Atheneum, 1967.

Norris, Kathleen. *Acedia and Me: A Marriage, Monks, and a Writer's Life*. New York: Riverhead, 2008.

Nute, Grace Lee. *Caesars of the Wilderness: Médard Chouart, Sieur des Groseilliers and Pierre Esprit Radisson, 1618–1710*. St. Paul: Minnesota Historical Society, 1978.

Oppenheimer, J. Robert. *Uncommon Sense*. Edited by N. Metropolis, Gian-Carlo Rota, and David Sharp. Boston: Birkhäuser, 1984.

Parkman, Francis. *France and England in North America: Pioneers of France in the New World*. New York: Library of America, 1983.

Pascal, Blaise. *Œuvres*. Paris: Gallimard, 1987.

Pascal, Blaise. *Pensées, fragments et lettres*. Edited by Prosper Faugère. Paris: Andrieux, 1844.

Pater, Walter. *Marius the Epicurean: His Sensations and Ideas*. London: Macmillan, 1896.

Pater, Walter. *The Renaissance: Studies in Art and Poetry*. New York: Macmillan, 1908.

Paxton, Robert O. *Vichy France: Old Guard and New Order 1940–44*. New York: Columbia University Press, 2001.

Péguy, Charles. *Œuvres en prose complètes*. Paris: Gallimard, 1992.

Percy, Walker. "The Coming Crisis in Psychiatry." In *Signposts in a Strange Land*. New York: Farrar, Straus, and Giroux, 1991.

Perry, Alex. "The Last Days of John Allen Chau." *Outside*, July 24, 2019.

Peterson, Jordan B. *12 Rules for Life: An Antidote to Chaos*. Toronto: Random House Canada, 2018.

Picard, Max. *The World of Silence*. Translated by Stanley Goodman. Chicago: Regnery, 1952.

Pieper, Josef. *Death and Immortality*. South Bend, IN: St. Ignatius, 2000.

Pinker, Stephen. *The Better Angels of Our Nature: Why Violence Has Declined*. New York: Penguin, 2012.

Pinker, Stephen. *Enlightenment Now: The Case for Reason, Science, Humanism, and Progress*. New York: Viking, 2018.

Powers, J. F. *Morte D'Urban*. Garden City, NY: Doubleday, 1962.

Putnam, Robert. *Bowling Alone: The Collapse and Revival of American Community*. New York: Simon and Schuster, 2000.

Quignard, Pascal. *Abîmes*. Paris: Gallimard, 2002.

Quignard, Pascal. *Georges de La Tour*. Paris: Gaililée, 2005.

Quignard, Pascal. *La barque silencieuse*. Paris: Seuil, 2009.

Quignard, Pascal. *Les ombres errantes*. Paris: Grasset, 2002.

Quignard, Pascal. *Petit Traités I and II*. Paris: Gallimard, 1990.

Quignard, Pascal. *Sur l'idée d'une communauté de solitaires*. Paris: arléa, 2015.

Quignard, Pascal. *Vie secrète*. Paris: Gallimard, 1998.

Quinones, Julian, and Arijeta Lajka. "What Kind of Society Do You Want to Live In? Inside the Country Where Down Syndrome Is Disappearing." *CBSN*, August 14, 2017.

Racine, Jean. *Abrégé de l'histoire de Port-Royal*. Paris: Table Ronde, 1994.

Racine, Jean. *Œuvres complètes I: Théâtre – Poésie*. Paris: Gallimard, 1999.

Rahner, Hugo. *Man at Play*. London: Burns and Oates, 1965.

Rhees, Rush, ed. *Ludwig Wittgenstein: Personal Recollections*. Oxford: Oxford University Press, 1984.

Rhodes, Richard. *The Making of the Atomic Bomb*. New York: Simon and Schuster, 2012.

Rieff, Philip. *My Life among the Deathworks: Illustrations of the Aesthetics of Authority.* Charlottesville: University of Virginia Press, 2006.

Rieff, Philip. *The Triumph of the Therapeutic.* New York: Harper and Row, 1966.

Rochefoucauld, Duc de. *Maxims.* Translated by L. Tancock. Harmondsworth, UK: Penguin, 1967.

Rudolph, Conrad. *Artistic Change at St-Denis: Abbot Suger's Program and the Early Twelfth-Century Controversy over Art.* Princeton, NJ: Princeton University Press, 1990.

Rumilly, Robert. *La Vérendrye: Découvreur Canadien.* Montreal: Albert Lévesque, 1933.

Ruskin, John. *Fors Clavigera: Letters to the Workmen and Laborers of Great Britain.* New York: Bryan, Taylor, 1894.

Ruskin, John. *Modern Painters.* Edited by David Barrie. New York: Knopf, 1987.

Ruskin, John. *The Seven Lamps of Architecture.* New York: Wiley and Halsted, 1857.

Ruskin, John. *St. Mark's Rest.* Sunnyside, NY: George Allen, 1879.

Ruskin, John. *The Stones of Venice.* Sunnyside, NY: George Allen, 1886.

Ruskin, John. *"Unto This Last" and Other Writings.* London: Penguin, 1985.

Russell, Bertrand. *Autobiography.* London: Routledge, 1998.

Russell, Stuart. *Human Compatible: Artificial Intelligence and the Problem of Control.* New York: Viking, 2019.

Sainte-Beuve, Charles. *Port-Royal.* Paris: Gallimard, 1953.

Schacter, Daniel L., Daniel T. Gilbert, and Daniel M. Wegner. *Psychology.* New York: Worth, 2011.

Seligman, Martin E. P. *Flourishing: A Visionary New Understanding of Happiness and Well-Being.* New York: Free Press, 2011.

Seneca. "De Tranquillitate Animi." In *Moral Essays*, II.202. Cambridge: Loeb Classical Library, 1932.

Shattuck, Roger. "De Gaulle and the Intellectuals." In *Salmagundi*, 16–25. Saratoga Springs, NY: Skidmore, 1993.

Shattuck, Roger. *Forbidden Knowledge: From Prometheus to Pornography.* San Diego, CA: Harcourt, Brace, 1996.

Sheffer, Edith. *Asperger's Children: The Origins of Autism in Nazi Vienna.* New York: W. W. Norton, 2018.

Sicart, Miguel. *Play Matters.* Cambridge, MA: MIT Press, 2014.

Silverglate, Harvey A. *Three Felonies a Day: How the Feds Target the Innocent.* New York: Encounter Books, 2009.

Simsion, Graeme. *The Rosie Effect.* New York: Simon and Schuster, 2014.

Simsion, Graeme. *The Rosie Project.* New York: Simon and Schuster, 2013.

Sitwell, Edith. *English Eccentrics.* London: Folio Society, 1994.

Sluga, Hans, and David G. Stern, eds. *The Cambridge Companion to Wittgenstein.* Cambridge: Cambridge University Press, 1996.

Snell, R. J. *Acedia and Its Discontents: Metaphysical Boredom in an Empire of Desire.* Kettering, OH: Angelico, 2015.

Spacks, Patricia Meyer. *Boredom: The Literary History of a State of Mind.* Chicago: University of Chicago Press, 1995.

Spotts, Frederic. *The Shameful Peace: How French Artists and Intellectuals Survived the Nazi Occupation.* New Haven, CT: Yale University Press, 2009.

Steiner, George. *The Death of Tragedy.* New Haven, CT: Yale University Press, 1996.

Steiner, George. *In Bluebeard's Castle: Some Notes towards the Redefinition of Culture.* New Haven, CT: Yale University Press, 1972.

Steiner, George. *Real Presences.* Chicago: University of Chicago Press, 1991.

Steinmann, Jean. *Pascal.* Paris: Desclée de Brouwer, 1961.

Stendhal, I. *De l'amour.* Paris: Gallimard, 1980.

Stendhal, I. *Œuvres romanesques complètes.* Paris: Gallimard, 2005.

Strachey, Lytton. *Eminent Victorians.* New York: G. P. Putnam's Sons, 1918.

Suger, Abbot. *Selected Works of Abbot Suger of Saint-Denis.* Translated by Richard Cusimano and Eric Whitmore. Washington, DC: Catholic University Press, 2018.

Sunstein, Cass. *Risk and Reason: Safety, Laws, and the Environment.* Cambridge: Cambridge University Press, 2002.

Strowski, Fortunat. *Pascal et son temps.* Paris: Plon, 1913.

Svendsen, Lars. *A Philosophy of Boredom.* Translated by John Irons. London: Reaktion Books, 2013.

Swaan, Win. *The Gothic Cathedral.* New York: Park Lane, 1969.

Symons, Arthur. *The Collected Drawings of Aubrey Beardsley.* New York: Crown, 1967.

Tame, Peter. *La Mystique du fascisme dans l'oeuvre de Robert Brasillach.* Paris: Nouvelles Éditions Latines, 1986.

Taverneaux, René. *Le jansénisme en Lorraine.* Paris: Vrin, 1960.

Taylor, Robert R. *The World in Stone: The Role of Architecture in National Socialist Ideology.* Berkeley: University of California Press, 1974.

Thullier, Jacques. *Nicolas Poussin.* Paris: Flammarion, 1994.

Timbs, John. *English Eccentrics.* Detroit, MI: Singing Tree, 1969.

Todd, Olivier. *Albert Camus: A Life.* Translated by Benjamin Ivry. New York: Carroll and Graf, 1997.

Toohey, Peter. "Acedia in Late Classical Antiquity." *Illinois Classical Studies* 15 (1990): 339–52.

Toohey, Peter. *Boredom: A Lively History.* New Haven, CT: Yale University Press, 2011.

Trivers, Robert. *The Folly of Fools: The Logic of Deceit and Self-Deception in Human Life.* New York: Basic Books, 2011.

Venner, Dominique. *Histoire de la Collaboration*. Paris: Pygmalion, 2000.

Voltaire. *Le siècle de Louis XIV*. Frankfurt, Germany: Knoch und Eslinger, 1753.

Watson, John Selby. *The Life of Richard Porson, M.A.* London: Longman, Green, 1861.

Waugh, Alexander. *The House of Wittgenstein: A Family at War*. New York: Anchor, 2010.

Waugh, Evelyn. *Sword of Honour*. Boston: Little, Brown, 2012.

Weber, Eugen. *The Hollow Years: France in the 1930s*. New York: W. W. Norton, 1994.

Weber, Max. *The Vocation Lectures*. Translated by Rodney Livingston. Indianapolis, IN: Hackett, 2004.

Wenzel, Siegfried. *The Sin of Sloth: Acedia in Medieval Thought and Literature*. Chapel Hill: University of North Carolina Press, 1967.

Wilde, Oscar. *The Letters of Oscar Wilde*. Edited by Rupert Hart-Davis. London: Rupert Hart-Davis, 1963.

Wilde, Oscar. *Plays, Prose Writings and Poems*. New York: Knopf, 1991.

Wilson, A. N. *The Victorians*. New York: W. W. Norton, 2003.

Wilson, Christopher. *The Gothic Cathedral: The Architecture of the Great Church 1130–1530*. London: Thames and Hudson, 1990.

Wittgenstein, Ludwig. *Culture and Value*. Translated by Peter Winch. Oxford: Blackwell, 1980.

Wittgenstein, Ludwig. *Philosophical Investigations*. Translated by G. E. M. Anscombe. Oxford: Blackwell, 1967.

Wittgenstein, Ludwig. *Tractatus Logico-Philosophicus*. Translated by D. F. Pears and B. F. McGuiness. London: Routledge and Kegan Paul, 1963.

Yeats, W. B. *Collected Works: III. Autobiographies*. Edited by William H. O'Donnell and Douglas N. Archibald. New York: Scribner, 1999.

Yeats, W. B. "To All Artists and Writers." In *Irish Writing in the Twentieth Century: A Reader*, edited by David Pierce. Cork, Ireland: Cork University Press, 2000.

Zaretsky, Robert. *A Life Worth Living: Albert Camus and the Quest for Meaning*. Cambridge, MA: Harvard University Press, 2013.

Notes

PREFACE

1. Pascal, *Pensée* 397, *Œuvres*, II.676–81. The argument doesn't work, however. It doesn't tell us which is the right religion, and it doesn't work if the question of God's existence is too uncertain to be assigned a probability (on which, see chapter 3).
2. Pascal, *Pensée* 126, *Œuvres*, II.583.
3. Pascal, *Pensée* 529, *Œuvres*, II.772.
4. Wittgenstein, *Culture and Value*, 41. See also 79.
5. Pascal, *Œuvres*, II.527–40.

CHAPTER ONE

1. Wittgenstein, *Philosophical Investigations*, 2.01a.
2. Elster, *Ulysses and the Sirens*.
3. George Ainslie, "The Dangers of Willpower," in *Getting Hooked: Rationality and Addiction*, ed. Jon Elster and Ole-Jørgen Skog (Cambridge: Cambridge University Press, 1999), 65, 70.
4. Eliot, *Romola*, 211.
5. Aristotle, *Nic. Eth.*, III.iii.11. Again, reason (*logos*) cannot tell us what we ought to do, because virtue aims at a middle course (*meson*), and what that might be will depend on the particular facts of the case. Determining what acts are virtuous will therefore require what Aristotle calls *phronēsis*, or practical judgement. *Nic. Eth.*, II.i.1104a4, VI.iv.5.
6. Pascal, *Pensée* 101, *Œuvres*, II.470.
7. Wilde, *Letters*, 569.
8. Camus, *Essais*, 1469.

CHAPTER TWO

1. See Hannah Schildberg-Hörisch, "Are Risk Preferences Stable?," *Journal of Economic Perspectives* 32 (2018): 135–54. *Risk-aversion* and *risk-neutrality* are technical terms in economics. A risk-neutral person will accept all opportunities whose

expected value (probability times outcome) exceeds the cost of taking it up. A risk-averse person will reject some opportunities with a positive expected value.

2. Howe, *Touched with Fire*, 32.

3. Holmes, *Essential Holmes*, 86, 82.

4. When Pierre Radisson was captured by the Iroquois, he was exposed on a scaffold for sixty hours, and four of his fingernails were pulled out. A red-hot iron was run through his foot, and he saw his companions, one by one, burned and hacked to death. Nute, *Caesars of the Wilderness*, 45–46.

5. Alex Perry, "The Last Days of John Allen Chau," *Outside*, July 24, 2019.

CHAPTER THREE

1. Perkins, *Northern Editorials on Secession* (December 17, 1860), 201.

2. *Entrepreneur*, September 25, 2014.

3. This is something of a pastiche of Chicago-style economics, which developed various models to deal with the problem of search costs where the outcome is uncertain. See, e.g., Joseph E. Stiglitz and Andrew Weiss, *"Credit Rationing in Markets with Imperfect Information,"* American Economic Review *71 (1981): 393–410.*

4. Wittgenstein, *Culture and Value*, 50.

5. Kirzner, *Competition and Entrepreneurship*, 35.

CHAPTER FOUR

1. Voltaire, *Le siècle de Louis XIV*. Xxix, 66

2. Pascal, *Œuvres*, I.775–76.

3. Sainte-Beuve, *Port-Royal*, III.150–51.

4. Attali, *Blaise Pascal ou le génie française*, 285.

5. Attali, 389; Strowski, *Pascal et son temps*, 365–72.

6. "Lettre à un soldat de la classe 60," in Brasillach, *Écrit à Fresnes*, 140.

7. "Procès en cours de justice," in Brasillach, 359.

8. Camus, "Les déclarations de Stockholm," *Essais*, 1882.

CHAPTER FIVE

1. Norman S. Poser, "Insider Trading and the Stock Market," *Virginia Law Review* 53 (1967): 753, 756.

2. Roy A. Schotland, "Unsafe at Any Price: A Reply to Manne, Insider Trading and the Stock Market," *Virginia Law Review* 53 (1967): 1425, 1439.

3. Newman, *Apologia*, 358.
4. Newman, 371–72.
5. Newman, 11.
6. Ker, *John Henry Newman*, 280.
7. Newman, *Apologia*, 215.
8. Pascal, 197.
9. Monk, *Ludwig Wittgenstein*, 368–69.
10. Russell, *Autobiography*, 330.
11. Russell.
12. Monk, *Ludwig Wittgenstein*, 41.
13. In 1973 W. W. Bartley III published a biography of Wittgenstein that purported
 to reveal episodes of promiscuous homosexual sex, based upon his coded note-
 books. But, as a more recent and thorough biographer notes, "there simply *are*
 no coded notebooks," in the sense of separate volumes, and Bartley does not
 appear to have had firsthand knowledge of the sources he mentioned. What
 those sources might have been Bartley "resolutely" refused to reveal before his
 death. Monk, 584.
14. Wittgenstein, *Tractatus*, 3.
15. Wittgenstein, 4.01.
16. Wittgenstein, 4.461.
17. Wittgenstein, 7.
18. Ayer, *Language, Truth and Logic*, 115, 107.
19. Wittgenstein, *Philosophical Investigations* § 2.
20. Malcolm, *Ludwig Wittgenstein*, 58–59.
21. Wittgenstein, *Philosophical Investigations*, 1.308.
22. Quoted in Fann, *Ludwig Wittgenstein*, 52, 57.
23. Malcolm, *Ludwig Wittgenstein*, 58.
24. Flowers and Ground, *Portraits of Wittgenstein*, 523.
25. Wittgenstein, *Culture and Value*, 53, 64.
26. Flowers and Ground, *Portraits of Wittgenstein*, 543.
27. Flowers and Ground, 579.

CHAPTER SIX

1. Arendt, *Human Condition*, 22–24.
2. Castiglione, *Book of the Courtier*, 255, 315.
3. Peter S. Smith, "The Effects of Solitary Confinement on Prison Inmates: A Brief
 History and Review of the Literature," *Crime and Justice* 34 (2006): 441–528.
4. Tina Moore and Natalie Musumeci, "Young Manhattan Dietician Tara Condell

Hanged Herself after Writing a Suicide Note," *New York Post,* January 31, 2019. See also Nicholas Kristof, "Let's Wage a War on Loneliness," *New York Times,* November 9, 2019; Cacioppo and Patrick, *Loneliness.*

5. Miller McPherson, Lynn Smith-Lovin, and Matthew E. Brashears, "Social Isolation in America: Changes in Core Discussion Networks over Two Decades," *American Sociological Review* 71 (2006): 353.

6. Justin R. Pierce and Peter K. Schott, "Trade Liberalization and Mortality: Evidence from U.S. Counties," Yale School of Management, November 2016.

7. Tara Parker-Pope, "Suicide Rates Rise Sharply in U.S.," *New York Times,* May 2, 2013.

8. Margaret F. Brinig and F. H. Buckley, "The Bankruptcy Puzzle," *Journal of Legal Studies* 27 (1998): 187; Margaret F. Brinig and F. H. Buckley, "No-Fault Laws and At-Fault People," *International Journal of Law and Economics* 16 (1998): 325.

9. Casanova, *Histoire de ma vie,* 146 [I.7].

10. Dante, *Vita Nuova,* II.4–6. In *On Love,* Stendhal describes two *coups de foudre* that really happened, one that ended tragically and another where the lady got over it the next day. Stendhal, *De l'amour,* 68–71.

11. Strowski, *Pascal et son temps,* 144.

12. Pascal, *Pensées, fragments et lettres,* 35–55; Escholier, *Port-Royal,* 85–95. Most scholars do not think that Pascal was the author of the *Discourse on the Passion of Love,* which formerly was attributed to him. See, e.g., the comments of the editor of the Pléiade edition, II.1209.

13. That was a novel, but the same thing reportedly happened to her real-life ancestor, Boniface de la Môle. When he was executed in 1574, his lover, Queen Marguerite of Navarre, rescued his head and placed it in a jeweled casket. That was a gruesome end, but la Môle is remembered in two novels: *The Red and the Black* and Alexandre Dumas's *La Reine Margot.*

CHAPTER SEVEN

1. Pascal, *Pensée* 72, *Œuvres,* II.564–65.

2. "I must study Politicks and War that my sons may have liberty to study Mathematicks and Philosophy. My sons ought to study Mathematicks and Philosophy, Geography, natural History, Naval Architecture, navigation, Commerce and Agriculture, in order to give their Children a right to study Painting, Poetry, Musick, Architecture, Statuary, Tapestry and Porcelaine." Adams, *Revolutionary Writings,* II.300 (May 12, 1780).

3. Adams, *Discourses on Davila,* 36.

4. La Jeunesse et al., *In memoriam: Oscar Wilde,* 42.

5. Ellman, *Oscar Wilde*, 366.
6. Descartes, *Second Discourse*, 15.
7. Wittgenstein, *Culture and Value*, 77.
8. Nicolson, *Diaries and Letters*, II.210.
9. Bazzana, *Wondrous Strange*, 179.

CHAPTER EIGHT

1. There doesn't seem to be a single creativity gene; rather, several instincts appear to be heritable, which, added together, promote creativity. Baptiste Barbot and Henry Eff, "The Genetic Basis of Creativity," in *The Cambridge Handbook of Creativity*, ed. James C. Kaufman and Robert J. Sternberg (Cambridge: Cambridge University Press, 2019), 132.
2. Plato, *Ion*, 534 a–e.
3. Sadness doesn't seem to matter, according to psychologists, and some highly creative people, such as Ludwig Wittgenstein, led anguished lives. Matthijs Bass, "In the Mood for Creativity," in Kaufman and Sternberg, *Cambridge Handbook of Creativity*, 257.
4. Wittgenstein, *Culture and Value*, 6c.
5. Carlyle, *Past and Present*, 148.
6. Hunt, *Pre-Raphaelitism*, II.106–8.
7. Hunt, II.110.
8. Hunt, 1:204–6.
9. Gaunt, *Pre-Raphaelite Tragedy*, 30.
10. Escholier, *Port-Royal*, 102.
11. Escholier, 130. This was the first poem in the 1936 *Oxford Book of Modern Verse*, which Yeats edited.
12. Benson, *Walter Pater*, 3.
13. See Donoghue, *Walter Pater*, chapters 6 and 7.
14. Benson, *Walter Pater*, 23.
15. Pater, *Renaissance*, 250.
16. Ruskin, *Modern Painters*, 178.
17. Pater, *Renaissance*, 250.
18. Pater, *Marius the Epicurean*, 23.
19. Yeats, *Autobiographies*, 235.
20. Gaunt, *Pre-Raphaelite Tragedy*, 91.
21. Ruskin, *St. Mark's Rest*, second suppl., *The Place of Dragons*, vi.

CHAPTER NINE

1. Hansard, House of Lords, October 7, 1831, §§ 251–52.

2. Baudelaire, "Journaux intimes," *Œuvres*, 684.

3. Stendhal, *Le Rouge et le Noir*, 702.

4. Wilde, *Letters*, 313.

5. Wilde, *Plays, Prose Writings and Poems*, 237.

6. Yeats, *Autobiography*, 236.

7. Gaunt, *Aesthetic Adventure*, 164.

8. Gaunt, 165.

9. Ellman, *Oscar Wilde*, 527–28.

10. Wilde, *Letters*, 857.

11. "Un nouveau théologien, M. Fernand Laudet." Péguy, *Œuvres en prose complètes*, III:572. Were scriptural authority required, see Matt. 9:9–13. Graham Greene employed Péguy's line as the epigraph for *The Heart of the Matter*.

12. Aristotle said something similar when he considered different life choices. The pleasures of an active life dim, he said, compared to the ideal of a life of contemplation and *theōria*. But then, as a philosopher, Aristotle was curious about just about everything: metaphysics, physics, logic, ethics, comedy, you name it.

13. Keating, *Intimacy with God*, 16.Kempis, *Imitation of Christ*, 33.

14. Luke 10:38–42.

15. Epictetus, *Encheiridion*, II.491.

CHAPTER TEN

1. Matt. 5–7.

2. Matt. 19:21; Mark 10:21; Luke 18:22.

3. S.T. II.2 77.3.

4. Forster, *Howards End*, 195.

5. Forster, 76.

6. Plato, *Protagoras*, 352c–d, 357c–358d. Socrates makes the same argument in the *Meno*, 77b–78b.

7. Pascal, *Esprit géométrique*.

8. There are other explanations for weakness of the will, such as willful ignorance, rationalizations, and emotional detachment, and the lengthy philosophical literature on the subject is beyond the scope of this book See, e.g., Mele, *Autonomous Agents*, chapter 2; *Motivation and Agency*, chapter 7. In "hyperbolic discounting," for example, we myopically overweigh the immediate reward and underweigh long-term benefits. Elster, *Ulysses Unbound*, 24–45. Alternatively, the choice we're offered might ask us to revise our overall life plan, permitting an excep-

tion for just such a case. See R. Holton, "Intention and Weakness of Will," *Journal of Philosophy* 96 (1999): 241–62.

9. Wittgenstein, *Culture and Value*, 3.

10. Camus, *Théâtre, recits, nouvelles*, 1518.

11. Camus, *Carnets*, III.240–41.

12. Montaigne, "On the Inconsistency of Our Actions," *Essays*, 377.

13. Pascal, *Pensée* 483, *Œuvres*, II.754.

CHAPTER ELEVEN

1. Gal. 6:7.

2. Gen. 18:11–15.

3. Isa. 14:12–15. See also Ezek. 28:12–19.

4. Job 1:7.

5. Gen. 2:8–9.

6. Gen. 2:17.

7. Job 40:8.

8. Gen. 3:5.

9. Similarly, Kant saw the story of the Fall as a metaphor for man's intellectual progress. "The fourth step of *reason* is also associated with man's release from the womb of nature, a change of status which undoubtedly does him honour, but is at the same time fraught with danger; for it expelled him from the harmless and secure condition of a protected childhood – from a garden, as it were." Kant, "Conjectures on the Beginning of Human History," *Political Writings*, 226.

10. Glaeser, *Triumph of the City*, 137.

11. E. Y. "Yip" Harburg, "Brother, Can You Spare a Dime?"

12. Peter Harrison, "Curiosity, Forbidden Knowledge, and the Reformation of Natural Philosophy in Early Modern England," *Isis* 92 (2001): 265–90.

13. Keynes, *Collected Writings*, X:363.

14. Bird and Sherwin, *American Prometheus*, 306.

15. Bird and Sherwin, 22.

16. Camus, *Camus à Combat*, 569 (August 8, 1945).

17. Camus, 309.

18. Camus, 323.

19. Monk, *Robert Oppenheimer*, 563.

20. Oppenheimer, *Uncommon Sense*, 9, 44.

21. Rhodes, *Making of the Atomic Bomb*, 563.

22. Monk, *Robert Oppenheimer*, 572.

23. Monk, 608.

24. Bird and Sherwin, *American Prometheus*, 443.
25. *In the Matter of J. Robert Oppenheimer*, III:450–51 (April 14, 1954).
26. Bird and Sherwin, *American Prometheus*, 507.
27. Henri-Pierre Roché, *Jules et Jim* (Paris: Flammarion, 1979), 161.
28. Germaine Greer, "Three's a Crowd," *Guardian*, May 23, 2008.
29. Pauline Kael, "Jules et Jim," *Partisan Review* 29 (1962): 4.
30. "Neighbour Who Called Police over Boris Johnson Row Goes Public," *Guardian*, June 22, 2019.
31. "The Last Hanging: There Was a Reason They Outlawed Public Executions," *New York Times*, May 6, 2001.

CHAPTER TWELVE

1. Pascal, *Pensée* 154, *Œuvres* II.600.
2. Joyce, *A Portrait of the Artist as a Young Man*, 150.
3. Pascal, *Pensée* 398, *Œuvres*, II.682.
4. Pascal, *Pensée* 397, *Œuvres*, II.677.
5. These propositions, which are found in St. Augustine, were condemned as heretical by the Church. Kolakowski, *God Owes You Nothing*, 13–17.
6. See also Wittgenstein, *Culture and Value*, 72. "If God really does choose those who are to be saved, there is no reason why he should not choose them according to nationality, race or temperament."
7. Pascal, Écrits sur la grâce, écrit xi, *Œuvres*, II.290. Again, "Jesus Christ came ... to call to penance and justify the sinners and leave the just in their sins." *Pensée* 220, *Œuvres*, II.523.
8. That was how Jansenist novelist Georges Bernanos (1888–1948) summed up the human condition in *The Diary of a Country Priest*, his story about a saintly priest denied God's favor during his life. The priest is surrounded by pettiness and meanness. His every effort at kindness is misunderstood. And he dies miserably. His last words are "What does it matter? All is grace."
9. Judt, *Burden of Responsibility*, 135.
10. Camus, *Carnets*, III.177.
11. Camus, II.129–30.
12. Camus, *Essais*, 99.
13. Gide, *Journal*, II:748 (January 12, 1941).
14. Gide, II:760 (May 10, 1941). Two years later, Gide wrote that the brutalities of Hitler and Stalin were simply wounds of a day over which the flesh would heal. They promise immense benefits and have told us that this is the only way to achieve them. That is what Hitler and Stalin say, "and what they have some

reason to think; and this also is what I repeat to myself endlessly, what my head answers back to my heart." Gide, II:921 (March 12, 1943).

15. Koestler, *Scum of the Earth*, 278.

16. Camus, *Carnets*, I:207.

17. Camus, II.322.

18. Augustine, *Confessions*, 4.4.9.

19. Quoted in Pieper, *Death and Immortality*, 2. Existentialists took their name from their claim that "existence precedes essence," by which they meant that there is no core to our nature that defines us, no natural law that governs us. Instead, we are defined by the choices we make, and for which we are responsible. As a philosophy, existentialism was never taken seriously in Anglo-American philosophy departments. On the other hand, we're living at an existential moment, one in which gender differences are questioned and people are permitted to choose their own sex and ways of living. Existence precedes essence in a way that would have surprised Camus.

20. Camus, *Théâtre, recits, nouvelles*, 1516–17.

21. Pascal, *Pensée* 693, *Œuvres*, II.405.

22. Gen. 32:24–32; Hos. 12:4.

23. Helliwell, Layard, and Sachs, *World Happiness Report*, 2018.

24. Baudelaire, *Œuvres*, 2.233.

CHAPTER THIRTEEN

1. Weber, *Vocation Lecture*, 10.

2. Bazzana, *Wondrous Strange*, 130.

3. Watson, *Life of Richard Porson*, 387.

4. Wenzel, *Sin of Sloth*, 25–28.

5. Cassian, *Institutes*, 219–20 [X.ii].

6. Virgil, *Aeneid*, vi.314. See also *Iliad*, 1.145, 24.554; *Odyssey*, iv.108, xx.130.

7. Fustel de Coulanges, *Ancient City*, 15–25.

8. Waugh, *Sword of Honour*, 8–9.

9. S.T. II.5, 1105b29–1106a2.

10. Burton, *Anatomy of Melancholy*, 201 [III.5.ii].

11. Modern brain science studies the relationship between our feelings and the brain at a molecular level. When people like Tara Condell commit suicide, the brain stem sends less than normal amounts of serotonin to the prefrontal cortex. Serotonin is a neurotransmitter, a chemical that transmits information by relaying an electrical signal past the junctions (synapses) between neurons (brain cells), from signal-sending to signal-receiving receptor cells. The serotonin

exerts a calming influence when received at the prefrontal cortex, which is the seat of the brain that prevents us from acting on dangerous impulses. Another neurotransmitter, dopamine, seems to be the chemical behind curiosity and desire. The brain includes several pathways through which dopamine is sent, one of which signals the desirability of a particular choice. We're always offered different choices, and dopamine seems to enhance the confidence felt in picking one of them. Yael Niv, "Cost, Benefit, Tonic, Phasic: What Do Response Rates Tell Us about Dopamine and Motivation?," *Annals of the New York Academy of Sciences* 1104 (2007): 357–76; Min Jeong Kang et al., "The Wick in the Candle of Learning: Epistemic Curiosity Activates Reward Circuitry and Enhances Memory," *Psychological Science* 20 (2009): 963–73; Michael J. Frank et al., "Understanding Decision-Making Deficits in Neurological Conditions: Insights from Models of Natural Action Selection," *Philosophical Transcations of the Royal Society of London, Series B* 362 (2007): 1641–54.

12. Isa. 38:1–5.
13. Camus, *Carnets*, I.182.
14. *Odyssey* 17:326–27.
15. A message seemingly lost on the wretched gourmands who dine on ortolans and who cover their heads with a napkin before downing the little bird whole, that God not see their disgrace.
16. Lev. 16.
17. Isa. 45:15.
18. Quignard, *Georges de La Tour*, 353.
19. Merton, *Seven Story Mountain*, 354.
20. 1 Kings 19:11–15.
21. Péguy, Victor-Marie, comte Hugo, *Œuvres en prose completes*, III.164–65.
22. Picard, *World of Silence*, 8–9.
23. Augustine, *Confessions*, 92–93 [6:3].
24. Augustine, 152–53 [8.29].
25. 2 Sam. 6–7.
26. John 13:3–15.
27. Jablonski, *Skin*, 106.

CHAPTER FOURTEEN

1. "Stanzas from the Grande Chartreuse."
2. Andrea McCarren, "Parents in Trouble Again for Letting Kids Walk Home Alone," *USA Today*, April 13, 2015.
3. https://www.apa.org/monitor/2019/01/ce-corner.

4. Gerald Sirkin, "DDT, Fraud, and Malaria," *American Spectator*, February 25, 2005.

5. J. L. Espinoza, "Malaria Resurgence in the Americas: An Underestimated Threat," *Pathogens* 8 (2019): 11.

6. J. Mark Ramseyer and Eric B. Rasmussen, "Are Americans More Litigious," in Buckley, *American Illness*, 69.

7. Emily Ekins, "Poll: 62 % of Americans Say They Have Political View They're Afraid to Share," Cato Institute, July 22, 2020.

8. Ursula Perano, "Dating in a Politically Polarized World," *Axios*, February 14, 2020.

9. Merleau-Ponty, *Humanisme et terreur*, 3.

10. Aron, *Opium of the Intellectuals*, 42.

11. The social justice warrior is more likely to want to interfere with people's choices than the libertarian. That doesn't mean that the libertarian is curious about those choices, however. He is more likely to be indifferent about what we choose. It's the social justice warrior who is curious about our choices and who wants to step in and police what he sees as bad ones.

12. Muggeridge, *Chronicles of Wasted Time*, 244–45.

13. ST III, Supplement, Qu. xciv, art. 1.

14. Mill, *Autobiography*, 139.

15. Steiner, *Death of Tragedy*, 8.

16. Virgil, *Aeneid*, I.462.

17. On the relation between the cult of Dionysus and tragedy, the canonical reference is to Nietzsche on *The Birth of Tragedy*.

18. Racine, *Œuvres*, 819.

19. Escholier, *Port-Royal*, 218.

20. That was our culture's answer to death, thought William Butler Yeats. "No man can create as did Shakespeare, Homer, Sophocles, who does not believe with all his blood and nerve, that man's soul is immortal." Yeats, *To All Artists and Writers*, 291.

Index

DESIGN & COMPOSITION BY CARL W. SCARBROUGH